A FINE DISREGARD

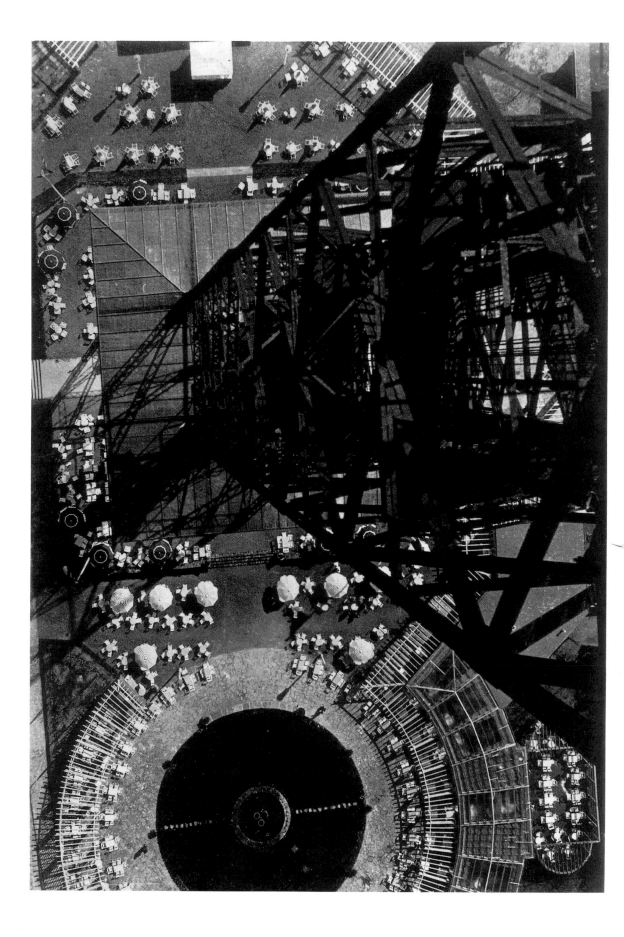

KIRK VARNEDOE

A FINE DISREGARD

WHAT MAKES MODERN ART MODERN

HARRY N. ABRAMS, INC.,
PUBLISHERS

Editor: Phyllis Freeman
Designer: Elissa Ichiyasu
Photo Editor: Neil Ryder Hoos

Frontispiece: László Moholy-Nagy. *Untitled (Looking Down from
the Wireless Tower, Berlin)*, 1932. Silver gelatin print, $14\frac{1}{4} \times 10''$
© 1989 Art Institute of Chicago, Special Photography
Acquisitions Fund, The Julian Levy Collection

FRONT COVER: CONSTANTIN BRANCUSI.
TORSO OF A YOUNG MAN. 1924. POLISHED BRONZE, H. 18".
HIRSHHORN MUSEUM AND SCULPTURE GARDEN,
SMITHSONIAN INSTITUTION, WASHINGTON, D.C.

BACK COVER: FRANK STELLA.
KASTŪRA. 1979. OIL AND EPOXY ON ALUMINUM,
WIRE MESH, 9'7" × 7'8" × 30". COLLECTION,
THE MUSEUM OF MODERN ART, NEW YORK

Library of Congress Cataloging-in-Publication Data
Varnedoe, Kirk, 1946–
A fine disregard : what makes modern art modern / Kirk Varnedoe.
320p. 19 × 24.5cm.
ISBN 0-8109-3106-0 (cloth) / ISBN 0-8109-2574-5 (pbk.)
1. Art, Modern—19th century. 2. Art, Modern—20th century.
I. Title
N6447.V37 1990 89-18074
709'.04—dc20 CIP

CONTENTS

ONE
INTRODUCTION

Somewhere back in a rainy summer in the 1970s, I made a pilgrimage of sorts to a place in the north of England that had fascinated me for years; it's a playing field (fig. 1, p. 10) that's part of the Rugby School, and on the wall next to that field is fixed the marker I came to see (fig. 2, p. 10). It reads: "This stone commemorates the exploit of William Webb Ellis, who with a fine disregard for the rules of football as played in his time, first took the ball in his arms and ran with it, thus originating the distinctive feature of the Rugby game. A.D. 1823." After duly photographing that stone, I ceremonially smeared two postcards with the turf of the field, and sent them to two brothers, who, along with me, had caught the bug of the Rugby game, an ocean and a century and a half away from that 1823 event.

It's a long tale how the game spread, then changed into eleven-man block-and-tackle football, and thus spawned a vast, expensive industry that absorbs American Saturdays and Sundays from the sweat of August to the ice of January. But in the late 1960s, a lot of American collegians, disenchanted with the corporate, semimilitary aspects of that industry, regressed against its grain. They went back to what seemed the simpler fun of Rugby, a rough but virtually equipmentless game without substitutions or time-outs, then played by makeshift clubs with few spectators and no publicity—in a spirit of sportsmanship that revered, in about equal measure, a hard contest and a good party afterward. I was among these primitivists; and as I moved back toward the bare essentials of the sport, I found my curiosity enduringly piqued by the tale of its origin. What possessed Webb Ellis, in the heat of a soccer game, to pick up that ball? And stranger still, why didn't they just throw him out of the game?

I understand now that it's all more complicated. Not just soccer but the broad variety of English schoolboy ball sports provided Ellis a panoply of waiting options, and the opportune moment was owed partly to Rugby's desire for a game of its own to match those, like the Eton wall game, of its rivals. The spread of the British Empire then did a lot to foster the branching diversity of seven-man, thirteen-man, Australian rules, and gridiron eleven variants that followed. Also, French "revisionists" try to argue that British chauvinism ignores the precedents in some ancient Gallic ball game, and so on. But whatever blurring these alternatives effect, and whatever historical details flesh out the tale, Webb Ellis's exploit still seems to me to be as sharply chiseled out a kernel as we could hope for of what cultural innovation is all about. Somebody operating in the context of one set of rules sees that there is another way to go, and takes matters into his or her own hands; and someone else, or a lot of others, chooses to view this aberrant move, not just as a failure or a foul, but as the seed of a new kind of game, with its own set of rules.

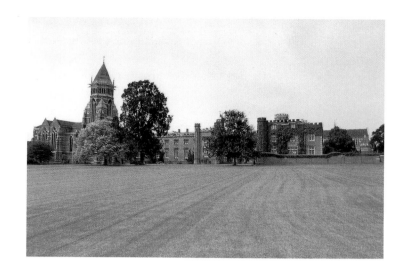

1. FIELD. RUGBY SCHOOL
RUGBY, WARWICKSHIRE, ENGLAND

The rest, we say, is history. And when we say so, I think we mean that, while the consequences (like the football industry) lend themselves to mundane chronicling, there's something about this kind of "fine disregard" that doesn't easily fit into that kind of history. A gesture such as Webb Ellis's explains what followed from it a lot more convincingly than it is itself explained by what came before. Nothing we could know of the boy and his background, nor any account of the circumstances of the school, could independently suffice to rationalize the wonder at the core: a charmed moment of fertilization between a gesture that might otherwise have fallen on fallow ground and a receptive field that might otherwise have gone barren. Innovation is a kind of secular miracle: secular, because it happens amid the humdrum machinery of life getting along, and virtually everything about it is comprehensible without recourse to any notion of supernatural mystery or fated destiny; miraculous, not only

2. STONE PLAQUE
RUGBY SCHOOL

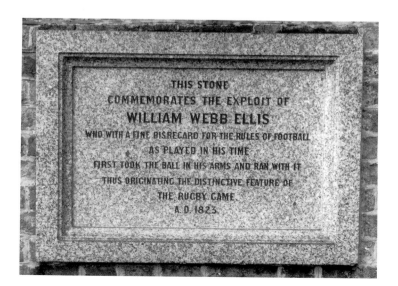

THIS STONE
COMMEMORATES THE EXPLOIT OF
WILLIAM WEBB ELLIS
WHO WITH A FINE DISREGARD FOR THE RULES OF FOOTBALL
AS PLAYED IN HIS TIME
FIRST TOOK THE BALL IN HIS ARMS AND RAN WITH IT
THUS ORIGINATING THE DISTINCTIVE FEATURE OF
THE RUGBY GAME
A.D. 1823

because it can change things dramatically, but because none of that machinery suffices to explain why it had to happen this way.

Among the rewarding, educating pursuits of my life, Rugby ran for many years in happy parallel with the study of modern art, and I don't accept the notion that they are incompatible. But when it comes to origin stories, there is a difference, and Rugby has the edge. It's not that I yearn for a Webb Ellis painter, and the clean simplicity of one originating gesture. The greater number of renegade players, the complexity of the audience, and the higher cultural stakes, all make the history of modern art a much more absorbing tale of change. But we need some better accounts of how that game, too, first got off the ground. The available ones tend to make the opening exploits seem all miraculous or all secular, too transcendent or too mechanical to properly credit some of our culture's finest and most fruitful transgressions of its rules.

On the side of miracles, we have to concede something to those who say modern art is like a religion. There has been a kind of orthodoxy, inculcated in countless devotees, about how it all came to be; and the doctrinaire version of that story, of Edouard Manet who begat Paul Cézanne who begat Pablo Picasso, in a march out of servile naturalism into the promised land of abstraction, explains what has happened in art since 1860 about as adequately as the seven days of Scripture account for the fossils in Devonian shale. Yet the people behind the weak gospels are often the very people who created the powerful art. Perversely, some of the liveliest rhetoric of artists and critics—the manifestoes and battle slogans of a pugnacious new minority out to change the world—has come to nourish the most inert, cardboard notions of what that art means. And though that embattled minority has now spread its domain to extents even its palmiest prophets never dreamed of, friends and enemies alike still look to these shopworn sermons as guides to understanding how it happened, and what it has all been about. In this sense, modern art after World War Two, and after 1960 especially, is not so much a cult with a bible as a culture without a constitution: a far-flung, complex republic that seems to keep flogging the propaganda of its founding guerrilla wars as its only operating charter.

It is not hard to see how this impasse developed. Any account of modern art's origins has to tie together a bewildering variety of objects and events, from Manet's urbane spaces (fig. 3, p. 12) and Claude Monet's landscapes (fig. 5, p. 13), through styles as disparate as Paul Gauguin's flat color and Georges Seurat's dots (fig. 4, p. 12), to the more hermetic departures of Picasso and Georges Braque in Cubism (fig. 6, p. 13). The canonical way to make sense of that story was to describe all those rapid-fire changes as a march of progress,

3. EDOUARD MANET
A BAR AT THE FOLIES-BERGÈRE
1881–82

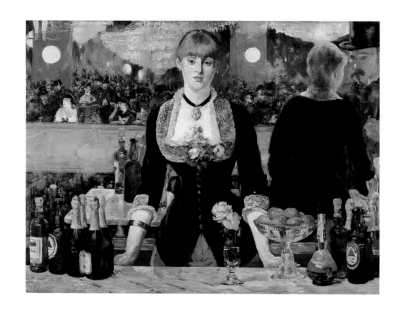

4. GEORGES SEURAT
SUNDAY AFTERNOON ON THE ISLAND
OF LA GRANDE JATTE, 1884–86

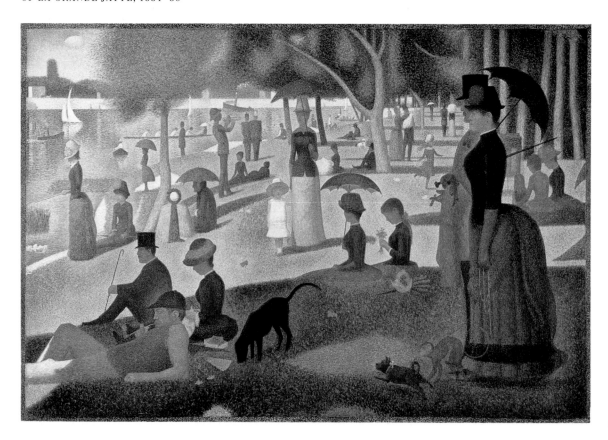

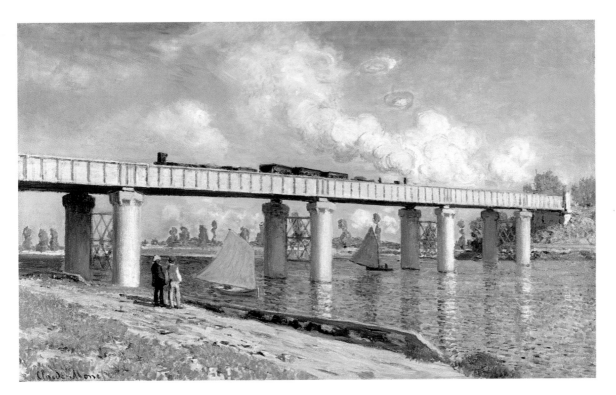

5. CLAUDE MONET
THE RAILROAD BRIDGE VIEWED FROM THE PORT, 1873

6. PABLO PICASSO
"MA JOLIE," 1911–12

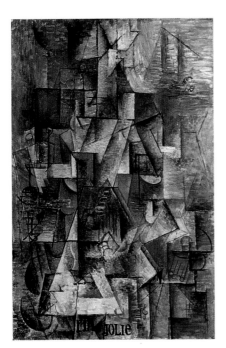

and explain the welter of new forms as revelations of necessary truths. This approach treats Auguste Renoir's portrait of Monet painting outdoors, for example, or Gauguin's "primitive" visions (figs. 7 and 8, p. 16) as emblems of discovery, almost in the fashion of pioneering science: Realists or Impressionists renouncing the musty academic studio to capture immediate sensations of natural light and color; and Post-Impressionists like Gauguin moving on to explore symbolic forms engendered deep within the mind. Such art was bound to succeed, the story goes, because it was RIGHT. Whether by fidelity to the givens of nature (Monet's truer observation) or to the structures of the mind (Gauguin's purer imagination), it reached outside the confines of mere convention, where the academics were mired, into the domain of the necessary and universal.

The more aggressive the changes, the greater the apparent need to claim a basis in something permanent and objective. When early modern painters broke established rules, and let go of resemblance to mundane reality, proponents typically maintained they were actually following better rules that charted a higher reality—according to the dictates of, say, Platonic philosophy, Bergsonian time-consciousness, or n-dimensional geometry. The push toward forms of abstraction around World War One brought this kind of advocacy to a special, fevered pitch. Discrediting familiar European artistic traditions, artists and supporters alike invoked the more absolutist authority of sources in science, mathematics, mysticism, primitive or exotic art, and so on,

that were "timeless" by virtue of their disconnection from the historical clocks of Western taste. And for more than half a century since, we have continued to hear such appeals to non-art systems of determining order and higher truth, variously found via recourse to dreams, mathematics, or cognitive theory, in sources that range from X rays to entropy, from new religions like theosophy to new sciences like cybernetics.

At the same time, though, others have preached that modern art's progress was shaped by an internal aesthetic logic that accorded with the most advanced intellectual spirit of its time and place. The most sophisticated version of this story describes a sequence of step-by-step refinements, in which each art form gradually moved toward a purer realization of its essential nature. Painting, for example, stripped itself of illusionism and literary reference to arrive at an unadulterated presentation of color and shape on a flat plane. In this reading, Monet and Gauguin pioneered not by superior advance toward facts, but by retreat from art's illusions. Their disdain for the conventional niceties of perspective and modeling, and the forthrightness of their bold brushstrokes or unalloyed color, inaugurated a world-spurning drive toward the medium's self-definition—a drive that, so the creed upholds, distinguishes the truly modern from the merely novel in twentieth-century creativity.

Clearly there's a big difference between explaining the last hundred years of art as a search for ultimate truths, and analyzing it as a baton race toward historically appropriate aesthetics. Yet both those stories are about focused movement toward absolute forms, and both evoke an air of destiny. That kind of vision—the kind that makes modern art a goal-oriented crusade and a cause of faith—has been indispensable in embattled times, and generative in crucial ways. For countless artists, a deep belief in one or another of these higher systems has been a key motivation to creativity, in the face of few other assurances and against considerable resistance. And histories based on such an idealistic sense of purpose—showing, for example, how the flat picture plane ultimately triumphed or how form hewed ever closer to function—have set the benchmarks for any account of modern art's origins and development. Like other kinds of evangelism, though, these credos degenerate into dogma. And more important, over the long haul and in the broader view, such stories about ordained progress and perfection just do not work.

As regards Monet and Gauguin, for instance, neither the notion of pure "impressions," nor that of eternal mental forms, stands up in terms of what we know about cognitive processes—or tells us anything useful about how their pictures were really made. And the subsequent path of modern art is littered with countless other lost causes, fad

enthusiasms, and misused authorities, from Milarepa to Mesmer to Mandelbrot. Grand pronouncements of aesthetic/ historical necessity have recurrently proved to be only excuses for a moment's taste; they invariably scant the complexity of modern art's origins, and crumble in the face of its ongoing permutations.

Such arguments for transcendent values also notoriously disregard the perturbations of history, to portray instead a grand procession that strides along above the muck of ordinary life. Little wonder, then, that as those claims have lost their credibility, the story of modern art should be retold—as it has been often in the past two decades—in a more tendentiously secular way, as a function of sociopolitical context. In this approach, for example, Monet's garden views (fig. 9, p. 18) aren't neutral glimpses of nature, but politically slanted fictions of 1870s suburban life in Paris; and Gauguin's glorifications of untutored rustics (fig. 10, p. 19) have less to do with eternal ideals of a pure mind than with dated illusions about France's rural underclasses.

This kind of demystification has substantial justice on its side. Countless modern artists have proclaimed that their boldness was an integral expression of the society of their time. And it is far more believable, just on a human level, that even the most potent innovations are less prompted by predestination than by a tangle of local motivations and conditions. Art historians love to unravel those tangles, too, because it involves fascinating sociological research and engages charged issues of political concern. But by shifting their emphasis to social context as the prime source of meaning, some of these historians are also devaluing the most basic notions of modern art's significance.

The crucially original aspect of later nineteenth-century art has always been seen to lie in the steadily more obtrusive inflections of style—Manet's peculiar spaces, Seurat's insistent geometry, and so on—that apparently began moving painting away from figurative representation toward abstraction. But the recent writing redefines these innovations as analog transcriptions of social conditions. The ambiguous space in Manet's *Bar at the Folies-Bergère* is said to convey, for example, the confusions of class mixing in Parisian cabaret life; and the frozen architectural rhythms in Seurat's *Sunday Afternoon on the Island of La Grande Jatte* are meant to critique the starchy rigidity of the middle-class strollers. The new social historians treat such monuments of the later nineteenth century—previously seen as premonitions of a new, autonomous language of art—as coded commentaries on the social conditions of their day.

Pictures like Monet's, formerly touted as transparent naturalism, are now interpreted as opaque screens, inscribed with the prejudices of a particular mind, class, and epoch.

And where we were formerly asked to see opaque devices closing off worldly representation, as in Manet's spaces or Seurat's repetitious rhythms, the new account asks us to read specially structured reports on the conditions of the day. Realism is unmasked as disguised stylization, and stylization —even as it later moves into abstraction—is deciphered as disguised Realism. The frontier between them, that crucial line that modern art crossed, seems diminished in significance.

This kind of revision has been most provocative when it unveiled new, hidden meanings in icons of early modern art like the *Bar* and the *Grande Jatte*. The revisionists maintain that the attention and honor given these works over the past few generations have been either misdirected, or sublimated,

7. PIERRE-AUGUSTE RENOIR
MONET PAINTING IN HIS GARDEN IN ARGENTEUIL, 1873

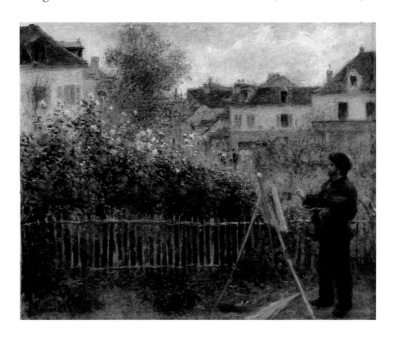

8. PAUL GAUGUIN
THE VISION AFTER THE SERMON (JACOB WRESTLING WITH THE ANGEL), 1888

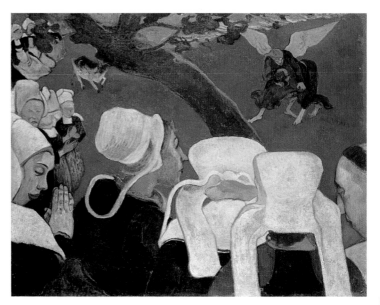

away from recognition of the real critical function of the pictures. But critiques that require a century to decipher have failed in some basic sense. And it is hard to categorize these artists as exemplary failures—unless one is willing to count the whole enterprise of modern art which they initiated as equally inadequate and unsuccessful, on the same grounds of a pesky lack of political clarity. That larger conclusion, in fact, seems to lurk not too much further down this interpretive path.

This new social history of art is often deeply researched and subtle. Rather than dealing in simplistic notions of literal content, it recognizes that innovative forms are the key aspect of early modern art. But its interpretations of those forms almost always scant something basic. If literalism and critical precision were their aims, certainly these artists were foolish to pursue them in terms of unfamiliar and often willfully illegible, nonreferential new forms. And to say that they used such devices in order precisely to map particular unfamiliar and imprecise conditions (e.g., an untraditional and confusing pictorial space is a calibrated analog for a novel and complex social space) is to put back into the art new elliptical versions of the very things that were highest on the modern artist's reject list: little moralizing narratives and legible, one-to-one correspondences between art forms and specific, textual meanings.

The effort to enlarge the human import in modern art's innovations must entail more than reducing them to a freshly clever form of oblique social reporting. It has to allow that these innovations succeeded as they did by resisting simple explanation, and by proving adaptable to other, unexpected uses, as bearers of an expanding set of meanings. If Manet's core contribution was to capture class anxiety in cabarets, or if the most telling challenge Seurat posed was how to take a stand on the social problematics of leisure time in Paris in 1884, would these pictures have gone forth and fructified as they did? More baldly, why would anyone but academic partisans care? Ultimately, history has valued these pictures more for the questions they raised than for the ones they resolved, more for what they opened up than for what they pinned down.

A moral issue is entangled with an interpretive strategy here. Some people think that unless a picture bears timely social freight, it is not doing any useful work; and that idle art is the devil's plaything. For those who reckon art a pawn to larger societal powers, it follows that it must graft itself aggressively to a chosen aim, lest it be taken hostage for someone else's purposes. Art with less than secure ties to explicit texts (like Jackson Pollock's dripped paintings, for example, or abstract art in general) runs a higher risk, so the argument goes, of being appropriated by unacceptable

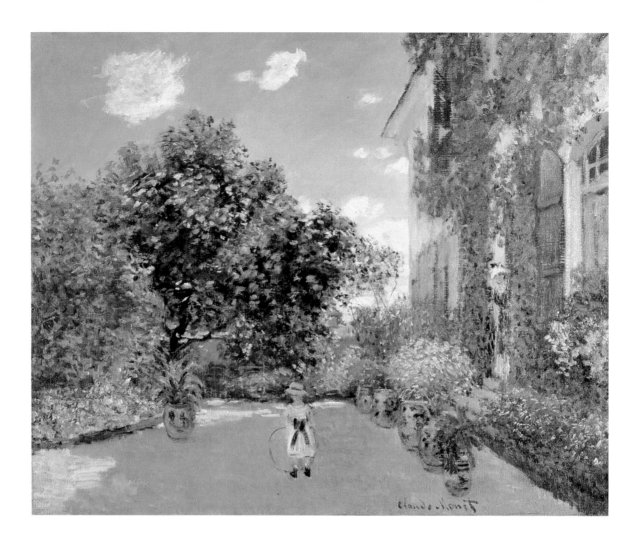

9. CLAUDE MONET
MONET'S HOUSE AT ARGENTEUIL
1873

admirers. Hence the new way of decoding makes an effort to rescue modern masterworks from a long history of such purported misuse, and rehabilitate their authors as adherents—at least by intention, if not by result—to this proper moral position.

But that's not how modern art works. Such discomfort with the vagaries of artistic license, and with the uncertainties of any art that is not didactic, is profoundly antimodern; and revalidating major monuments of modern art in these terms is a chillingly perverse enterprise. Besides delimiting the bounds of innovation on the artist's end, it also devalues the contemporary viewer's perception and judgment, and mistrusts the possibility for art, without attendant documents, to be intelligible in any worthwhile way. If the only real meanings of the work are those that we derive from understanding its original context, then the merely "visual" is to be mistrusted and must be heavily framed with research. In place of the close-order (but historically unconcerned) looking required by adepts of the "pure" analysis of form, the social history of modern art demands a detailed "reading," in which

what is *not* present in the work is asserted to be just as important as (or more important than) what is.

This effort to reweave a net of original contextual linkages around modern art's experiments, as a way to capture and constrain its meanings, is born of a basic skepticism about human communication. Can the things people make in one set of circumstances communicate anything useful to other people in other times and places, without some explanatory lexicon? Can an insider language say anything to outsiders—or more pointedly, when rogue individuals transgress the limits of a consensus vocabulary, how can the forms they invent carry any real significance for a wide and diverse community? Some of the stories we hear about modern art are illegitimately optimistic on this question, and ignore the difficulties involved; others harden them into impossibilities. One side proposes that as it becomes more abstract, art approaches the domain of guaranteed truths. By implying that people can have access to universal truths through personal insight, this notion continues the venerable hope for an ideal language that could transcend time and place, and make the same sense to cavemen and nuclear physicists. The opposing view, skeptical of the possibilities for individuals freely to gain and transfer knowledge, sees modern art, and especially abstraction, as a set of time-determined conventions that only force into higher relief the artificial, limiting nature of all languages.

These positions are interwoven, too, with emotional assessments of the gains and losses of modern experience. In the one view, art is the partner of modern creative discovery and heightened consciousness; in the other, its virtue lies in a critical mirroring of modernity's failings and special injuries.

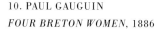

10. PAUL GAUGUIN
FOUR BRETON WOMEN, 1886

Here in a nutshell is the familiar antinomy of utopian and dystopian views of modernism, and the characteristically modern mood swing between extremes of hope and despair—or intellectually between extremes of absolutism and relativism. Each side has its evidence, for there are lists of artists' statements and powerful works of art that seem to back up one or the other view: a positive exhilaration about the expanded possibilities of individual freedom, and liberation from the dead weight of tradition; and an alienated ache for lost stability and consensus, or the equal dread of monotonous conformity, and inescapable oppression. In such dilemmas, there is not going to be a final "right side"; experience tells us modern life is a mixed blessing whose mix keeps changing. But if we will never resolve this problem, we might at least get a better fix on what modern art—unquestionably the signal, defining cultural invention of our epoch—has to tell us about it.

As the disenchanted never tire of pointing out, there are glaring disparities between what modern art promised in the manifestoes and what it has proved to be. But the problem is not just that a lot of the early utopian visions don't square with what went wrong—as in the gap between the reformist hopes of some architects and the mean uninhabitability of instant slums built to their model. It is also that such rhetoric, and the standard origin stories built on it, offer no adequate explanation for all that went right—no plausible way to account for the immense dissemination of modern art's innovations, or for the pleasure and stimulation diverse masses of people have derived from them. Even the most overreaching early claims made for the new art tend to tie it to a specific set of intentions and a focused destiny in a way that shortchanges its potentials for more complex meanings and a broader base of acceptance.

The importance of Monet and Gauguin is not measurable against a scale determined by perceptual theory, any more than it is delimited by Third Republic politics. We do not have to agree either with Seurat's color theories or with his anarchism to find profound human content in his landscapes, any more than we have to be Einstein to be fascinated by Cubist portraits. And only an infinitesimal percentage of those who jammed Picasso's 1980 retrospective at The Museum of Modern Art, or who have come to stand before Pollock's drip paintings in various degrees of bewilderment and thrall, cared an iota about the historical destiny of the picture plane. And yet people—a broad range of ages and types of people—have found in these odd and difficult things a rich spectrum of meanings and uses, in private, social, and civic life. Those Pollocks, for example, which at first seemed only like spattercloths or chimpanzees' scribbling, have swiftly come to

inform a spectrum of visualization and thought that runs from banal decorative patterns to the most serious efforts to reimagine the sublime, and have served in turn to empower a vast, expanding field of art that in no evident way resembles his. Modern art's most salient and valued attributes have to do, not with absolutism and exclusivity, but with this heterogeneous inclusiveness and unprecedented open-endedness, in its means, its concerns, and its audience.

The choice between determined, explicit meaning and no meaning at all is a false one. Abstraction, for example, has proved to be an enduringly fecund aspect of the culture of this century, without being either a universal *lingua franca*, or a code for hidden textual meanings. The willingness to explore such forms, without defined, consensus significance, has been the motor force of modern art. In this regard, the progressive arguments about the search for truth and perfection get things backward: the art has turned out to be more accessible and replete with meaning, more powerful and enduring, than the authoritative systems or historical destinies that supposedly produced it and gave it significance. Such art has persisted, and been generative, by failing to fulfill, and thus outstripping, the claims its advocates made; and even, in many cases, the boldest intentions of its creators. This dissemination, moreover, had nothing to do with destiny. The astonishing thing is that a whole array of outrageous new forms was produced and accepted, proliferated, and eventually radically transformed Western visual culture—though there was no historical necessity, and no foundation in fixed Truth with a capital *T*, that justified the oddities or validated the attention paid them. In sum, the art works, and the stories do not.

We need better stories. To recover a truer sense of the secular miracle in modern art, we have to replace its conventional genesis accounts with a genuinely Darwinian notion of evolutionary origins and growth. The record of its history so far—the succession of fault lines and fissures, the mix of extinctions and expansions of new family trees—doesn't present just a roster of forms developed to fit changing conditions, any more than it reveals the playing out of some predestined design. It is a powerful demonstration of the creative force of contingency—the interaction of multiple mutations with special environments that started with a few basic reshufflings of the existing gene pool, and has yielded an amazing, diverse world of thriving new forms of life.

The signal difference, of course, is that this evolution has nothing to do with universal, natural law. Its unfolding depends on (though its results are not determined by) the conditions of specific cultures at a distinctive moment in history. The shaping "environment" is a shifting cast of

people who have decided, for a panoply of reasons noble and ignoble, to tolerate, pay attention to, or actively support, an unprecedented expansion of artists' prerogatives to create what a biologist might call "hopeful monsters"—variations, hybrids, and mutations that altered inherited definitions of what could be. The profligacy modern art needed in order to grow—the seemingly gratuitous attempts to adapt familiar things to unexpected purposes, the promiscuous couplings of disparate worlds of convention—could not survive outside this climate. And the raw material here is not random change, but personal initiative: the individual decisions to be an outsider within one's own world, to try new meanings for old forms, and attack old tasks with new means, to accept the strange as useful and to reconsider the familiar as fraught with possibility.

That's why Webb Ellis's exploit seems such an apt model—not as a determining stroke of genius, but as a seemingly gratuitous rearrangement within a fluid set of established conventions, that finds its possibilities and purposes as its ripples spread. The act focuses our attention on the indispensable role of personal will and initiative, certainly. But precisely because this act was so simple, human, and willfully contrary, it illuminates the creative power that lay around it, in the interplay between the possibilities a culture offered, and those it proved willing to accept. We should not allow the power and complexity of the universe of artistic forms by which we have come to identify our epoch and ourselves in it, from Manet to Pollock and beyond, to blind us to its origins in just such occasions, when individual acts of conviction deflect known but neglected potentials to meet a field of latent but undefined opportunities, and thereby empower whole new systems of unpredictable complexity, with far more than intramural appeal.

A prime intention of this book is to honor those exploits: modern art, I hope to show in detailed examples, did not originate in the wholesale overthrow of all conventions and the protean creation of wholly new forms, nor in the impact of alien influences from outside the Western world. Nor were its innovations shaped by the grinding-wheel of local social forces. It has been the product of individual decisions to reconsider the complex possibilities within the traditions available to them, and to act on basic options that were, and remain, broadly available and unconcealed.

This kind of art is conceivable only within a system that is in crucial senses unfixed, inefficient, and unpredictable—a cultural system whose work is done by the play within it, in all senses of the word, in a game where the rules themselves are what is constantly up for grabs. More than the forms themselves, it is this frame of mind, individually and societally, that is crucially new about modern art. That is why those early innovations, those first ruptures of convention that

detonated the sequence, remain so fascinating as exemplary acts. If we lose sight of them in the fog of theories, or overrationalize them in the web of art-historical detailing, if we let them get hardened into legends of predestination or reduced to mechanical responses to circumstance, we explain away modern art's birthright. But if we can have better, more accurate stories that do justice to those origins—to the initial moments of "fine disregard" when artists grasped new possibilities from within established games, and transformed what was known into the seeds of something new—we will have a better sense of why the rest is history.

TWO
NEAR AND FAR

Modern painting seems to say no to a lot of things, and the first of these is space—the kind of pictorial space, with the illusion of recession into depth, that had been a prime aspect of pictures for centuries before. The virtually airless, depthless stripes of Frank Stella's *Marriage of Reason and Squalor, II* of 1959 (fig. 11, p. 26), for example, can be taken as the outcome of a process announced in Henri Matisse's *Harmony in Red* (fig. 12, p. 26) of 1908. Matisse's wallpaper of huge floral swags pushes forward so aggressively that it begins to squeeze all the space out of the room; by the time Stella comes around, there is literally no more room, and his painting is more like the wall itself. For some people that advancing wall is what modern painting was all about. Each medium has its specialty, they tell us: literature is better at storytelling, sculpture can deal with forms in space, but painting is unbeatable at being purely optical, and flat. Its modernity depended on figuring that specialty out, and focusing in on it exclusively. By this account, what pioneers like Matisse initiated was a series of narrowing refinements that eventually led artists to distill the essence of being pictorial, in the absolute particulars of color and shape on a plane. This vision of modern art's destiny is what art history students used to call "the Road to Flatness."

There is a great deal of complex, sophisticated historical thinking behind this idea, but finally it does not yield a very expansive or satisfying vision. If the One Great Scorer eventually comes to write against this civilization, and sees that classical antiquity gave us the Parthenon, and the Middle Ages Chartres, and that the Renaissance left behind the Sistine ceiling, will it be said that the century that split the atom and put a man on the moon left us a series of odes to the inviolate integrity of the picture plane? If we accept that the thing which has most distinguished the visual arts of this century is a series of systematic exclusions and reductions, of ever firmer refusals to participate in a broader communication with the life of the world, then we have accepted something damning.

There must be a better way to think about this, from the beginning. There is a period before Matisse, in the late nineteenth century, when paintings first began to look less like windows and more like walls, because—according to a story that is widely familiar—the traditional illusion of space in pictures had become irrelevant to modern experience, and artists concerned with modern life found they had to discard it in order to be true to the world they lived in. The tradition they had inherited depended ultimately on the system of perspective invented by the fifteenth-century architects Leone Battista Alberti and Filippo Brunelleschi: a geometrical and mathematical technique for producing a coherent illusion of

11. FRANK STELLA
*THE MARRIAGE OF REASON AND
SQUALOR, II*, 1959

12. HENRI MATISSE
HARMONY IN RED, 1908

depth on a flat surface, geared to one fixed point of view. Its invention seemed tied to a whole world view, evident in early perspective pictures like Pietro Perugino's *The Delivery of the Keys to Saint Peter* (fig. 13, p. 28) or the *Ideal Townscape* by a painter close to Piero della Francesca (fig. 14, p. 28), that had to do with harmony, balance, measure, proportion, and stability, and that placed the eye and mind of man firmly at the center of the overall order.

With the coming of the modern age—with a time sense speeded up by the new pace of industry, and changes in economic and social structures, and a new sense of the more complex interior life of man—it is certainly credible that the terms of such a world, or space, would be called into question. In pictures like Edgar Degas's *Place de la Concorde* (*Vicomte Lepic and His Daughters*) of 1875 (fig. 15, p. 30), the urban world that had been stable, balanced, and measured in Perugino becomes chaotic: the horizon gets pitched up at the back, sudden leaps into space abut forms thrusting forward in front of us, and the figures of Degas's friend Lepic and his little girls slant in several different directions, running in and out of the frame. The decomposition of the spatial order seems a symptom of the collisions, shocks, and dynamism of modern life, as well as of the painter's more self-consciously subjective viewpoint; and one of its major aspects is the way the shapes of the figures, cut by the edges of the canvas and sometimes covering the field from top to bottom, disrupt any measured entry into the picture. By calling attention to the surface of the image, this enlarged foreground also begins to insist on the painting's nature as an abstract object. Thus we are off on the Road to Flatness, where all these new intuitions—modernity, painterly self-consciousness, and abstraction—will ostensibly find their apotheosis together.

I have already sketched the beginnings of a familiar explanation of why this should have happened, in terms of influence by social circumstances: a changing world brought an altered world view, which in turn demanded a new set of forms that would express it. There are more and less subtle versions of this way of thinking about change. Formerly, historians who dealt in the zeitgeist were involved with airy abstractions about the intellectual ether of the day. Recently, we are told grittier specifics about things like urban renewal and demographics. But sooner or later, histories of art as a social phenomenon tend toward the basic notion that art is a reflection of the society around it, and thus that changes in art are the result of changes in the larger culture. The artist is seen as a switching agent, receiving the message and sending it back out in code.

Other explanations, though, propose to deal more specifically with concrete, visual influences as the agents ostensibly provoking the changes in pictorial forms. The first

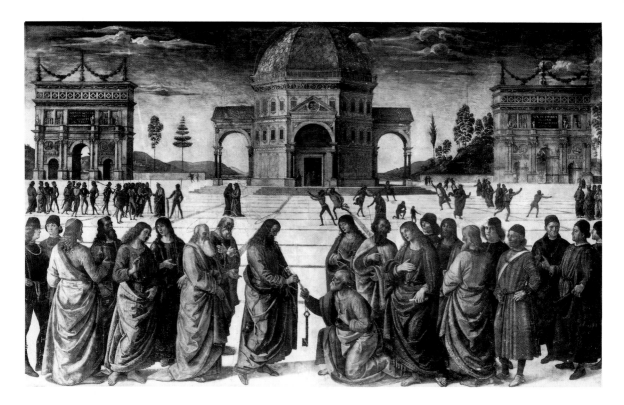

13. PIETRO PERUGINO
*THE DELIVERY OF THE KEYS TO
SAINT PETER*, 1482

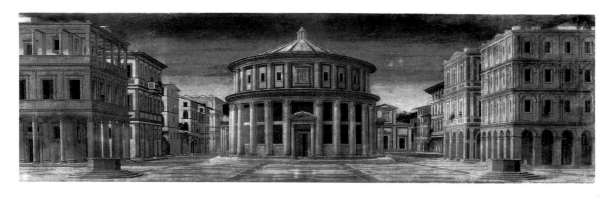

14. CIRCLE OF PIERO DELLA
FRANCESCA
AN IDEAL TOWNSCAPE, CA. 1470

one, evident with Degas, involves the influence of photography. The argument maintains that, with the development in the 1860s of the fast-shutter, light-sensitive photography of stereoscopic views (figs. 16 and 17, p. 31), artists suddenly began to see a world that was full of odd spaces, where the picture plane tilted up, the horizon disappeared, and things began to be oddly cropped at the sides of the pictures. The whole Renaissance perspectival system was thus supposedly called into question by a new technology that seemed more attuned to contemporary reality. It is this set of untraditional "photographic" cues that Degas, and other Impressionist painters of the 1870s, supposedly adopted.

The generation that followed immediately after Degas's picked up these obtrusive foregrounds and exaggerated their effect even more. Pictures like Gauguin's *Vision After the Sermon* of 1888 (fig. 18, p. 32) canceled the sense of a steady recession into space by outlining large shapes against unmodulated planes of color, with drastic leaps of scale and unnatural hues that declared the artificiality of the picture even more aggressively. It is generally understood that this taste for flattened artifice expanded on the lessons of Degas, and thus ultimately of photography, but that Gauguin's boldness—as in the big foreground branch that cuts the scene diagonally—was also owed to another, equally important influence: the Japanese woodblock prints that began to circulate in Europe in the 1860s.

While some explanations hold that photographs undermined Western spatial representation from within, like termites, others feature Japanese woodblock prints (e.g., fig. 19, p. 33, and fig. 21, p. 36) invading from outside the system, like killer bees. Artists like Gauguin, in search of an art based more on imagination than on copying nature's appearances, ostensibly found the "irrational," non-Western look of the prints' preternaturally enlarged foregrounds and unmodeled flat forms to be absolutely in tune with what they were after. Thus, from the paintings of Manet in the 1860s onward, in the work of Degas and Gauguin and countless other painters of the day, the crucial innovations in pictorial space have again and again been attributed interchangeably either to the influence of photography, or to that of Japanese prints, or to both together, with the same result in view: the breakdown of the Western perspectival tradition.

So goes the oft-told story: the link-up of the termites and the killer bees helped destroy Renaissance perspective and set Western art out on the Road to Flatness. This idea of change wrought by new machines or foreign influences is essentially a variant on an old Romantic notion which claims that real creation depends on getting outside all of our familiar cultural conventions. In this version (also found in recent

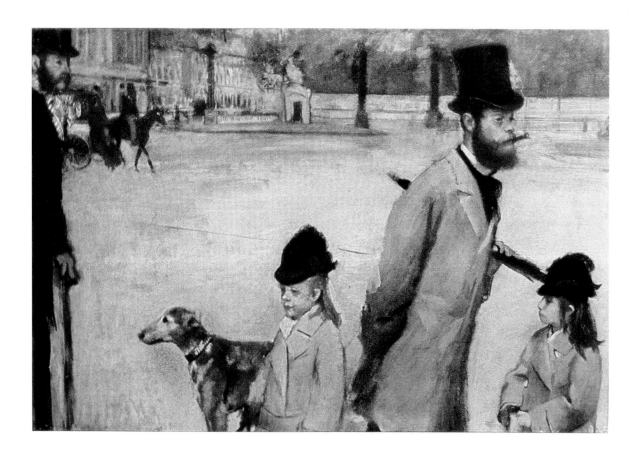

15. EDGAR DEGAS
PLACE DE LA CONCORDE (VICOMTE
LEPIC AND HIS DAUGHTERS), 1875

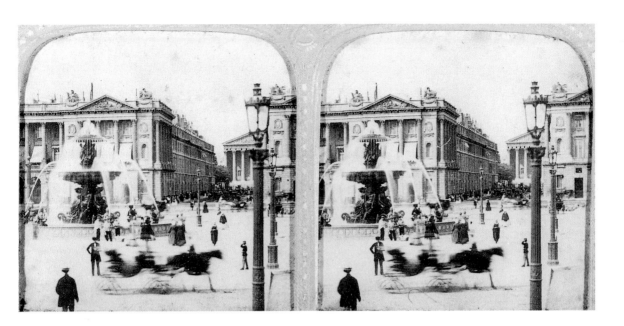

16. ANONYMOUS
PLACE DE LA CONCORDE, PARIS, 1863

17. A. HOUSSIN
PLACE DES VICTOIRES, 1863

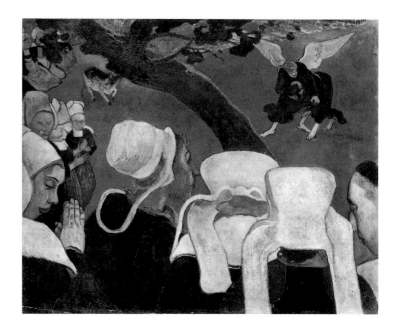

18. PAUL GAUGUIN
*THE VISION AFTER THE SERMON
(JACOB WRESTLING WITH
THE ANGEL)*, 1888
(FOR COLOR SEE P. 16)

19. ANDO HIROSHIGE
MOON PINE, UENO
FROM THE SERIES *ONE HUNDRED
FAMOUS VIEWS OF EDO*, 1857

books like *The Tao of Physics*), the world as revealed to us by our advanced technologies is remarkably like the one embodied in systems of thought never tainted by Western rationalization. Photography and Japanese prints, like particle physics and Zen Buddhism, come together to demolish our old world view and give us a new one.

It seems to me that these explanations do not work, for all sorts of reasons, both historical and logical. Photography, for instance, would have had a tough time countering perspective because, in essence, photography *is* perspective. The system by which the Rue de Rivoli is represented in 1860s stereoscopic views (fig. 20, p. 35) is basically identical with that invented by Brunelleschi and Alberti in the fifteenth century. Their triumph was to invent a way of matching nature with mathematics. Their mathematical and geometric technique of constructing a view produced results—the angles of recession on the side of a box or in a floor-tile pattern, for example (fig. 22, p. 37)—consistent with the behavior of light rays according to the laws of optical physics. A view constructed their way and a view seen through a lens could thus coincide in every proportion and particular. Photographic cameras are in this sense just little Brunelleschi boxes, laborsaving devices for producing views that could as well be made by the Renaissance method. The invention of photography in the 1830s was thus the beginning of a massive reaffirmation of perspective rather than its defeat. But the history of perspective that invention belongs to, and expands, is not the one of harmony, balance, and measure suggested by Piero and Perugino.

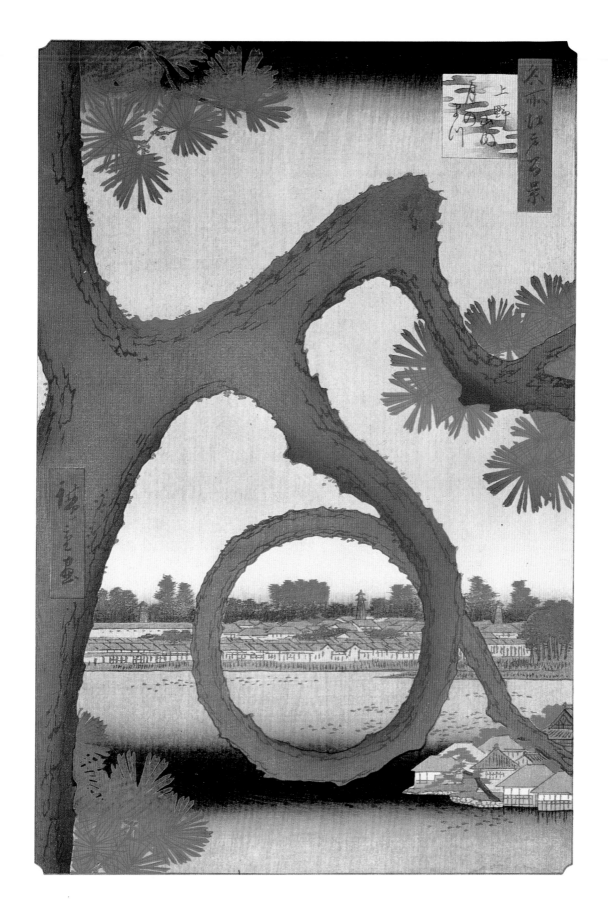

The world according to Renaissance perspective does not look like a rational globe laid out in a grid. Instead it looks like an older map, where strong contours surround the known world, and beyond them are inscribed admonitions that say, "Here lie monsters; go not here." Perspective is a system of norms and margins, and it does one thing for you if you stay within the rules and another if you venture outside. From the very beginning of perspective constructions, for example, it had always been known that if an artist moved his or her station point (the geometric substitute for the eye's position) too close to the imaginary "window" that would frame the view, or widened the field of that view to include large things near the edges of the field, perspective's perfectly consistent, rational system was perfectly capable of producing immensely weird imagery, in which the foreground became enormous and the background was drastically diminished, and the world looked twisted and deformed (fig. 23, p. 37).

All instruction manuals of perspective tried to put a governor on this machine, and cautioned the user to stay within assigned limits unless he wanted to explore strange, unfamiliar domains. But even if an artist held to the rules in his own perspective constructions, he could, from at least midway in the sixteenth century onward, have had a glimpse into those unfamiliar domains of marginal perspective through the lens optics of prephotographic camera devices. These devices worked either through pinhole projection of light or through lenses, and early on involved a whole darkened room (in Latin *camera obscura*) as a projection chamber (see fig. 24, p. 38). In more compact versions, the scene shining through the lens was projected, often by a mirror, onto a ground glass, for viewing from outside the darkened box (fig. 25, p. 38). These portable cameras became a useful shortcut to rendering for artists, as well as a source of delight and fascination in themselves.

For centuries before there was light-sensitive emulsion to record their images, the ungoverned optical projection of these pinhole and lens cameras showed people a great many of the oddities that lived outside of the limits of normal perspective. The question is not, Were such effects known, or available—they were—but, Did artists (or anyone else) find them meaningful, or see any use for them in representing the world? And the evidence, by and large, answers no. We know, for example, that Canaletto, the eighteenth-century Venetian artist, used a portable *camera obscura*. His notebooks show recurrent references to it and sketches done with its help. We are certainly licensed to think that this camera played a role in leading him toward the protophotographic crispness and casual compositional arrangements in his views of the Thames (fig. 26, p. 39), or to the intrusive effect of the foreground

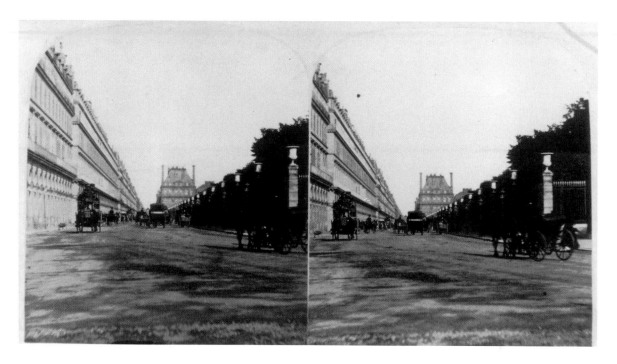

20. HIPPOLYTE JOUVIN
RUE DE RIVOLI, CA. 1865

arch in his view of the Piazza San Marco (fig. 27, p. 40). But we should also think about all that Canaletto left out of such pictures, intentionally. He tricked up the perspective in the latter picture, for example, so that the figures in the foreground would not loom up and obscure the piazza; their scale is made inconsistently small in relation to the arches near them, whose "obscuring" effect he wanted to use to heighten the picturesque scenography.

Every time Canaletto set up his *camera obscura* in the Piazza San Marco, he saw Degas's Lepic walk by. Countless Lepics walked by, but he did not choose to paint them. Such grossly enlarged foregrounds and other bizarre effects have been available since the beginning of perspective, built into the system itself; and they have been visible, indeed virtually unavoidable, every time someone looked through a lens device for hundreds of years before the advent of photographs. The more important questions concern what meaning those marginal effects might have, and who chose to do what with them. It is not what is available that shapes art, but what an artist chooses to find meaningful.

For example, there is no indication that the painter Jean-Etienne Liotard, in the eighteenth century, needed or had recourse to a camera at all in order to crop a servant girl at the left edge of his pastel breakfast scene (fig. 28, p. 41), or in order to intrude a window parapet, a jamb, and a self-portrait into the foreground of an extraordinary Swiss vista (fig. 29, p. 44). These are constructions made, not by optics, not by the lens, but by an artist because he wanted to. The same holds for the more famous instances of the seventeenth-century Dutch, with their

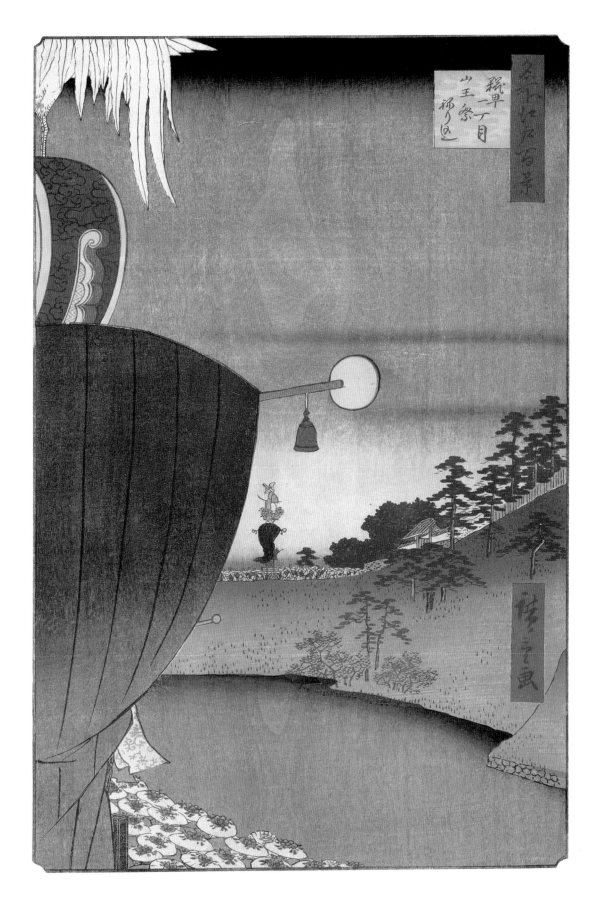

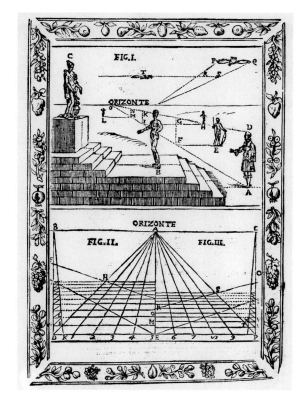

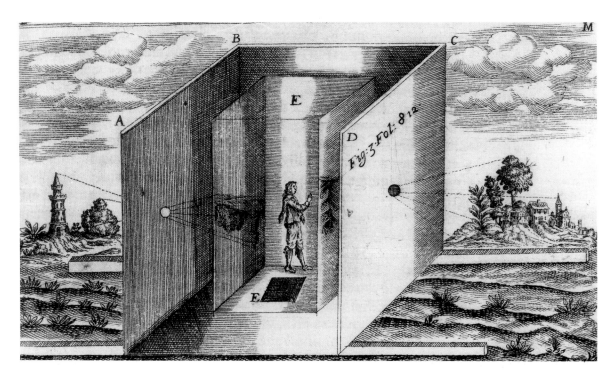

24. ATHANASIUS KIRCHER
LARGE CAMERA OBSCURA, 1646

25. CHRISTIAAN ANDRIESSEN
ARTIST WITH CAMERA OBSCURA
CA. 1810

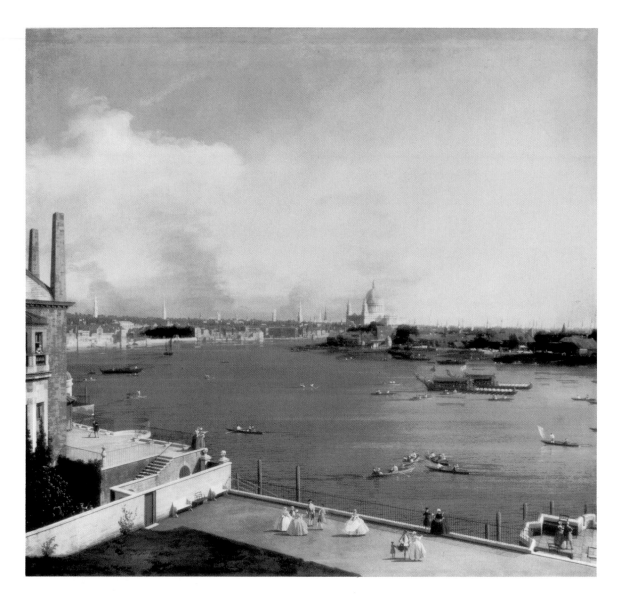

26. ANTONIO CANALETTO
*THE THAMES AND THE CITY OF
LONDON FROM RICHMOND HOUSE*
CA. 1747

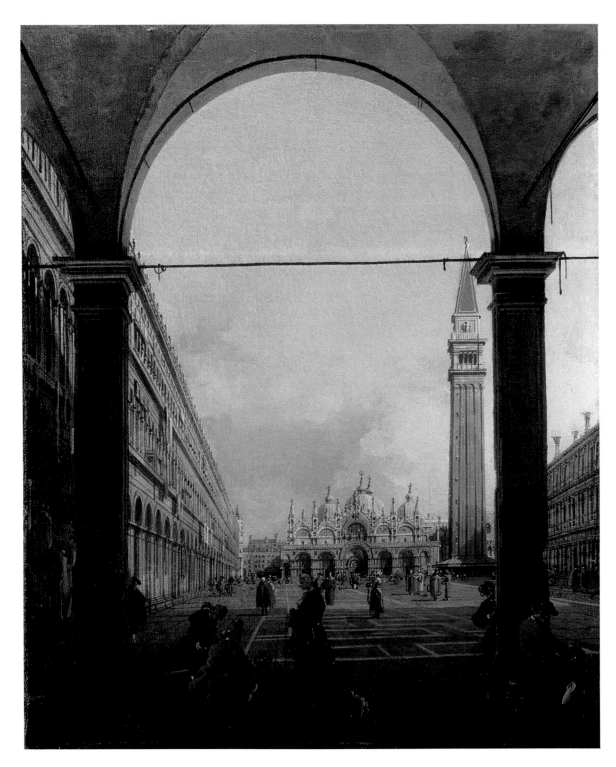

27. ANTONIO CANALETTO
PIAZZA SAN MARCO, 1756

28. JEAN-ETIENNE LIOTARD
BREAKFAST, 1753–56

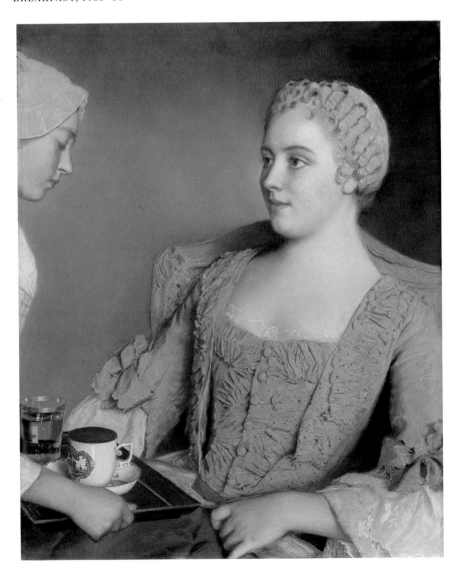

known fascination for optics. Regarding the enlarged frontal planes in Jan Vermeer's *Officer and Laughing Girl* or Carel Fabritius's *View of Delft* (figs. 30 and 31, p. 45), there is constant argument among scholars as to whether these are the products of a *camera obscura* or simply of clever mathematical and geometric constructions. The argument is hard to resolve because there is nothing in these unusual effects that permits us to differentiate the two possible sources. The compositions could have been made either through deliberate perspectival construction or by using the shortcut of a camera. The point is not the means, but the end, and the desire to get there. In marveling at the willfully unusual structures in the work of these two artists, we have to keep in mind all the seventeenth-century Dutch—and sixteenth-century Italians, and eighteenth-century French, and so on—who did not venture into this territory, but stayed, by choice, within the governing norms and middle ranges of perspective.

If we think about the history of perspective in this fashion, as a history with a main line (itself varied, and evolving) running down the middle and a set of sports or marginal possibilities intermittently explored on the side, then we get a different view of what photography inherited when it came into being. The situation is clear in the first preserved photograph, a view of rooftops by Nicéphore Niépce (fig. 32, p. 46). Light-sensitive emulsion does not look through the lens and decide what it wants to see; it takes what is there. Thus, trying to make a view out the window, Niépce got an enormous looming rooftop on the right, blocking a full half of the picture. But this was not a new problem. It is a problem that arises whenever someone tries to do a topographic survey in which the aim is to record the view from one point, where what is to be conveyed about the world includes evidence of the viewing position as a defining part of the accuracy of the view. We could go back to an image like Eduard Gaertner's panorama of Berlin, for example (fig. 33, p. 47), done in 1834, before he had any notion of photographic views. In order to be accurate about the vista from the top of the church, he included the roof, which occupies an enormous part of the foreground of the picture. Or further back, in seventeenth-century Rome, a draftsman named Israel Silvestre made a view from the dome of Saint Peter's (fig. 34, p. 47) in which the right foreground is dominated by a roof finial and the tiles of the dome, eclipsing in scale the architecture of Rome stretching out beyond and below.

The overenlarged foreground—the very device that seemed so integral to the sense of a modern, enhanced subjectivity in Degas—appears in these earlier images as the by-product of a particular attitude about topographic accuracy. It arises almost by a kind of default, from the decision to admit it rather than to exclude it. Photographers had these

same options, and had to make the same decisions. Since their emulsions would not discriminate for them in such matters, they had to maintain a censoring vigilance over the ability of photography to give permanent form to perspectival "mistakes." Early cartoons (figs. 35 and 36, p. 48) show us that camera operators were well aware of a raft of possible errors the lens could promulgate. Putting something near the lens, for example, can make it disproportionately enormous and things behind it far too small—so that the cartoonist warns us not to shove a hand too close. But these "blunders" were not unique to, or new with, photography. Parmigianino's sixteenth-century *Self-Portrait*, done in a convex mirror (fig. 37, p. 48) takes an aggressive interest in precisely the deformation that the photographers were warned against. The artist finds the deformation meaningful, not merely odd: he is interested in asserting the enormity of the hand, perhaps as token of his role as maker of the image, in the foreground of his presentation of himself. For Parmigianino, the oddity of the convex mirror is a vehicle for something he wants to do; it literally makes sense. The cartoons lead us to suppose that early photographers saw such oddities only as intrusions into their other purposes. And the evidence of early photographs confirms this supposition.

When early camera operators set out to photograph the streets of Paris, their goal, by and large, was to make pictures that looked like what people thought pictures should look like. They were not out to disrupt the history of normative representation, but to force the camera to stay within it. For example, to avoid having a big looming foreground of pedestrians crossing in front of the lens, one could elevate the camera, eliminate the foreground, and overlook the boulevard (fig. 38, p. 50, and fig. 39, p. 51). Or still on the ground, the photographer could make sure he stood a good distance away from his subject (fig. 40, p. 51). As a result, we rarely find in early photography anything remotely resembling Degas's edge-cropped foreground figures (fig. 41, p. 52). And when such effects occur, it is as a kind of static, as a kind of random noise in the middle of the organized, conventional representation of the world the photographer was trying to convey.

In the thousands and thousands of professionally controlled photographs that Degas could have seen, the ones potentially most interesting to him should have been stereoscopic views—because they captured random, fast-moving scenes with swift, stop-action exposures, because (like 3-D movies later) they had a special interest in exploiting unusual effects of contrast between things near and far, and because they were produced in volume, with less strict concern for traditions in individual compositions. Logically, they should be a fertile breeding ground for the kinds of

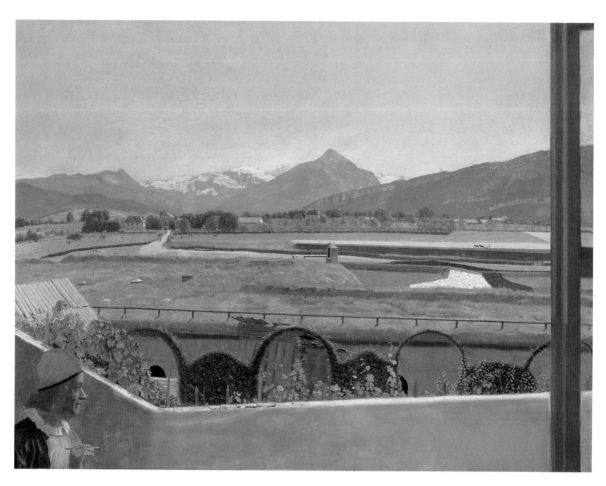

29. JEAN-ETIENNE LIOTARD
VIEW OF GENEVA FROM THE
ARTIST'S STUDIO, CA. 1765–70

30. JAN VERMEER
OFFICER AND LAUGHING GIRL
CA. 1655–60

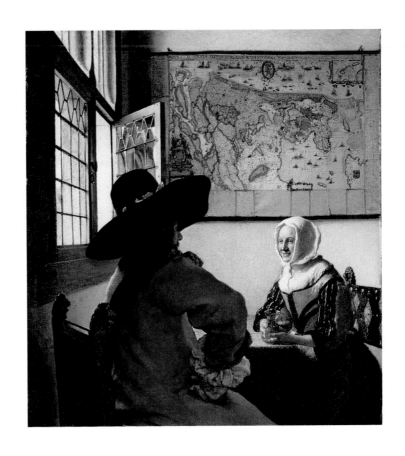

31. CAREL FABRITIUS
*A VIEW OF DELFT, WITH A MUSICAL
INSTRUMENT SELLER'S STALL*, 1652

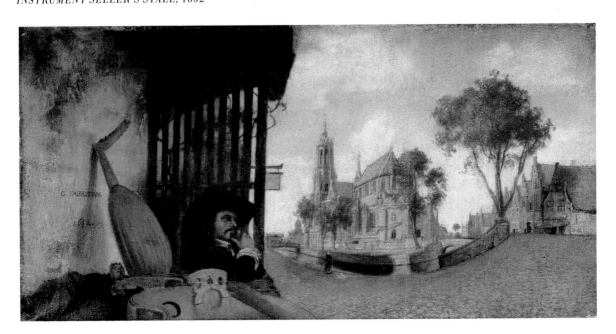

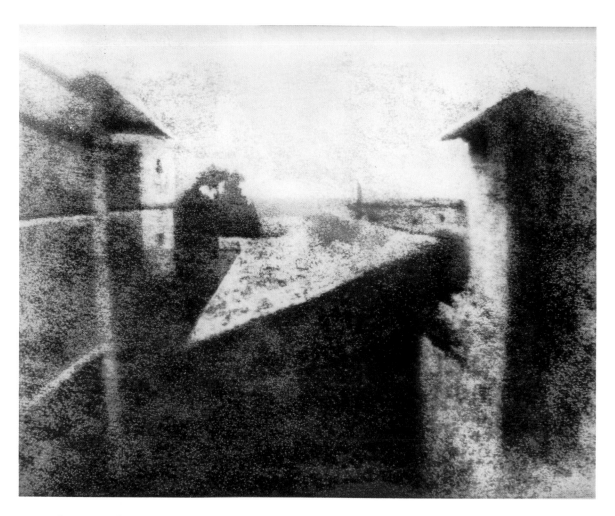

32. NICÉPHORE NIÉPCE
VIEW FROM WINDOW AT GRAS
CA. 1826

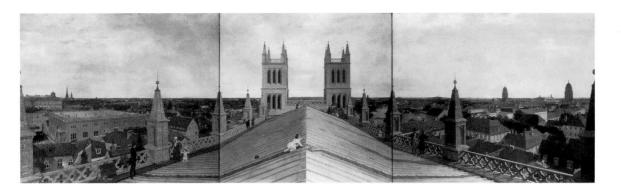

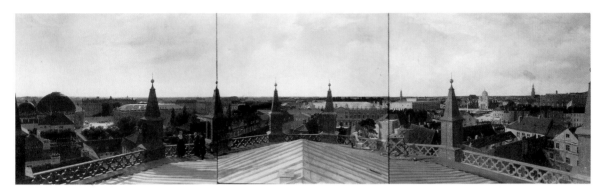

33. EDUARD GAERTNER
PANORAMA OF BERLIN FROM
THE ROOF OF THE
FRIEDRICHWERDERSCHE KIRCHE
1834

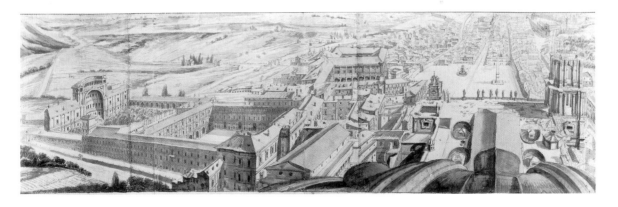

34. ISRAEL SILVESTRE
PANORAMA OF THE VATICAN FROM
THE DOME OF SAINT PETER'S, 1641

35. ANONYMOUS
PHOTOGRAPHIC EXPERIMENTS
FROM *UEBER LAND UND MEER*
CA. 1860

36. WILHELM BUSCH
FORGIVE THE PHOTOGRAPHER! HE
CAN'T DO ANYTHING ABOUT IT!, 1871

37. PARMIGIANINO
SELF-PORTRAIT IN A CONVEX
MIRROR, CA. 1524

accidents or mistakes that would have interested a painter out to create an image like the *Place de la Concorde*. But when we look at the hard evidence of photography in Degas's day, and compare the stereoscopic views of the 1860s and '70s to Degas's painting (fig. 41, p. 52), the difference is enormous— a difference in degree so intense as to be a difference in kind.

The advent of true snapshot photography came later, a crucial decade or so after Degas's innovations. The availability of cameras and processing systems simple enough to put photography into the hands of masses of amateurs is a phenomenon of the late 1880s (marked especially by the appearance of the first Kodak in 1888). The *Place de la Concorde* was painted in 1875. No matter how convincingly the picture suggests to us that there is something "photographic" about it, and no matter how thoroughly we search through archives of stereoscopic views (I have spent many a long hour doing just that), there are no photographs from this date that look like this painting in any serious way. And an artist so primed and so interested as to be able to create a painting like this based on the kind of clues provided by, for example, a little snip of a gent cropped at the knees in some stereoscopic view is an artist so prepared to do what he is doing that he hardly needs a stimulus that tiny to get going.

The *Place de la Concorde* involves a very sophisticated orchestration of a set of devices. It is not just that Vicomte Lepic's figure is cropped at the knees. He is cropped at the knees *and* placed off center. And it is not just that he is cropped at the knees and placed off center. He is cropped at the knees and placed off center *and* set against a tilted field with a high horizon; and cropped at the knees and placed off center against a high horizon and opposite a big void to the left. The painting orchestrates these separate devices into a coherent world view; and it is that kind of coherence that is completely lacking in the street photos of the 1860s and '70s. The *Place de la Concorde* is *about* accident. It makes accident meaningful, and takes it to be a truth. The stereoscopic views merely contain elements of the accidental. The gap between the two worlds is enormous because it is precisely the gap of will and of invention. And once the will to invent—to exploit neglected possibilities in the available conventions of art—is there in sufficient quantity, the significance of "clues" like those in the photographs shrivel into insignificance.

This story about perspective and photography relates to ongoing arguments about the influence of photography on Impressionism. But it also brings into question a whole larger notion, by which innovation occurs as a result of in-fluence, literally a flowing in, or pressure, passively received from the outside. This notion does not work to explain what Degas did.

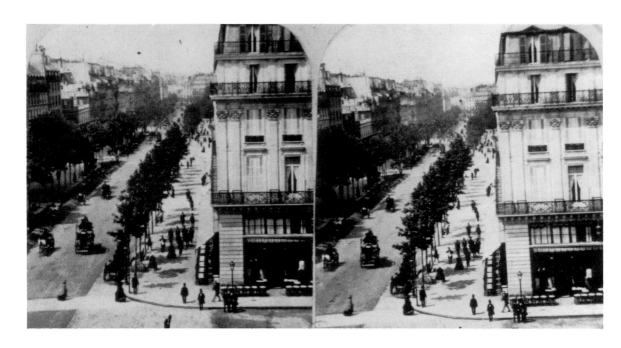

38. A. HOUSSIN
BOULEVARD IN PARIS, 1863

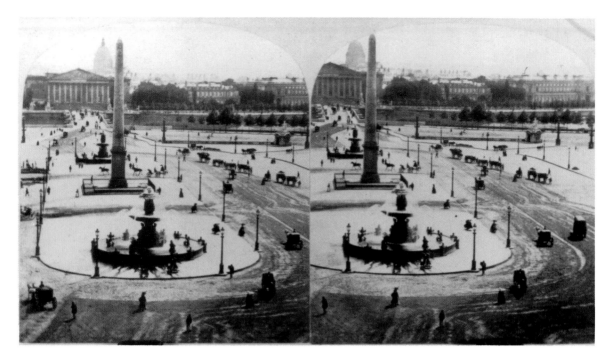

39. HIPPOLYTE JOUVIN
PLACE DE LA CONCORDE, 1867

40. BENEDICT
SAINT JOHN IN LATERAN, ROME, 1867

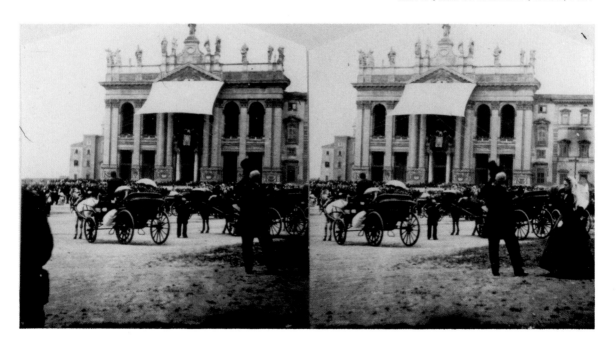

41. EDGAR DEGAS
*PLACE DE LA CONCORDE (VICOMTE
LEPIC AND HIS DAUGHTERS)*, 1875
(FOR COLOR SEE P. 30)

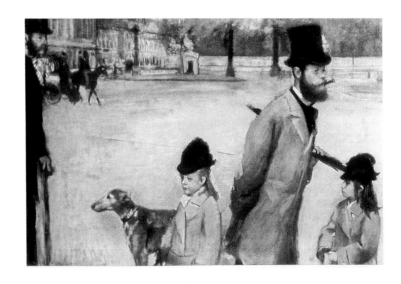

42. GARRY WINOGRAND
UNTITLED, 1969

And the inadequacies of this idea of external influence are tied to the inadequacies of the other explanation, that sees his new vision in terms of the oncoming wall, and the modern flatness of the picture plane. The modernity of Degas's picture does not lie just in some step it provides on the way to Matisse and to Stella. It involves the initial codification of a whole way of seeing the world, a way that has since been so widely propagated in film and photography that we now assume, in very basic ways, this is just the way the world is. When we see a photograph by Garry Winogrand, for example, a hundred years later, we are looking at a related vision (fig. 42). By dissociating Degas from the influence of photography in 1875, we are insisting that this sense of reality, this world of the odd and contingent, of the accidental and the ephemeral, this offbeat sense of the crazy street, is an invention. This is not at its inception a truth of the world "captured" or revealed to us by a new technology. It is neither the product of photography's nature nor a given of modern society, but a construction willed into being by an artist.

This is why it is important to rethink exactly what role photography, and the social changes of the day, might have played—and did not play, I think—in Degas's inventions. Degas's reality is the composition of a set of conventions—a world made, not found. The basic elements from which it was made had been available, through lenses or just through the application of perspective's rules, for centuries. The important lesson to be learned here, about influence and about the generation of new forms, is, first, that crucial acts of invention can derive from finding new potentials in old, taken-for-granted conventions; and second, that invented devices, and this includes reinvented devices, have the capacity to alter our sense of reality. Degas did not merely respond to a modernity picking up speed, or fragmenting into chaos; he created from a combination of traditional elements a vision of speed and contingency that still defines our sense of what modernity is.

But let us leave, for the moment, that notion about the influence of photography. What about the other explanation? What about Japanese prints? Certainly when we compare Degas's *Racecourse, Amateur Jockeys* (fig. 43, p. 54) of around 1880 and a Japanese woodblock print of a view with a wagon wheel (fig. 44, p. 55), all the objections raised with regard to photography as an influence seem countered. The print has a very coherent world view, in which the croppings and spatial devices are more than just random. If anything, it is even bolder in its segmentations and enlarged foregrounds than is the Degas, and has a far more impressive, powerful graphic punch than any "accidental" photograph of the day.

Certainly, we might think, this Japanese aesthetic must represent the kind of alien vision, the jolt from outside of the standards of Western rationalism, that was necessary to

43. EDGAR DEGAS
RACECOURSE, AMATEUR JOCKEYS
1876–87

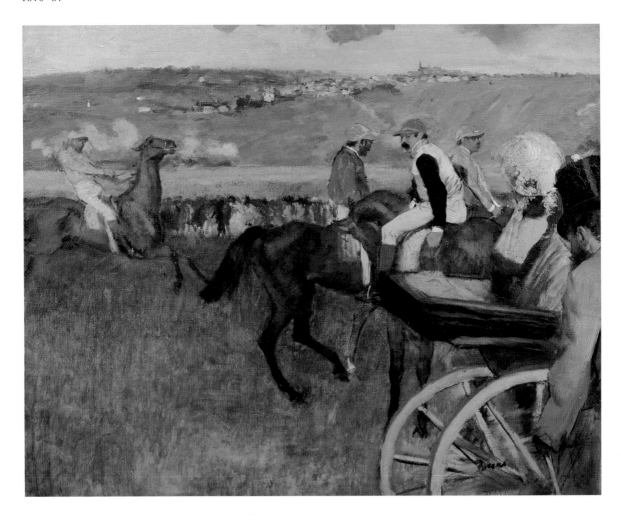

44. ANDO HIROSHIGE
USHIMACHI, TAKANAWA
FROM THE SERIES *ONE HUNDRED
FAMOUS VIEWS OF EDO*, 1857

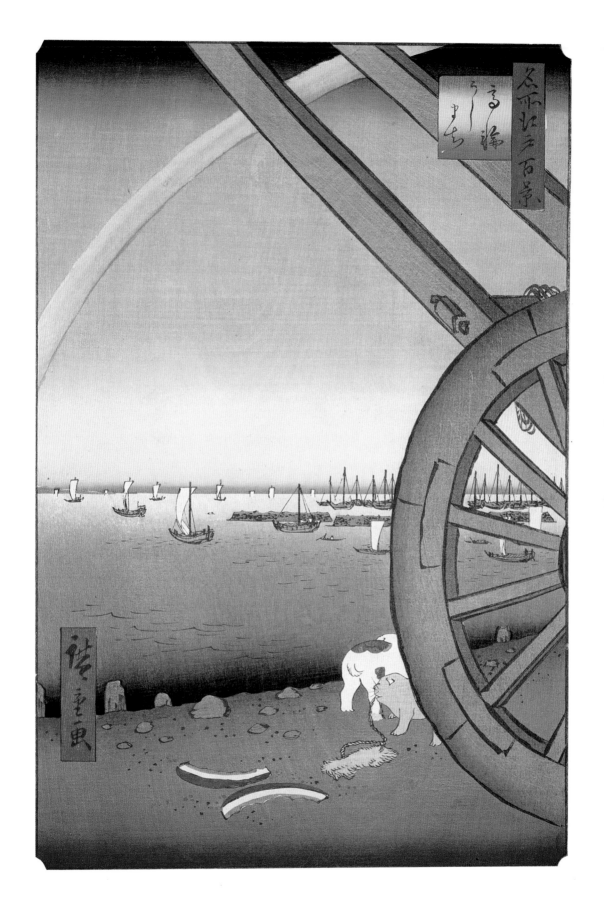

dislodge European painting from its traditions and set it on the road to modernity. And we have more than just after-the-fact comparisons to force that conclusion onto us. We have hard evidence that early modern painters from Manet onward knew these prints quite well: Van Gogh's 1887 copy after a print of a plum branch (fig. 45, p. 58, and fig. 46, p. 59) is only one of many items of proof that let us know Japanese prints were enormously popular, and widely copied or imitated from the 1860s through the turn of the century.

Again and again, in book after book, prints like these are set next to paintings like Degas's, or Gauguin's, or Van Gogh's in order to prove the influence of Far Eastern, non-Western structures on Western vision. But there is something interesting about all those books: the comparisons keep coming back to the same Japanese artist and the same set of prints. Ando Hiroshige is the artist who made both the wagon wheel and the plum branch, and the series of prints to which both those images belonged, the *One Hundred Famous Views of Edo* of 1856–58. A great many of the images in art history's usual repertoire of "influential" woodblock prints—some familiar like the lantern in the snow (fig. 47, p. 60), or some less familiar but perhaps even more striking, like the *Moon Pine, Ueno* (fig. 48, p. 60)—also come from this same series. In fact, without the existence of the twenty boldest foregrounds in Hiroshige's *One Hundred Famous Views of Edo*, the whole case for Japanese influence on spatial innovations in Western painting would be immeasurably weakened. That suggests that we should think less about Japanese influence as a generality, and harder about who Hiroshige was, and what the *One Hundred Famous Views of Edo* were, in order to understand their connection with the work of Western artists.

When we inquire where these prints came from, we circle back on ourselves. The tradition in which the *One Hundred Views of Edo* was made was a tradition of Japanese engagement with Western perspective. The historian of Tokyo (formerly Edo) Henry Smith has published a remarkable book on this series of prints, and from his work, we can learn that, long before there was Japonisme in Europe, there were waves of European influence in Japan. When the Japanese first dealt with Western art, in the seventeenth century, the contact was primarily through religious painting; and after a brief flurry, this interest largely died out. But then a second wave began in the late 1730s. Perspective first arrived indirectly through Chinese prints, then Dutch books provided interior views, landscapes, and anatomical charts. Even without diagrams or explanations of perspective's principles, Japanese artists understood that they were confronted with a new way of showing the world, a manner of representation connected with Western science's ability to understand and master nature. Their amazement at the accuracy of the anatomical drawings,

for example, carried over into a special fascination with perspective, as a parallel manifestation of scientific thinking.

So the Japanese began to copy, without understanding the principles, the perspectival convergences in the diagrams and pictures they saw. Some of the images thus produced were made to be seen through lens devices which would emphasize the "float" of planes in a system of illusory spatial recession, and were taken as curiosities, lying somewhere between magic and science. Exceptional artists like Shiba Kokan, though, made independent, fully perspectival views, like that of the Ryogoku Bridge (fig. 49, p. 61), that were as advanced as anything by Canaletto at the same date in the workings of enlarged foregrounds and recession in optical space.

While they venerated Western perspective, the Japanese artists had a freedom that came from not being informed about, or bound by, all its rules. They thought of it as something they might try to splice together with aspects of their own, local pictorial strategies. So Shiba Kokan, for example, grafted a deep Western space onto a vertical image of a woman in a familiar, completely flat and unmodeled woodblock-print style (fig. 50, p. 61). For our purposes, the most arresting of these splices in eighteenth-century Japanese art occur in pictures like the Odano Naotake of a vase of peonies, done before 1780 (fig. 51, p. 62), or the Satake Shozan pine tree with a bird, from about 1785 (fig. 52, p. 63). These artists took a Chinese-style tradition of close-up, veristic treatment of things like flowers and birds—a format that typically set such renderings against empty, neutral grounds—and married it with the mid-level horizons and deep space seen in Dutch landscape prints. They simply overlaid the Oriental still life on the sense of deep space from the West.

As they experimented with deep-space perspective, especially in the increasingly popular new print motif of figures in landscapes, woodblock artists like Katsushika Hokusai began to run into difficulties in making this spatial system truly consistent. In *View of Mount Fuji from Takahashi*, around 1800 (fig. 53, p. 64), he set the foreground down properly, including a perspectival sense of the bridge seen from below; but when we look at the second bridge, lower and in the background, and at the convergence of the riverbanks, and then try to make sense of these aspects in relation to Fuji in the distance, we see that he did not completely master the system.

One solution to the problems Hokusai had in this view, as he and others discovered, was to give up on the ideal of a consistent, continuous recession into space, through all the intermediary planes from near to far. That ability to rationalize a measured "processional" space was not what seems to have interested him in any event. Instead, it was the

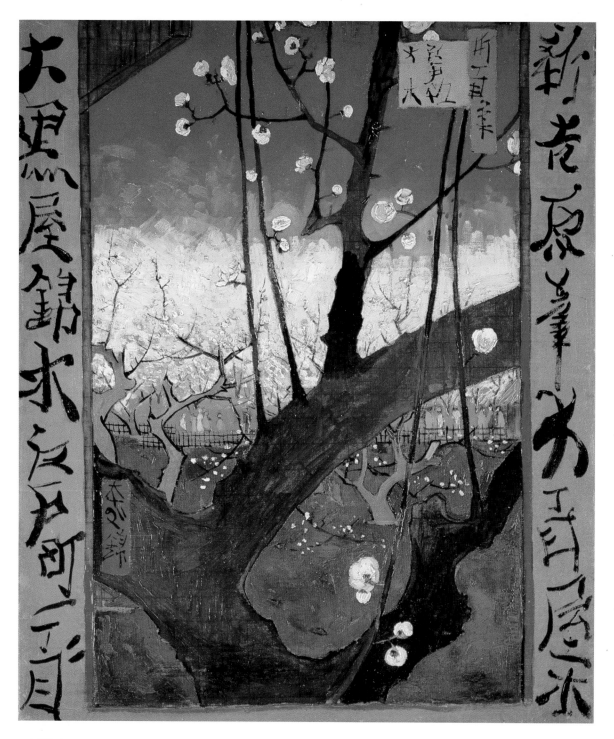

45. VINCENT VAN GOGH
JAPONAISERIE: THE TREE, 1887

46. ANDO HIROSHIGE
PLUM ESTATE, KAMEIDO
FROM THE SERIES *ONE HUNDRED
FAMOUS VIEWS OF EDO*, 1857

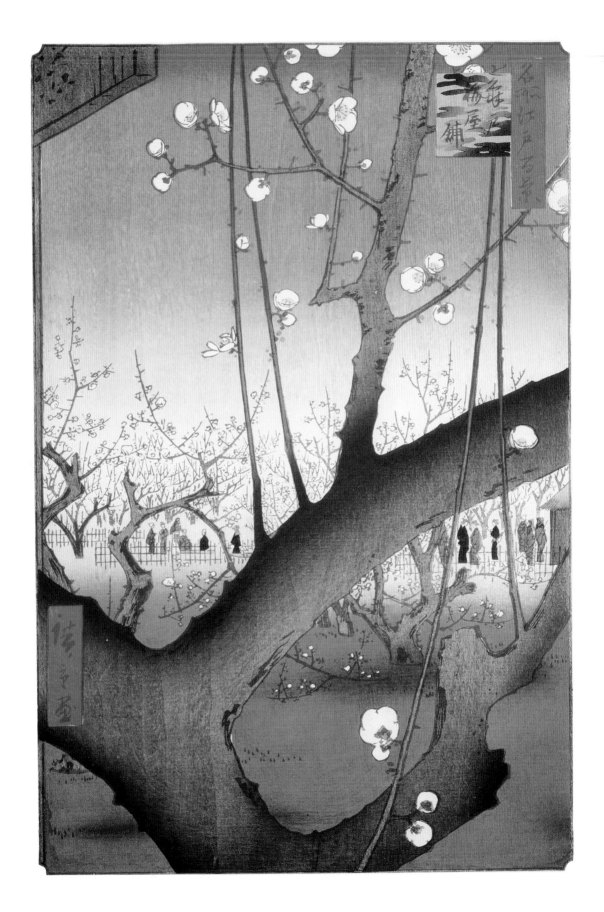

47. ANDO HIROSHIGE
KINRYUZAN TEMPLE, ASAKUSA
FROM THE SERIES *ONE HUNDRED*
FAMOUS VIEWS OF EDO, 1856

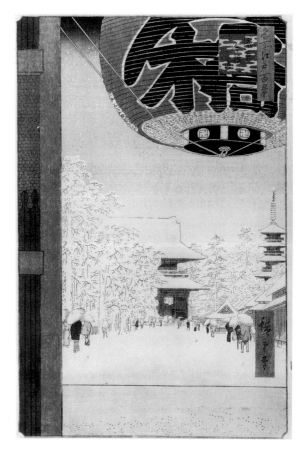

48. ANDO HIROSHIGE
MOON PINE, UENO, 1857
(FOR COLOR SEE P. 33)

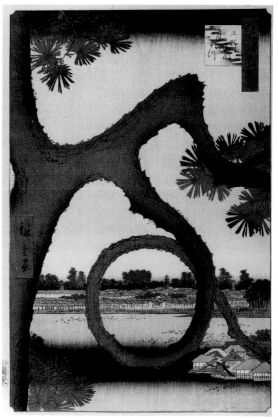

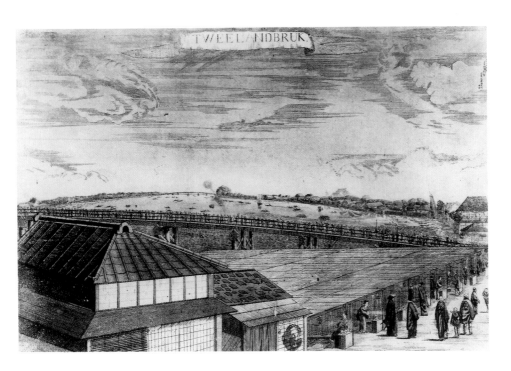

49. SHIBA KOKAN
RYOGOKU BRIDGE, EDO, 1787

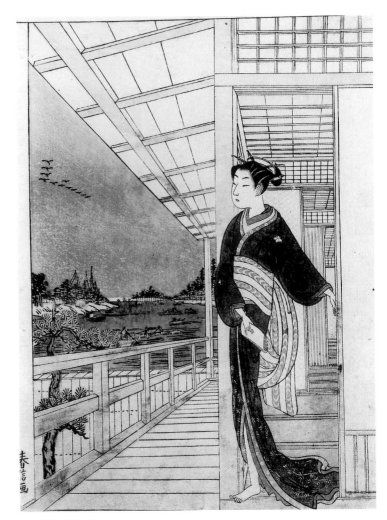

50. SHIBA KOKAN
COURTESAN ON VERANDA, CA. 1771

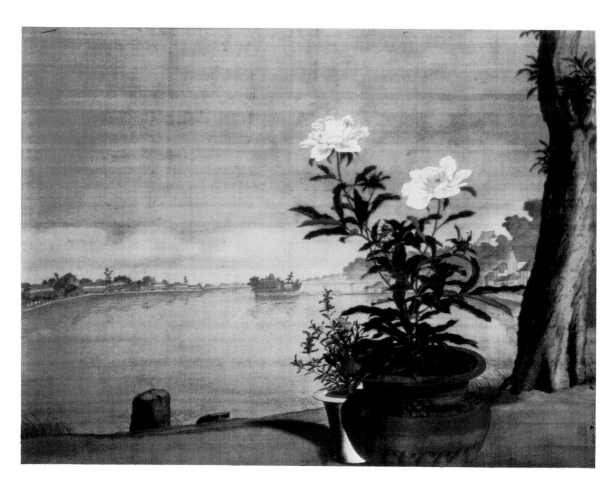

51. ODANO NAOTAKE
SHINOBAZU-NO-IKE, BEFORE 1780

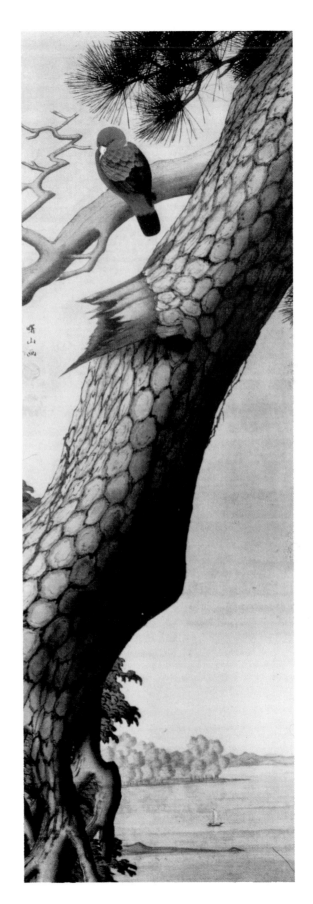

52. SATAKE SHOZAN
PINE TREE WITH A FOREIGN BIRD
BEFORE 1785

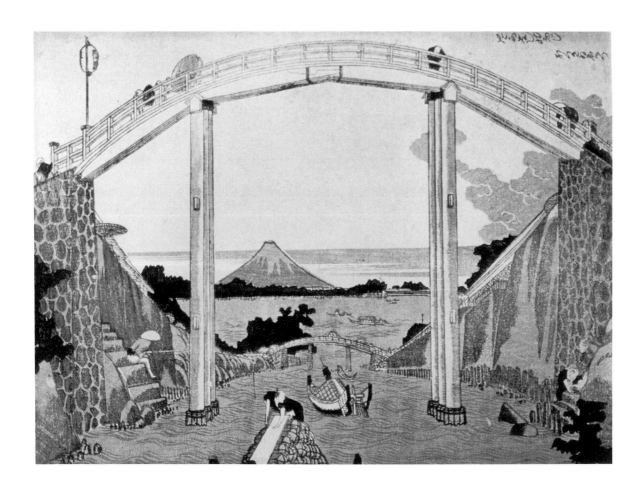

ability of the Western system to generate peculiar, novel effects of relationship. Most notably, the rules of Western perspective mandated that little things in the foreground, of no importance, should be prominent, while big and monumental things that were distant, like Fuji, should be relatively small. That suggested all sorts of odd possibilities of juxtaposition, and the way to exploit those possibilities was to leave out the awkward difficulties of continuous recession in between, and return to something like the overlay, or montage, in the earlier Odano (fig. 51, p. 62).

A later Hokusai, from the *One Hundred Views of Mount Fuji* in the 1830s (fig. 54), reverts to a compositional strategy very much like that of the splice between big foregrounds and deep horizons in the eighteenth-century experiments (fig. 55): the artist simply lays a large foreground directly over the silhouette of the distant Fuji, in order to play a witty kind of peek-a-boo. This kind of image made artistic capital from oddities of one-viewpoint perspective that might seem failures or impediments in traditional Asian landscape depictions. Instead of allowing distant things to be stacked up higher and higher in the image, so that each could be read clearly despite any interfering foreground, Western perspective required that

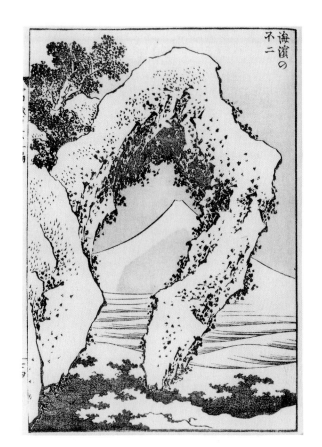

54. KATSUSHIKA HOKUSAI
FUJI FROM THE SEASHORE
FROM THE SERIES *ONE HUNDRED
VIEWS OF MOUNT FUJI*, 1834–47

55. KATSUSHIKA HOKUSAI
FUJI STRADDLED
FROM THE SERIES *ONE HUNDRED
VIEWS OF MOUNT FUJI*, 1834–47

faraway landmarks remain obscured or eclipsed by things close at hand, in order to be true to the limitations of a fixed point of view. Hokusai saw that he could use this set of rules to upset familiar orders of importance, and create surprising, unbalanced juxtapositions of proportion. For him, the limitations opened up the components of a new visual language.

In the course of Hokusai's development, he learned to use that language to say many different things. Sometimes he exploited the comic possibilities, by showing Fuji under the legs of a barrel maker, for example (fig. 55). But other uses were more subtle and interesting, as in the rhyming of looming stacks of rice packages—literally mountains of wealth—with Fuji (fig. 56); this created an immediate, one-to-one dialogue between riches stored up in earthly life and the true, enduring monumentality of nature beyond. It is that kind of play between the near ground, as the zone of the

56. KATSUSHIKA HOKUSAI
FUJI BOUNTIFUL
FROM THE SERIES *ONE HUNDRED
VIEWS OF MOUNT FUJI*, 1834–47

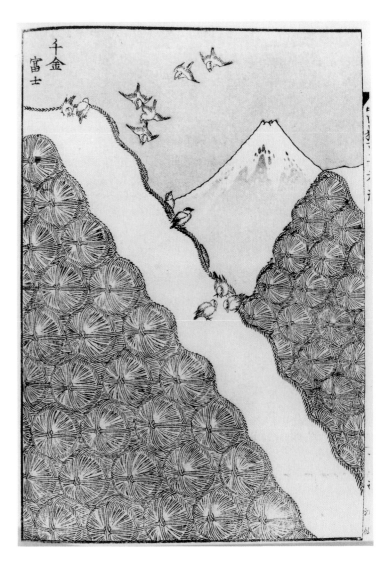

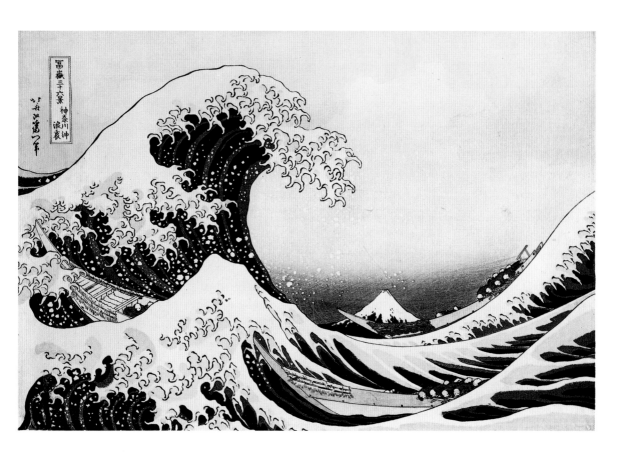

57. KATSUSHIKA HOKUSAI
THE GREAT WAVE OFF KANAGAWA
FROM THE SERIES *THIRTY-SIX
VIEWS OF MOUNT FUJI*, 1823–29

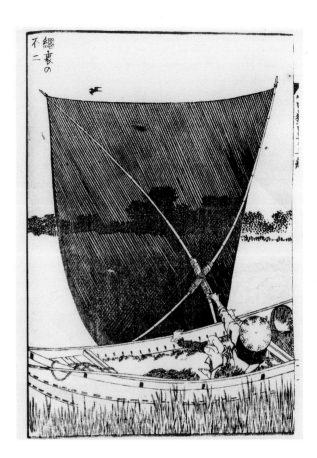

58. KATSUSHIKA HOKUSAI
FUJI BEHIND A NET
FROM THE SERIES *ONE HUNDRED*
VIEWS OF MOUNT FUJI, 1834–47

59. KATSUSHIKA HOKUSAI
FUJI THROUGH A WEB
FROM THE SERIES *ONE HUNDRED*
VIEWS OF MOUNT FUJI, 1834–47

human and the temporary, and the deep space as the area of remote permanence, which underlies one of Hokusai's greatest and most familiar prints, *The Great Wave Off Kanagawa*, from the *Thirty-six Views of Mount Fuji* in the 1820s (fig. 57). What is at issue there is not simply the visual pun of the mountains of foam in the foreground and the snow-covered cap of Fuji in the background; it is the idea of storm-tossed humanity amid the dangers of life, embodied in the boats at the mercy of unruly nature, set against the sense of immovable eternity beyond. (One etymology of "Fuji" is "eternal life," and the mountain has long stood, in Japanese verse and thought, for the idea of immortality.)

Hokusai also discovered that by leaving out the middle ground and montaging big foregrounds and little backgrounds together in this fashion, he could create imagery with a high novelty value, simply as a demonstration of his innovative virtuosity. Within the *One Hundred Views of Mount Fuji*, for example, we see Fuji through a fishnet (fig. 58), or through a spider web (fig. 59), in images whose appeal lies not only in a symbolic microcosm/macrocosm opposition, or in setting the laboring life against implacable nature, but also in sheer show-off bravado. This kind of surprise imagery, an assertively perverse mannerism, appealed to the clientele of the woodblock prints, who were hungry for novelty. It is specifically in that context, of market expectations and printmaker rivalry, that we have to see the link between Hokusai's innovations and those we began with, in Hiroshige's *One Hundred Famous Views of Edo*.

Though they worked as contemporaries in the 1840s, Hokusai was Hiroshige's senior by thirty-seven years. When Hiroshige began the *One Hundred Famous Views of Edo*, at the very end of his life, Hokusai had been dead for seven years. But the bold departures of Hiroshige's last series must have been partially spurred by the lingering memory of Hokusai's fertile inventiveness in his old age. *One Hundred Famous Views of Edo* evidences Hiroshige's desire both to pay homage to this legacy, and to best it; several of the views in this series are, Henry Smith suggests, in direct dialogue with Hokusai. One of Hokusai's *One Hundred Views of Mount Fuji*, for example (fig. 60, p. 70), is certainly the stimulus behind Hiroshige's view of Edo with banners in the foreground (fig. 61, p. 71). The radical spatial structures that recurred throughout the *One Hundred Famous Views of Edo* were crowning moments in the give-and-take of these two exceptional careers, and also in the larger lineage of Japanese experiments with perspective that the two printmakers had done so much to prolong and expand.

Hiroshige's is not just a general Japanese aesthetic. It is a hybrid form, the product of a tradition carried by a limited strain of artists in a special area of Japanese art. Its

絆屋
町の不二

development stems not from any collective, anonymous expression of a general national aesthetic, but is the result of a specific series of inventions by artists of genius, acutely conscious of each other. The striking manipulation of enlarged foregrounds, and dramatic plays between near and far that seem to foreshadow Degas and that so intrigued Van Gogh, are the offshoots of a lineage of Western perspective we can follow from an early optical view by Shiba Kokan of the Ryogoku Bridge, through a Hokusai from the 1830s of the Nihon Bridge, directly into Hiroshige's view of the Nihon Bridge in the *One Hundred Famous Views of Edo* (figs. 62–64, p. 72). (By the time of this last image, the manipulation of the system is sufficiently sophisticated and self-conscious to allow some gamesmanship. The artist shows the tops and sides of the two lower, squared-off rungs in perspective depth, while the top rail—actually round and hence without edges— is made to appear as if spacelessly flat.)

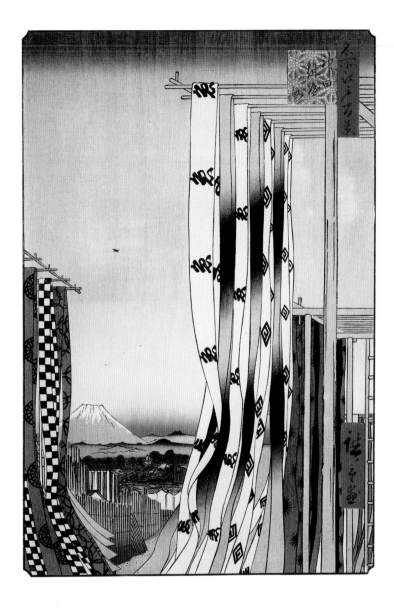

Hiroshige's mastery of this special tradition extended as well to a keen understanding of the ways it could be interlocked with a special conception of storytelling. When he decided to represent the Nihon Bridge locale by just a chunk of its structure, cropped in the foreground, he counted on the informed viewer recognizing the finial posts, which were particular to that bridge, and the bonito in the bucket, which was typically sold nearby. The assertive horses' hindquarters in his view of Shinjuku (fig. 65, p. 73) are also more than decorative visual surprises. As Henry Smith tells us, Shinjuku lay just outside the gates of Edo along a major highway, and it had a large, well-frequented brothel quarter. Pack caravans often stopped here on their way out of town. And evocations of this area, in poetry going back for decades before Hiroshige, dwelt on the characteristic collision between the perfume of the courtesans and the stench of the horse

62. SHIBA KOKAN
RYOGOKU BRIDGE, EDO, 1787

63. KATSUSHIKA HOKUSAI
NIHON BRIDGE
FROM THE SERIES *FIFTY-THREE
STATIONS OF THE TOKAIDO*, CA. 1804

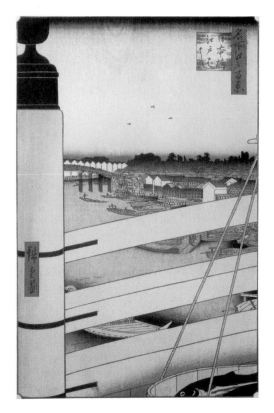

64. ANDO HIROSHIGE
NIHON BRIDGE AND EDO BRIDGE
FROM THE SERIES *ONE HUNDRED
FAMOUS VIEWS OF EDO*, 1857

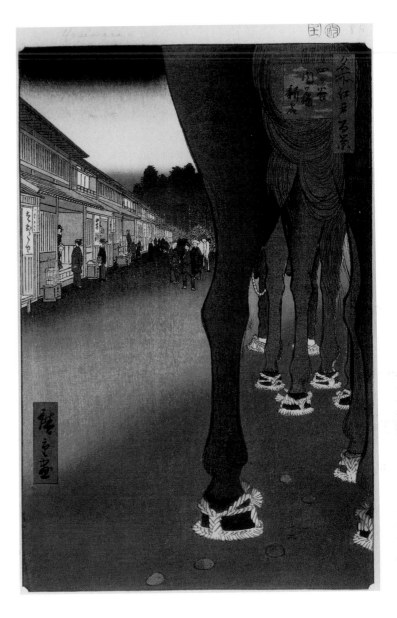

droppings. By putting the rumps and the manure so
aggressively in the foreground, Hiroshige translates this satiric
poetry into a visual form whose advances and recessions
pithily encapsulate the split identity of the place.

His extremely sophisticated games with perspective, here
as elsewhere, involved systems of condensed meaning. And it
was a key part of his genius to make the stunning spatial
oddities yield, in this way, wittily fresh yet subtle statements
about the places, seasons, and feelings of Edo. The recurrence
of large screening foregrounds may also have had, as Smith
suggests, a personal psychological import as well, as a token of
the increasing distance the aging Hiroshige must have felt
from the bustle of these urban scenes. Just before he began
this series, he had undergone a tonsure and taken up
monastic vows, in a traditional old-age ceremony of quitting
the world; he died while the series was still in progress.

66. VINCENT VAN GOGH
PORK BUTCHER'S SHOP IN ARLES
1888

67. VINCENT VAN GOGH
SPRING IN ARLES, 1889

When we look at prints like these in regard to their effect on Western painting in the later nineteenth century, what we are seeing is not an invasion like that of the barbarians at the gates of Rome. It is something more like the British rock music invasion of America in the early 1960s—that is, it is a cultural boomerang. This kind of export-import exchange involves sending out a tradition, perhaps taken for granted or denigrated locally, that then comes back to you slightly misunderstood, but newly alive and fertile. (Send out a few 45 rpm's of rhythm-and-blues, some Muddy Waters and John Lee Hooker and Bo Diddley, and a few years later you get back Mick Jagger and John Lennon.)

When Degas, or later Van Gogh, discovered Hiroshige's prints, what he saw was not a criticism of the impoverishment of his own tradition. It was a criticism of the narrowness of its use. These prints were a revelation of the unexplored potentials lying within the perspective system, of the richness that lay within the French painter's own heritage. And the effect of such Japanese prints on these artists was not simply to give them foreign formal devices, such as a diagonal branch or tree trunk, to overlay other borrowings as aggressively flat decorative declarations of the picture plane. The prints were catalysts that allowed innovative Western artists to reimagine the uses they might make of what they had at home. A print like the *Plum Estate* gave Van Gogh, for example, a way to reconsider how his ordinary daily experience—not just the history of Renaissance perspective—might become the vehicle for a new set of meanings.

Van Gogh copied the plum branch print when he was in Paris in 1887. Its impact can be seen in a view painted soon after, when he first arrived in Arles—a view from a café, looking across the street at the shop on the other side (fig. 66, p. 74). It was a view the likes of which he had doubtless seen a thousand times in life, one that every painter who ever sat in a café had seen innumerable times. It needed only to be understood as capable of meaning something. If so accepted, the spatial structure of that view could become a kind of metaphor for loneliness, for enclosure outside the active world, with the foreground welling up and screening one in—and thus, a poetic device for Van Gogh's own feelings of estrangement as a newcomer to Arles. The ordinary, thanks to the cue of the borrowed, became something original, and deeply personal.

That same plum branch helped him to represent the coming of spring in Arles in a particularly meaningful way (fig. 67, p. 75). By including the trees in the foreground of a Japoniste perspectival structure, he orchestrated a near/far dialogue in which the central subject of the rebirth of life, in the blooming of the flowering orchards, was placed between the distant spire of the church as a symbol of transcendence

or resurrection, and a foreground of wintry, blue-green trees sprouting verdant shoots of spring. Van Gogh set those gnarled, trimmed-back trees down exceptionally close, like surrogates for himself, bars that defined the space from which he observed (and hence unsettling premonitions of his later asylum cell window—from which, by the way, he eliminated the bars in every view). Signs of a more difficult, humble form of renewal, they are juxtaposed with the image of the lone man turning the soil amid the blossoming of light and color beyond. The whole picture becomes a meditation on regeneration, from the church, to the orchard, to the artist, whose rhythmic brushstroke as he works the canvas is his own act of tilling. Formally and symbolically, this picture is about the hope of returning to new life possibilities that have been buried dormant at one's feet.

This is another situation that calls on us to rethink what we mean by influence. In the case of Degas, the photographs were too far away from the painting's innovations to function credibly as sources or causes. But in this case the opposite seems true: what Hiroshige was doing in 1858 is so close to what Van Gogh was doing in 1889 that a simple transmission of forms by influence does not seem adequate to explain the resemblance. After all, regardless of his admiration for the prints, Van Gogh would have understood nothing about the reason for the enlargement of the horses in the Shinjuku image, or about any of the other plays of meaning that Hiroshige, like Hokusai before him, created with these foreground-background relationships. And thus he could not have understood how Hiroshige's visual language worked with condensed devices of storytelling in any way that could have guided him toward making such similar condensed symbolic narratives of his own.

When he saw Hiroshige's prints at an exhibition in 1893, Camille Pissarro wrote to his son that "the Japanese artist Hiroshige is a marvelous Impressionist." He was right, and in deeper ways than he could have known. The close resemblance between these Eastern and Western innovations in perspective structure is not explicable simply by copying, or influence. And the occurrence of such parallel usages in dramatically different societies poses a challenge to any notion that social circumstances ultimately determine changes in art. Neither an account of the circumstances of late nineteenth-century France, nor the traditional wisdom about the shaping influence of photography and Japanese prints, really explains the origin of the new spatial forms in Degas or Van Gogh. These explanations leave out something crucial. In their eagerness to equate creativity with escape from conventions and with the defiance of tradition, they underestimate the potential for innovation that lay in resources close at hand, within a tradition like that of

68. EDGAR DEGAS
REHEARSAL IN THE DANCE STUDIO
CA. 1875–80

69. EDGAR DEGAS
THE REHEARSAL, CA. 1878–79

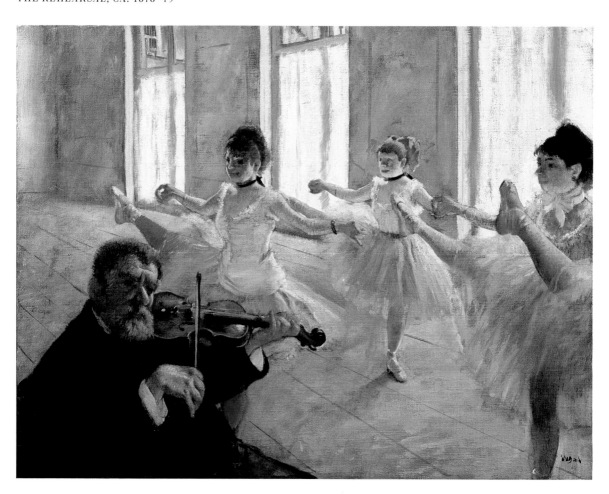

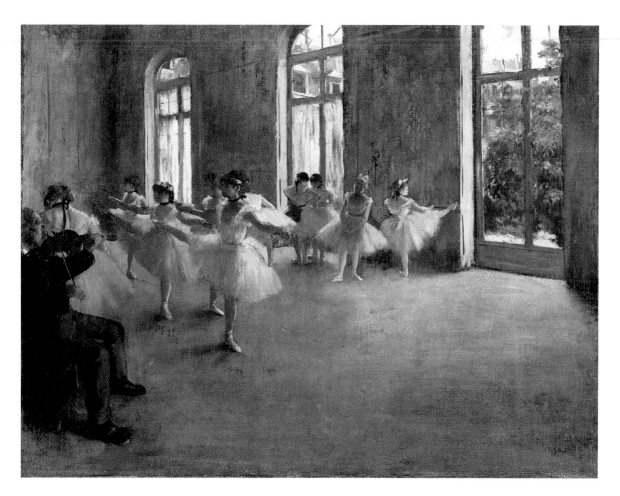

70. EDGAR DEGAS
THE REHEARSAL, CA. 1873–78

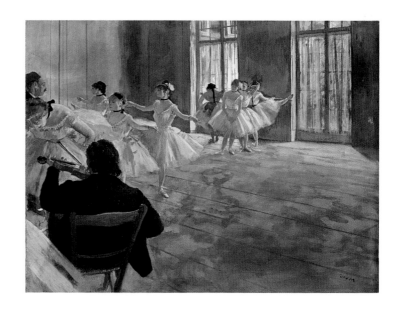

71. EDGAR DEGAS
THE DANCE SCHOOL, CA. 1875

perspective. And in their attempt to rationalize the process of change and make it understandable, they portray the artist as a responder, and slight the crucial role that individual initiative played in deflecting one tradition and starting another.

I want to look at these changes in a different light. What I have done so far has been primarily negative: saying no to photography, and no to Japanese prints, and no to the spirit of the time. Now I would like to go back to where we started, moving from Degas's innovations forward, and think positively about where this new sense of spatial arrangements might have come from, and about what that might tell us with regard to the larger enterprise of modern art.

In comparing Degas to Winogrand (figs. 41 and 42, p. 52), I stressed that Degas's view of reality was a fiction built from conventions. When we look at the way he made his pictures, we see what that means in particular terms. It means that a spacious rehearsal hall could have a column and a staircase one moment, and then have them whisked away the next (figs. 68 and 69, p. 78). And in the same hall, the floorboards that ran toward the windows could, in another view, suddenly run the other way. It also means that the figures in such rooms were like chess pieces that could be moved around, with groupings constantly rearranged in every picture. This Realism doesn't describe a world, it proposes one. And in practical, working terms, these spaces and perspectives are neither just abstract traditions nor visual givens, but structures repeatedly reborn from rulers, calculations, and tracing paper every time Degas put one of these pictures together. Every time it could come out differently. When he put a violinist with a group of dancers he could decide to "pull back" and stress the openness of the room (fig. 70, p. 79)—or simply by drawing a line around that composition, move in closer and isolate one part of the group. Or he could move in still tighter (fig. 71, p. 79), with yet another cropping line imposed around the original conception.

All these potentials lay on his drafting table when he constructed the first version: all he had to do was decide, literally, where to draw the line. He did not need any outside aid to determine this for him. And when we examine the way that he composed the spatial structures in his most aggressively modern pictures, it is precisely the absence of some predetermined model for the whole that seems most striking.

In some of his most ambitious pictures of the early 1870s, Degas clearly took great pains to arrange large groups of figures within continually receding spaces (fig. 72), in carefully plotted perspective. But the more interesting things happen when he does less, in pictures like *The Ballet from "Robert le Diable"* of 1876 (fig. 74, p. 83), or *The Orchestra of*

the Opera (fig. 73, p. 82). Here he took the parts that were lying on the drafting table—the studies of heads, the drawings of background architecture, etc.—and set them down without bothering to calculate any transitions between them. He saw that he didn't need those fillers, that if he put two disparate parts together that would be enough. Alone together they evoked a domain of experience—a part of what it is like to be in the theater—that had not been charted in accepted, traditional arrangements of these same elements.

The curious thing about these compositions is that they are not composed, in any normal sense. There are studies for the parts (figs. 75 and 76, pp. 84 and 85), but no document predetermining how they will fit together, no overall preparatory drawings for the scenes. What we seem to see in these pictures and their sketches is a kind of jazz, a partially improvisational set of decisions about the arrangement of components broken out of other traditions. Degas's understanding of the possibilities within the perspectival system allowed him to play fast and loose with it, conjuring the scene's space from disjointed elements of scale, rather than harnessing the various scales to a given stage-set of depth.

What Degas learned about perspective and space is the same thing that Hokusai learned: that you do not have to construct it as a deep stage and coherently organize everything to fit consistently into it; that if you layer together little and big elements, foreground and background parts, and leave out the transitional middle ground, the viewer will use these clues to fill in the binding, overall space. As long as the viewer cannot measure or see the recession between the two parts, then the interval of space he or she "reads," and the

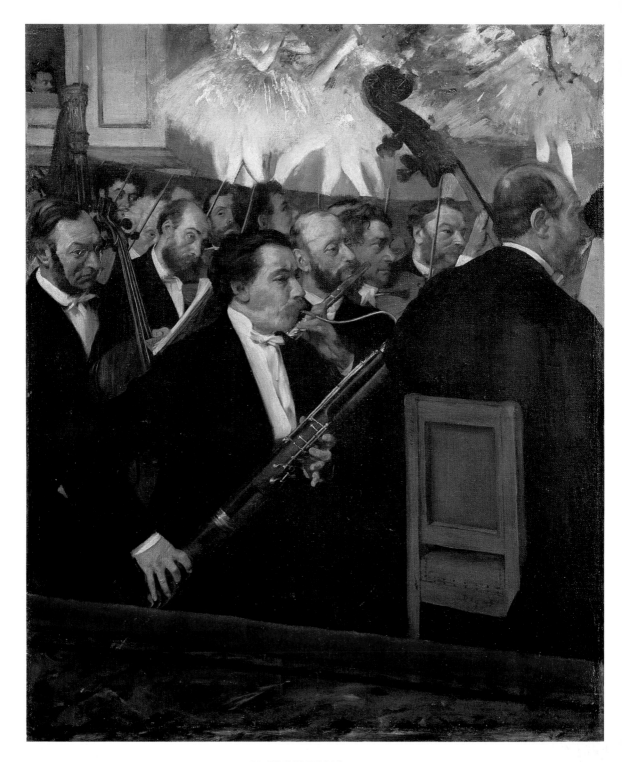

73. EDGAR DEGAS
THE ORCHESTRA OF THE OPERA
CA. 1870

74. EDGAR DEGAS
THE BALLET FROM "ROBERT LE DIABLE," 1876

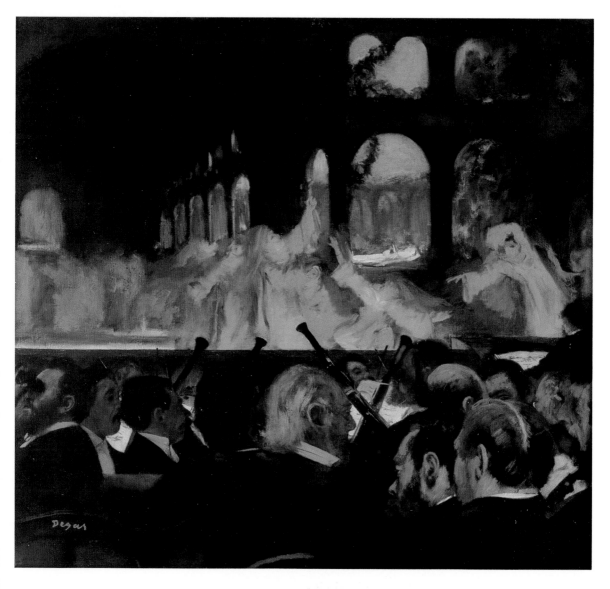

speed of imaginary entry into the picture, depends solely on the decision of how big to make the foreground and how little to make the background.

Degas saw that he could do something new and powerful by doing less, by shortcutting the process of constructing a pictorial space, and working instead with a process of assemblage. That way of working is confirmed again and again in his work. Comparing a *café-concert* lithograph of the 1870s (fig. 77), for example, with another impression of the same lithograph that he reworked with pastel in 1885 (fig. 78, p. 86), we see him create an entirely new space simply by drawing a new foreground plane of spectators over a preexisting composition, as if he were dealing, like a cartoon animator, with a series of clear-ground overlay elements. Similarly, a dancer with a bouquet (fig. 79) may later be overlaid with a loge below, and a woman with a fan (fig. 80, p. 86—with strips of paper added to accommodate the new additions), and suddenly the whole sense of viewpoint and depth is changed. Conversely, a drawing of a woman with a fan (fig. 81), with the addition of a dancer composition behind it (fig. 82, p. 87), produces a stunning hybrid of intimacy and spectacle, viewer and vista. Nothing exists as a control, or measure, in these combining operations: the new space is generated by, and solely dependent on, the decision of how much of this added viewer to show, and how big to make her in relation to the preexisting dancer. Moreover, all of the elements of disparate scales and bold cropping exist within his working process itself. The opposition of large and small scale occurs naturally in individual sheets of studies, or in the chance conjunction of sketchbook pages and larger studies. And the malleability of scale was a standard, banal part of the process of making the image, achieved by "squaring up" a drawing with a grid that permitted it to be recreated, box by box, in another place, on another scale (fig. 83, p. 89). Every

75. EDGAR DEGAS
STUDY FOR "THE BALLET FROM 'ROBERT LE DIABLE,'" 1872

time Degas looked at the pieces of such a grid, with every box he drew separately, he had before his eyes cues for radical figural segmentation, and compositions of cropped forms within a frame.

The material needed for Degas's achievements—the separate elements, the visual cues, the possibilities of combination, the structure of new spaces—was lying on his drafting table. The potential was readily available in familiar things—not only in the history of perspective and the untapped possibilities it provided, or in the long heritage of marginal explorations of enlarged foregrounds that might have informed him, but more particularly in the elements and techniques he worked with every day in his drawings. The decision to reconsider these elements differently is all that was needed to produce a totally different world view in the pictures.

In this sense, the apt comparison for the *Place de la Concorde* does not lie in Japanese prints or photographs, but in earlier works by Degas himself, like *Woman Leaning Near a Vase of Flowers* (fig. 84, p. 90). These pictures are both montages in a conceptual sense: what is important about them is the wedding of disparate genres. Mechanically, in fact, in the *Woman Leaning,* Degas seems to have begun with a perfectly normative and conventional conception of a flower still life; then he added a little of another, portrait convention, and the result became something that alters both parts, and will not settle down into either norm. The portrait aspect now involves a sense of personality that depends on a dialogue between her sense of inwardness and the expansive beauty of the still life, and suggests thereby a whole different format for showing being and surroundings, person and place, as interconnected bearers of identity.

The same strategy is at work in the *Place de la Concorde.* It is not remarkable that Lepic is cropped at the knees. A zillion portraits before this had been cropped at the knees: we

76. EDGAR DEGAS
*STUDY FOR "THE BALLET FROM
'ROBERT LE DIABLE,'"* 1872

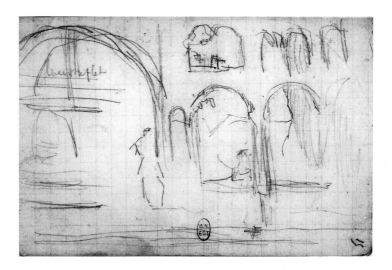

77. EDGAR DEGAS
*MLLE. BÉCAT AT THE CAFÉ DES
AMBASSADEURS*, 1877–78

78. EDGAR DEGAS
*MLLE. BÉCAT AT THE CAFÉ DES
AMBASSADEURS*, 1885

79. EDGAR DEGAS
DANCER WITH A BOUQUET BOWING
CA. 1877

80. EDGAR DEGAS
DANCER WITH BOUQUET, CA. 1877–78

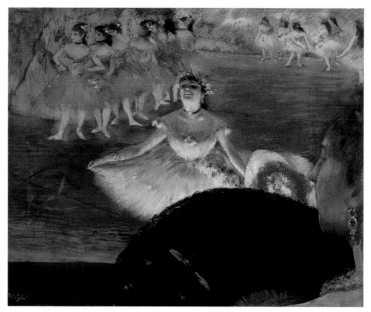

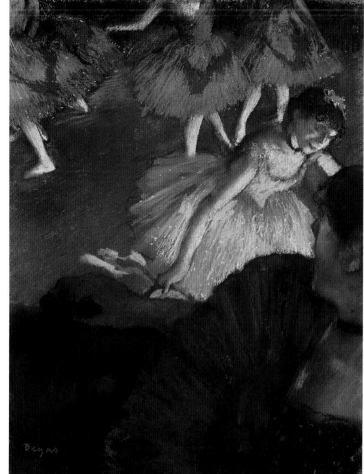

81. EDGAR DEGAS
*AT THE THEATRE, WOMAN WITH A
FAN*, CA. 1880

82. EDGAR DEGAS
BALLERINA AND LADY WITH FAN
CA. 1880

always see people up close in portraits. What's odd about Lepic is that he is striding past without looking at us, so that we have a portrait's intimacy with a narrative, genre aspect added to it. And what's even odder is that it is set in the middle of a cityscape. The cityscape is not so odd. The portrait is not so odd. The genre scene is not so odd. What is new and crucial is a portrait-cityscape-genre scene, which is the form of something unknown: a new sense of the engagement of a private personality with a public space, a new idea of how one might define a singular personal identity in modern Paris, a new sense of the interaction between intimate things, like inner life and family, and a wider sphere of contingencies. That conceptual montage, that violation of the margins of conventionally defined genres, was the crucial breakthrough. Once he decided to undertake those splices, all the devices, all the elements, all the parts lay to hand.

If we think about Degas that way, and rethink in this fashion the old story about that crucial "break" with the tradition of perspective, where does it get us with regard to the rest of modern art? Where does it get us, for example, with the next step on the Road to Flatness, in Gauguin's *Vision After the Sermon* (fig. 85, p. 91)? Clearly, this picture is deeply indebted to Degas: the near-space enlargement of the peasant women beholding this hallucinatory vision of Jacob wrestling with the angel is a modified transcription of Degas's *café-concerts* and theater pieces (fig. 86, p. 91). And the more we look around the landscape of later nineteenth-century art, the more we see that this is just one instance of a typical, but largely unacknowledged, pattern. Many of the key compositional and spatial devices on which the expressive, antinaturalist art of painters like Gauguin, Munch, and Van Gogh are built are modified versions of devices found in Realist art a decade or so earlier. The disturbingly enlarged and confrontational foregrounds that add such psychic intensity to Munch's scenes of the 1890s, for example (fig. 87, p. 92), also have their direct antecedents in Realist experiments with unusual perspectives, like those of Degas's admirer Gustave Caillebotte in the 1870s (fig. 89, p. 93); in the 1880s and early 1890s, these kinds of spatial structures—tilted ground planes, looming foreground figures, funneling recessions—appeared in any number of lesser works as well (for example, fig. 88, p. 92). In art-historical terms, this helps confirm the suspicion that the lines between Realism and Symbolism—or more generally between an art of description and one of expression—may have been too simplistically drawn in the past. A progressive, protomodern art like Munch's or Gauguin's that supposedly rejects Realism may in fact achieve some of its key innovations simply by turning up the volume on selected aspects of a supposedly outdated, or even *retardataire*, Realist art.

In blurring the borders between these standard art-historical categories, though, I do not mean to say that the formally innovative art we find in the generation of Gauguin or Munch or Seurat is essentially just Realism in a new costume, and that it can be read as a description of the world in the same fashion. Just the opposite. I read these relationships—Degas/Gauguin and Caillebotte/Munch—as showing how an invention made for one purpose can be adapted to do something sharply different. It is the powerful differences in the outlook, approach, and intentions of such disparate artists that help release the complex potentials, the multiple artistic lives, resident in previously ignored or suppressed uses of perspective. Taken all together, these diverse instances suggest that the late nineteenth century, far from witnessing the death of perspective, saw a richness of perspectival experiment unprecedented since the early Renaissance—a ferment in which virtually every option, from archaic to mannerist, with many previously untapped variants in between, had a new chance at life.

In this matter of traditional versus modern spatial structures, and borrowed versus created innovations, *The Vision After the Sermon* helps us focus on some basic questions about originality. The composition here is taken

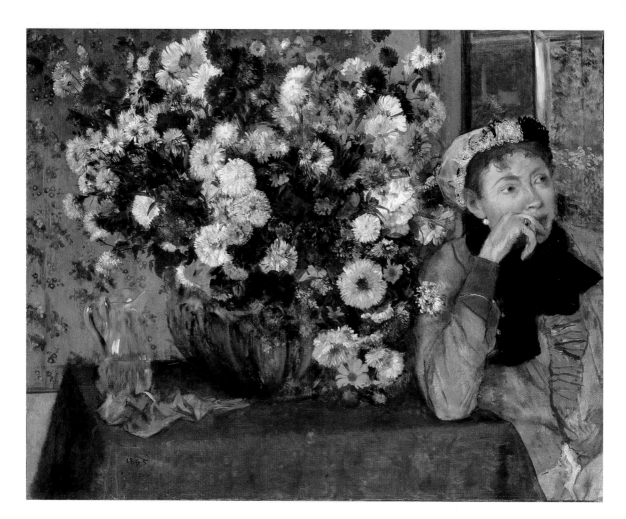

84. EDGAR DEGAS
WOMAN LEANING NEAR A VASE OF
FLOWERS, 1865

85. PAUL GAUGUIN
*THE VISION AFTER THE SERMON
(JACOB WRESTLING WITH THE
ANGEL)*, 1888 (FOR COLOR SEE P. 16)

86. EDGAR DEGAS
*CONCERT AT THE CAFÉ DES
AMBASSADEURS*, CA. 1877

87. EDVARD MUNCH
EVENING ON KARL JOHAN STREET
1892

88. FRANS VAN LEEMPUTTEN
DISTRIBUTION OF BREAD IN THE
VILLAGE, 1892

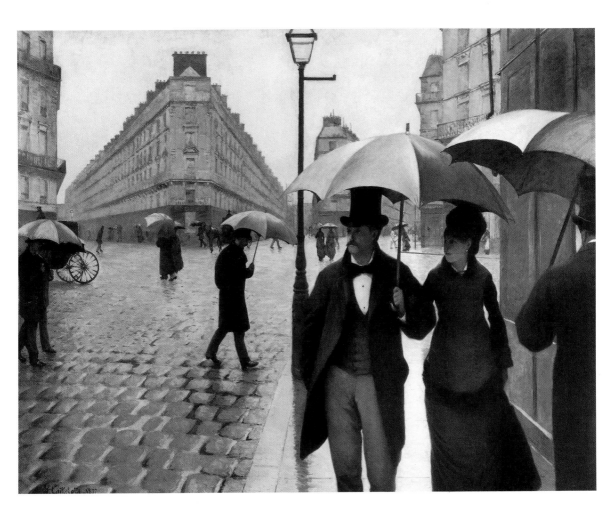

89. GUSTAVE CAILLEBOTTE
PARIS; A RAINY DAY, 1876–77

from Degas, the line quality owes a lot to Daumier, the branch comes out of Hiroshige's plum branch, the wrestling couple is lifted from Hokusai's sketchbooks, and the flat planes of color and bold outlining derive from contemporary stylistic experiments by Gauguin's younger associate Emile Bernard. Yet the picture was boldly original. Innovations such as this often have just that kind of patchwork nature. They do not look like a spaceship from Mars, with a mysteriously seamless form never seen before. Instead, they look like the machine the Wright brothers built: pieced together from the parts lying around a workshop. This picture is composed out of existing elements, through the making of new marriages between things considered low, like Daumier, and things considered high, like Degas; and through putting all that together with things considered foreign, like Hiroshige. That's where the novelty of the picture comes from; that's how the machine flies.

This gives us a different grasp of what Gauguin was saying when he claimed an artistic brotherhood with artists like Hokusai and Hiroshige. He claimed his art was like that of non-Western artists in that it was uncorrupted by academic tradition and free from the shackles of convention, touching on some universal power of innovation in the human brain. Yes, he was like Hiroshige, and, yes, he was touching something fundamental about innovation—but in a completely different way. Hiroshige put his work together like the Wright Flyer, too. His achievement was a cobbling together of something new out of a grab bag of local and imported parts, established conventions, and appropriated devices.

If we reconsider what Gauguin has to do with Hiroshige in this way, and rethink what he has to do with Degas as we did before, we will have to reevaluate where that might leave us on the Road to Flatness. When we associate the flattening pattern in Matisse's *Harmony* (fig. 91, p. 97) with those foregrounds that we have seen looming larger in Degas and Hiroshige and Gauguin's *The Vision*, we can still think about the Gauguin as a step along the way to the Matisse. But then, can we any longer read the Gauguin as representing an aggressive rejection of Western traditions of depiction, in a way that lets us see the Matisse solely in terms of a closing window and an advancing wall? Are we telling a story that is primarily about denials? Certainly this does not seem to fit with the mood of the Matisse, which is expansively celebratory.

The basic theme of the painting, involving the comforts of the home, is hardly new; Matisse himself had painted a similar scene years before, and variants on it had been a commonplace in genre paintings going back to Holland in the

seventeenth century. But the bright colors and assertive patterning in the art of immediate predecessors such as Gauguin, and perhaps a catalyzing admiration for Eastern decorative arts as well, gave him a way to invest the implicit dialogue here, between the natural and the domestic world, with a new urgency. By enlarging the repetitive, simplified swags of the wall pattern, and giving both that design and the intense red such dominion over the relatively thin and spindly imagery of nature seen through the window, he imparts a near-ecstatic pulse of life to what others might see as a quiet, modest moment of decorative table preparation. In every respect, the opulence in this picture, the thrilling, engulfing energy that spills out of its borders, is tied to the simple act of arrangement at its center; it has to do with the immense enrichment of human life through culture, conceived not in terms of the additive piling-on of acquisitions, but in the attentive reconsideration of what lies to hand. What Schiller called the "poetry of possession" is often thought of as the seat of smug, padded, conformist inertia. But Matisse reimagined this sense of the interior as a condition for radically compelling artistic change and personal assertion.

The dominant formal device in the picture derives from an unexceptional bolt of printed fabric Matisse had owned for years, and had been using as a backdrop in previous still lifes (fig. 92, p. 97). Perhaps following the lesson of Gauguin's interest in bold printed designs (see fig. 185, p. 184, and fig. 188, p. 188), and his own attraction to other exotic textiles, he looked again at this fabric, in making *Harmony in Red*, and saw that its condensed, schematized way of ordering organic variety had an energy he had been ignoring. This commonplace, rather passé fabric, insisted upon with inordinate intensity, provided the structure that put new power into the commonplace, overfamiliar theme he wanted to reconsider.

This picture is not about denying, or closing down. It is about embracing, and enlarging from within. The theme it treats and the way it was made both have to do not just with the new artistic mileage that can be gotten out of supposedly dead forms, but with the newly energized sense of life, and human experience, that can be gotten from that kind of reconsideration, and from that kind of self-consciously "artificial" art. The eliminations and simplifications—the reduced detail, or most notably the minimized cues for depth—are pursued with this end in view, of reopening, rather than narrowing, the play between what we know and what we discover, between our awareness of a limited set of conventions and our ability to enlarge our response to life through their manipulation.

When we consider a still more resolute abstraction, like Frank Stella's (fig. 90, p. 96), in relation to a picture such as

Harmony in Red, we can now think again about the hermetic, black painting as part of a larger process, in modernism and in Stella's own art. Its apparently draconian denial was not only a goal attained, but also a means: a way to draw a new baseline, and refresh a sense of new possibilities, by insisting aggressively on such simple "givens" as commercial house paint and the geometries of the canvas itself. The overall pattern of modern art contains numerous episodes of such rigorous reduction, stringent attempts to eliminate familiar clues to any representational content. These works often have a compelling intrinsic beauty, and a unique ability to move us. But they permit the question as to whether this form of reduction is always an end in itself, or whether it cannot also serve as the starting point for something else. Is the wall only what modern art is, or also what it builds on? In Stella's case, as often throughout the development of twentieth-century art, reductions toward austerity represent what the French call a *reculer pour mieux sauter*, a purifying impulse that leads to a new expansiveness.

Look where Stella's career went—to the *Exotic Birds* of twenty years later, or to the *Indian Birds* after that (fig. 94, p. 100, and fig. 96, p. 101). These compositions were made, quite literally, from things usually left lying on the drawing board. The shapes they are made up of are those of common drafting and engineering tools, such as French-curve templates and shipwrights' devices. But what Stella does with them detonates a much wider sphere of references. These exotic, heteroclite creatures look back both to Picasso's constructions of around 1915 (fig. 95, p. 100), and—in a way Stella has been at pains to explain—to possibilities of spatial manipulation raised in early Baroque art. By their colors and (especially in the *Indian Birds*) their surfaces, they also evoke a different kind of hybridization, between the gestural skeins of Jackson Pollock and the world of discos and graffiti.

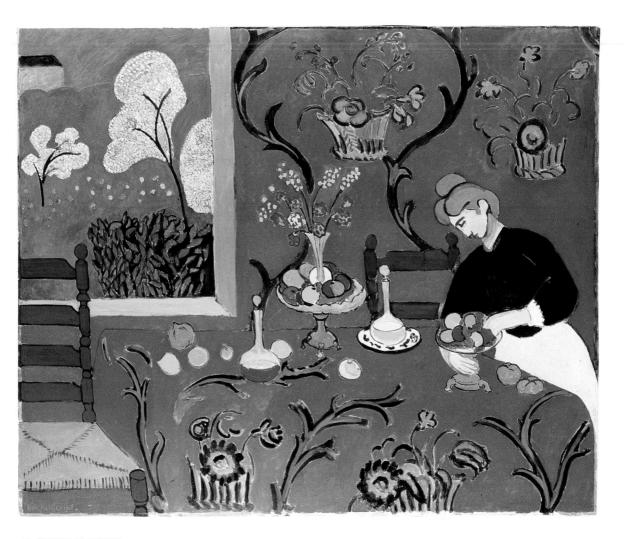

91. HENRI MATISSE
HARMONY IN RED, 1908

92. TOILE DE JOUY FABRIC
USED FOR *HARMONY IN RED*

Cubism and Caravaggio, punk and Pollock, are compressed
into these sets of forms that tie together in explosive knots of
energy the rational, "necessary" elegance of engineers' curves
and the gaudy punch of Las Vegas neon signs. Such work is
"decorative" and "abstract" in the best senses of the words as
Matisse understood them. That is, it clarifies and makes more
powerfully immediate a set of forms that—far from drawing
us out of our time or excluding the broader range of our
experience—can send us, altered, back into the street to
awaken and redefine our feelings for the particular worlds of
possibilities we move through.

The origin of the *Indian Birds*, too, involves a cultural
boomerang whose basic elements should sound quite familiar.
The high-power glitz of these paintings took its cue from the
wild polyglot of their maquettes, which Stella made in India
from sheets of color-printed metal intended for soft-drink cans
(fig. 93, p. 98). The actual sheets he used were rejects, sold as
scrap because of sloppy printing. He became aware of the
material when he saw craftsmen in the local markets using it
to fashion decorative boxes. The serendipity of finding these
foreign recyclings of American commercial designs helped
catalyze, not just the making of the maquettes, but the

complex dance of sources in the final constructions. Like Van Gogh's experience of Hiroshige, this was a lesson in how to make what we have work for us. Like a lot of modern art, these pieces have their origins in a creative retooling of what we had become accustomed to seeing only as detritus.

The lessons to be learned from these works, the principles that define the path we have been following from Degas to Gauguin to Matisse to Stella, are very different from those we sketched when we set out. This is not a history that starts with the exhaustion of tradition and ends up with the impoverishment of art. It has more to do with the revivification of traditions and the expansion of art. Nor is it a story just about closing a window on to nature, but one about opening up a set of human potentials. It does not rest on the idea of refinement toward an absolute perfection, narrowing down until we arrive at a hermetic nut that no one can crack, in the stoic disillusionment of the self-declaring picture plane. It is a history that has more to do with alchemy—making new elements out of base matter, and giving new life to things that seemed inert. Or in more recent science, its analogy lies in a characteristic modern process by which—when we probe down ever closer to the most basic building blocks of nature, refining and isolating our focus to a maximum degree of apparent exclusion—we then find two things: the unavoidable presence of our own conventions for representing, standing always between us and an unobtainable objective representation of the world; and a whole new dimension of our universe opening up where previously we thought nothing existed. We have come to understand both together, as paired elements of our condition. The self-conscious manipulation of our inherited conventions brings us to live in an irreversibly expanded world, with an altered understanding of it, and us in it.

We have become all too familiar with the notion that modern art began by breaking all the rules, and that its creation depended on escaping from the confines of all the systems, like perspective, that tradition had imposed on art. But this is wrong. The modern tradition is not one that began by simply destroying or ignoring all previous conventions. Nor has it been just a search for some new set of rules or restrictive formulas about what is permissible and what—like the illusion of spatial depth—is not. Like all cultural endeavors, modern art has some of the character of a game, and as such inevitably it is concerned with rules. But it seems to me that one of the basic messages we learn from looking at how that tradition began, and how it has grown, is that its cardinal instruction is the same one William Webb Ellis understood instinctively in 1823: The rules of the game here are not something you play by. They're something you play with.

94. FRANK STELLA
STELLER'S ALBATROSS
FROM THE *EXOTIC BIRD* SERIES, 1976

95. PABLO PICASSO
VIOLIN, 1915

96. FRANK STELLA
KASTŪRA
FROM THE *INDIAN BIRD* SERIES, 1979

THREE

FRAGMENTATION AND REPETITION

Modern art is often taken to be a matter of form. In the late nineteenth century, the forms of paintings and sculptures become independently assertive, and content—in the traditional sense of recognizable things and figures composed in ordered scenes or legible stories—seems to become secondary. We may admire artists of that time for their incisiveness about social facts, or their expanded range of emotion, but studying them as pioneer modernists, we often focus instead on innovative aspects of their spatial structure or composition: the way Degas's figures are cut in half, for example, or the way Rodin reuses identical casts of the same figure to form a triad (fig. 97, p. 104, and fig. 99, p. 106). These formal innovations provide points of comparison between modern art's beginnings and its later developments—affinities between Mondrian and Degas, for example, in regard to segmentation of motifs (figs. 97 and 98, p. 105), or between Minimalist sculptors and Rodin, because of the use of modular parts (figs. 100 and 99, p. 106).

Such lineages of resemblance appear to have evolved, more or less independent of subject matter, across the decades. And a certain vision of modern art's progress can even be measured in terms of the way the forms in question slough off vestigial descriptive or symbolic functions, and appear in "pure" abstract terms. Mondrian thus distills Degas's sense of dynamic oppositions, removing the dross of Realism and materialism; and Donald Judd's modules clarify a seriality that had been latent in Rodin, and evident in Brancusi (fig. 101, p. 107), by purging their respective taints of pathos or folk piety.

The question begged by such histories is, What do these forms *mean?* Do they tell us something about modernity in and of themselves, apart from what they represent in a given work—in the way, for example, that perspective is thought to tell us something about the Renaissance? Early modernists like Mondrian or Brancusi held that the purified forms of twentieth-century art expressed an elevated idealism, by encapsulating the world's essences rather than dealing with illusory appearances. What you see in structures like Brancusi's *Endless Column*, they said, represents a basic schema, or an unalloyed nugget, of the hidden order of things. But for many in Judd's generation, the thrust of modernism was beyond content of any kind—especially idealist or metaphysical—toward forms devoid of associative meaning that insisted solely on the viewer's present-tense experience. What you see in our art, they said, is what you see, and its only content is that of deadpan geometry and cognitive process.

These two camps, the optimists and the stoics, differ sharply as to what "pure" abstraction can offer its audience: an authoritative way, like religion for some or science for others, to get in touch with hidden essences of the universe;

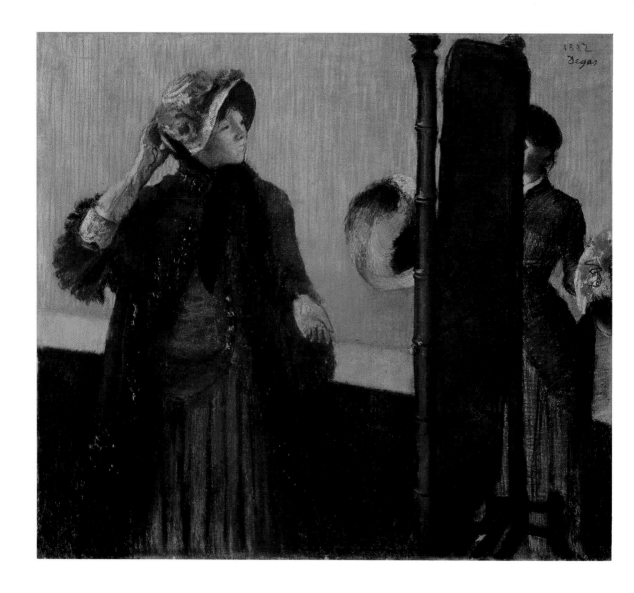

97. EDGAR DEGAS
AT THE MILLINER'S, 1882

or a philosophical way, like linguistic analysis, to sharpen our critical self-consciousness about the blocks from which we build our artificial worlds. In one view, modern art became modern when it began a hopeful search for fundamental things; in the other, when it began to rid itself of inappropriate illusions. In either case, mundane subjects, and mundane meanings, were no longer the issue.

But a third alternative, much favored in more recent writing, calls down a plague on both these houses. It holds that the notion of an emptied-out art is just as false as the utopian dream of an ideally full one. In this materialist view, what you see in the forms of modern art is neither a route to higher truths nor a lesson in cognitive austerity but an index of the material conditions of modern society. The formal concern with the fragmentary that Degas initiated, for example, would be his response to the new dislocations of

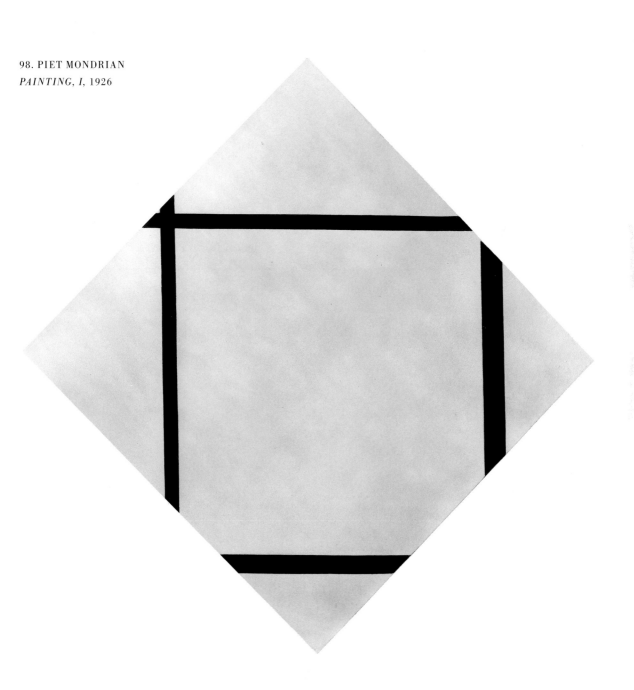

98. PIET MONDRIAN
PAINTING, I, 1926

99. AUGUSTE RODIN
THE THREE SHADES, 1880

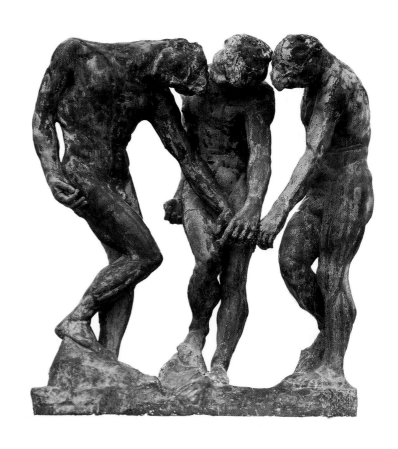

100. DONALD JUDD
UNTITLED, 1968

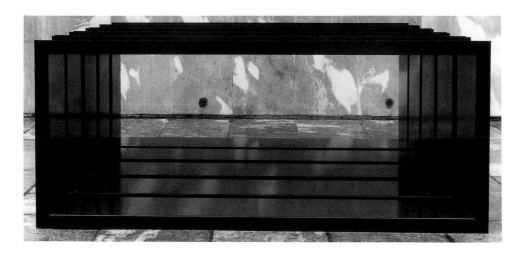

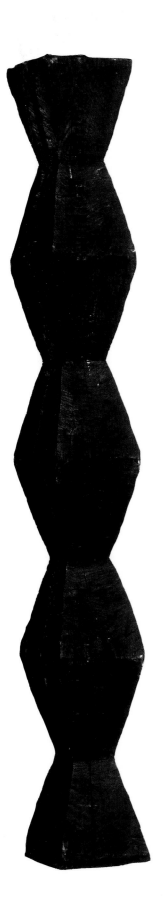

102. ANDY WARHOL
100 CANS, 1962

101. CONSTANTIN BRANCUSI
ENDLESS COLUMN, VERSION 1, 1918

urban society in his day, and a harbinger of harried modernity's lack of social cohesion. The steady-beat recurrence announced in Rodin would similarly be a form that foretold the loss of uniqueness in a world of mechanized reproduction, and the leveling monotony of a culture of commodities—as revealed more self-consciously in the art of Warhol (fig. 102, p. 107) and others since.

Yet all these aspects of modern art are closely tied together: its capacity to present a truth about the world, its self-consciousness about its structure as a language, and its connections to a social context. We need to think at all these levels if we are going to come to more serious terms with the forms we have already been discussing. One is fragmentation—literally, in Rodin's practice of exhibiting broken-off sculptural parts instead of whole figures (fig. 103), or metaphorically, as ellipsis, in the way Degas segments figures and crops scenes to suggest a glimpse chopped out of a

103. AUGUSTE RODIN
IRIS, MESSENGER OF THE GODS, 1890

104. EDGAR DEGAS
*PLACE DE LA CONCORDE (VICOMTE
LEPIC AND HIS DAUGHTERS)*, 1875
(FOR COLOR SEE P. 30)

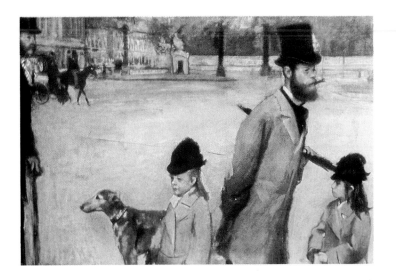

larger continuum (fig. 104). The other is repetition—the clustering of identical motifs, as in Rodin's *Shades*, or near-identical motifs, as in *The Burghers of Calais* and the dancers in Degas's later groups (figs. 105 and 106, p. 110).

These "abstract" devices have had a complex history, in both theory and practice, inside and outside art, for more than a century and a half. That history involves changing ideas of what art should accomplish, and it asks us to question how these ideas help or hinder our understanding. And if we want to try to draw conclusions from a broad cast of individual artists and works, from Degas and Rodin to Warhol and Judd with a lot of others in between, it requires considerable patience in balancing the hold of particulars against the concern for larger, ongoing issues. The payoffs for tracing such a history, though—both in terms of our understanding of these forms, and in our grasp of basic issues about what and how modern art means—should be substantial.

THE NINETEENTH CENTURY

Instances of fragmentation and repetition began to appear in a broad range of representations in the late nineteenth century, setting up visual echoes between such disparate things as photographs by Etienne-Jules Marey and Eadweard Muybridge (figs. 107 and 108, p. 111), paintings by Degas, and sculptures by Rodin. We might suspect that these similarities just indicate the spread of influence—of photography on the artists, or of one artist on the other—but we have seen in the preceding chapter how problematic this way of explaining innovations can be. And even if we could prove direct borrowing in these cases—which we cannot—it would not settle the tougher questions the comparisons raise.

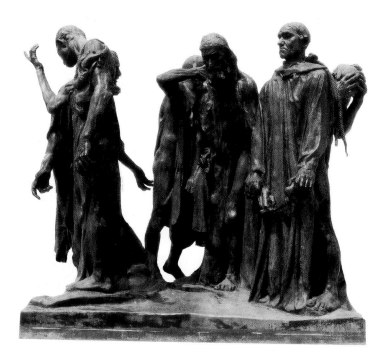

105. AUGUSTE RODIN
THE BURGHERS OF CALAIS, 1884–86

106. EDGAR DEGAS
DANCERS IN GREEN AND YELLOW
CA. 1903

107. ETIENNE-JULES MAREY
MAN JUMPING, CA. 1886

108. EADWEARD MUYBRIDGE
ANNIE G. IN CANTER, 1887

The challenging issue is whether the superficial resemblances have anything substantial behind them—whether these forms in art, for example, carry the same set of meanings as the parallel structures in the photographs.

The meanings of the photographic forms can be traced, in a clear line of descent, to new scientific ideas about the proper way to study the order of the living world. Marey was a French physiologist who subscribed to the same progressive beliefs championed by his colleague Claude Bernard, in his *Introduction to the Study of Experimental Medicine* of 1865. That influential tract, which has been called the nineteenth-century counterpart to Descartes's *Discourse on Method,* outlined a program to debunk mystifying notions of Vitalism (that is, of some ineffable, pervasive life force in organisms), by finding laws of organic life that would correspond with the laws of physics and chemistry. Bernard argued that the secrets of living things would yield to the same methodology that had been the route to discovery in the material sciences: break a substance or process down into parts, and study them within a frame of uniform, duplicable conditions. In his case this meant gruesome ventures in vivisection (he was fond of saying that science was like a wonderful banquet that could be approached only through a ghastly kitchen). But in the work of Marey, it took a less gory turn toward visual representation.

The phenomena Marey studied—like tortoises' heart rates, or seagulls' wing beats—often moved too fast or too slow for simple observation, or were spatially too complex to record in a legible image. As a result, he needed special ways to break these events down into precisely isolated data, and reconstitute them in standardized, measurable form. In the 1860s, he devised a series of ingenious graph-plotting devices (fig. 109, p. 114) to allow such functions to describe their own quantified profiles. And later, in the 1880s and '90s, he used the camera's eye, snapping open and closed with a protocinematic mechanism, to analyze motion with the same ends in mind (fig. 110, p. 115). By decomposing an action into a fan of equidistant instants, these stroboscope-like chronophotographs (literally, "photographs of time") manifested Bernard's methods, and served Marey's search for the rules that governed bodies in motion.

The same ideas informed Muybridge's work. It was apparently Marey's earlier, graph-oriented studies of animals on the move, detailed in *Animal Mechanism* of 1873, that stimulated California's Governor Leland Stanford to conceive and commission Muybridge's photographs of running horses. When these photographs were published in *La Nature* in 1878 (fig. 111, p. 115), they caused a sensation in science (Marey himself saw the possibilities of the camera through them) and

also in art, where they ended old debates about how to show the horse's gait, and started new ones about the relation of artistic and scientific truths. Ever since, these arrested hoofbeats have been taken as a shining instance of the triumph of raw fact over art's outmoded conventions. But Muybridge's photographs, like Marey's subsequently, are really about determinism as well as discovery.

These are documents not just of instantaneity, but also of standardization. In keeping with the experimental method, their isolating backdrops had to be uniform (Muybridge ran his subjects past a long white wall, and Marey past a deep shed lined with dark velvet); and the repeated slice of the shutter had to be utterly regular (Marey turned his negative plate in clockwork increments behind a single lens, while Muybridge set up a battery of evenly spaced cameras, triggered by the passing horse). The fragmentation of time was tied to those structures of measured recurrence, which framed the splinters of information and made them useful for learning. The goal of these bloodless vivisections, after all, was not merely the isolation of a fact, but the discovery of a pattern—and a workable pattern at that. Marey intended to use the information he gathered to help design things that would rationalize nature, from heart pumps to flying machines. Similarly, Stanford, who owned a racing stable, apparently thought that by learning how his horses ran he could fashion training procedures to make them run better.

When we inquire about the meanings of these pictures, we should think less about the information they showed, and more about the ways in which they presented it: in paired, complementary forms, of separated parts tied to regimented rhythms. This dual structure is the mark of the positivist, instrumentally oriented science that lay behind the projects—an outlook that imposed a ruling pattern in its method, and supposed a ruling pattern in the results. In these respects, Muybridge's sheets (fig. 108, p. 111, and fig. 111, p. 115) are like boldly simplified provincial prints based on a complex foreign text. The way they break apart a process, and array its elements in identically repeated frames, gives an almost caricaturally schematic, memorably vivid form to experimental science's program of rationalizing the flux of the natural world. That pairing of decomposed precision and standardized regulation—of fragmentation yoked with repetition— embodies the vision Bernard had articulated of invading nature with the mechanisms of understanding, and imposing on it the mechanisms of control.

We would not have to posit a direct influence from the photographs to believe that this general background in science might also provide the right context from which to interpret, in similar fashion, parallel forms in Degas, or in Rodin. The

109. ETIENNE-JULES MAREY
WOOD ENGRAVINGS OF GRAPHIC
DEVICES FROM *ANIMAL MECHANISM,*
1873

(A) SPHYGMOGRAPH TO
REGISTER PULSE BEATS

(B) BIRD TRANSMITTING WING
BEATS VIA AN ELECTROMAGNETIC
SIGNAL TO THE STYLUS OF A
MYOGRAPH

(C) INSTRUMENT TO RECORD
CHANGES IN THE ACTIVITY OF A
TORTOISE HEART

110. ETIENNE-JULES MAREY
POLE VAULTER, 1890–91

lancé au trot avec une vitesse de 727 mètres à la minute: La figure 5 enfin est un véritable tour de force photographique; elle reproduit la succession des temps de l'allure de *Sallie Gardner*, au grand galop de course, fendant l'espace avec une vitesse de 1142 mètres à la minute.

Nous recommandons à nos lecteurs de bien étudier chacune des positions du cheval dans ce mou-

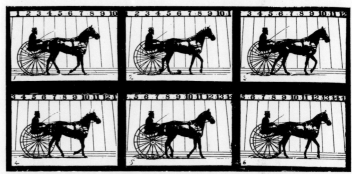

Fig. 1. — Cheval au pas. — 106 mètres à la minute.

vement vertigineux. Dans le n° 1 (fig. 5) une seule jambe, celle de devant droite touche terre, tandis que les trois autres sont suspendues par une énergique contraction des muscles. Dans le n° 5 (fig. 5) on voit le cheval entièrement isolé, aucune de ses jambes ne touche le sol, elles sont ramassées sous le ventre, au moment où elles vont être lancées, comme sous l'action d'un ressort qui se détend.

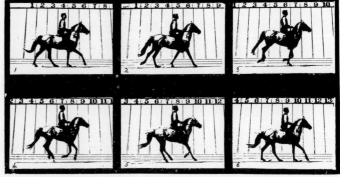

Fig. 2. — Petit galop. — 200 mètres à la minute. (Reproduction par l'héliogravure de photographies instantanées.)

On remarquera dans les n°⁸ 8 et 9, comme une des jambes de devant est singulièrement tendue, dans une position qui n'aurait jamais été soupçonnée sans le secours de la photographie instantanée.

Nous devons ajouter que l'écartement des lignes verticales sur les photographies de M. Muybridge est de 21 pouces anglais, soit de 0ᵐ,582 millimètres et celui des lignes horizontales de 0ᵐ,102 millimètres. — Les numéros indiqués au-dessus de chaque figure ont été ajoutés après coup sur le cliché, et servent à l'étude de chacune des images.

Ces différentes gravures héliographiques forment

111. EADWEARD MUYBRIDGE
HORSE TROTTING, 1878

112. EDGAR DEGAS
THE IMPRESARIO, CA. 1877

basic ideas about the dynamic order of life that Marey and Bernard held were shared, after all, with many other progressive thinkers, and most notably with Darwin: the idea that change was integral, not incidental, to the order of nature; that knowing the way an organism functioned was the key to understanding it; and that transient events, properly understood, were meaningful traces of permanent laws. A later nineteenth-century artist would hardly have needed to see chronophotographs to be affected by these notions. Especially in terms of a widespread fascination with evolutionary theory, they had long since come to bear on the whole question of understanding, and representing, human variety.

Someone seeking an intellectual context to illuminate Degas's work, for instance, could show that these ideas strongly affected his immediate circle. Zola wrote his early, document-based novels directly under the sway of Bernard's idea of dissecting life, and his contemporary, Degas's friend Edmond Duranty, argued in his magazine, *Le Réalisme*, that the modern novelist undertook a "philosophical anatomy" of society, analyzing it part by part to "formulate its physiology" as a scientist would do with any organism. Duranty's essay on *The New Painting* of 1876, which is widely held to echo Degas's own views, insisted even more clearly that the modern artist's goal was to reveal the typical in the individual, and the pattern behind the ephemeral and seemingly accidental. And when it called for the study of "the relationship of a man to

113. EDGAR DEGAS
WOMEN IRONING, CA. 1884–86

his home, or the particular influence of his profession on him, as reflected in the gestures he makes" and the scrutiny of "all the aspects of the environment in which he evolves and develops," it not only updated old notions about reading character from physique (as Degas once envisioned modernizing Lavater's phrenological studies), but couched the modern painter's ambitions in terms evocative of evolutionary theories of adaptation, and a paleontologist's decoding of functions from fossils.

Under this intellectual aegis, all those who observed society were encouraged to consider a passing street scene the way Marey considered a running man: as a welter of moments to be analyzed in its most precise bits, in order to discern how the appearances and behavior of individuals evidenced the impact of shaping laws. "A back," said Duranty, "should reveal a temperament, age and social position, a pair of hands should

114. EDGAR DEGAS
DANCER RESTING, CA. 1879–90

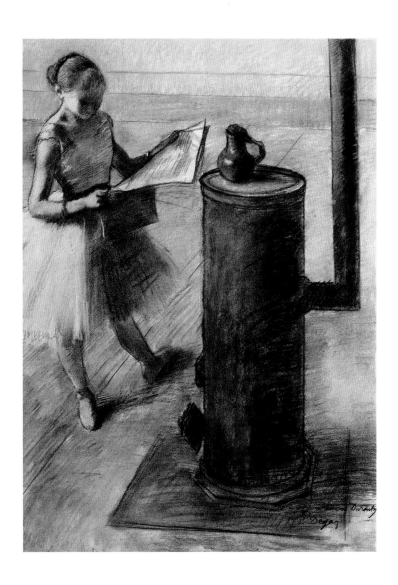

reveal the magistrate or the merchant . . ." (fig. 112, p. 116). Thus even the way a woman yawned should, if the artist captured it correctly, speak volumes about her type (fig. 113, p. 116); and the way a person stood or sat, even relaxing, would betray the impress of his or her training (fig. 114, p. 117).

It is tempting to infer that just such a pseudo-scientific program underlay the series Degas devoted to the characteristic gestures and body language of various occupations—dancers, laundresses, and milliners especially—where habitually repeated actions made even the unconscious behavior of workers conform to typical patterns. One could plausibly argue that the underlying theme of these series was the formative force of adaptation, shaping individual variety to fit the niches of the social environment. Degas's heightened attention to the "accidental" would thus reflect his conviction that society's orders were encoded in these ephemeral clues the modern observer snatched from the flux of life.

If this reading were true, then part of our problem would be neatly solved, for the paired forms of fragmentation and repetition in Degas could be seen as carrying the same basic freight of meaning as the parallel forms in the chrono-photographs. The Marey-like repetitive structures in his later dance studies (fig. 106, p. 110, and fig. 115) could be read as the natural complement to his apparently casual, more "instantaneous" views of rehearsal scenes (figs. 116–18, p. 120). These sequences of organized movement would be simply bringing to the fore the steady-beat pattern of collective training that had previously been a covert theme. Just as in the time-motion studies, the two forms taken together would, again, be paired expressions of an underlying ideology about order. Where the photographers used them to chart laws of organic physiology, Degas would have deployed them to fix the no less binding patterns of social organization. And we would have an arresting instance of the way the concerns of an epoch give rise to similar forms in all its manifestations.

Alas for neatness and simplicity, this kind of interpretation, despite the circumstantial evidence in its favor, is wrong—not just about these particular pictures, but about the larger questions of form and meaning as well. For all we know, Degas may indeed have taken Duranty's ideas, and the associated theories of social Darwinism with which they seem to flirt, quite seriously. But Duranty's kind of science, of telltale gestures and clues read from clothes, is now just the stuff of body-language guides on the dubious fringes of the paperback book racks. And his idea that art becomes modern by aspiring to a similar one-to-one correlation between signs and messages about the world is equally flawed.

The process that Duranty championed—and that guided Bernard, Marey, and Muybridge—was that of plucking from the

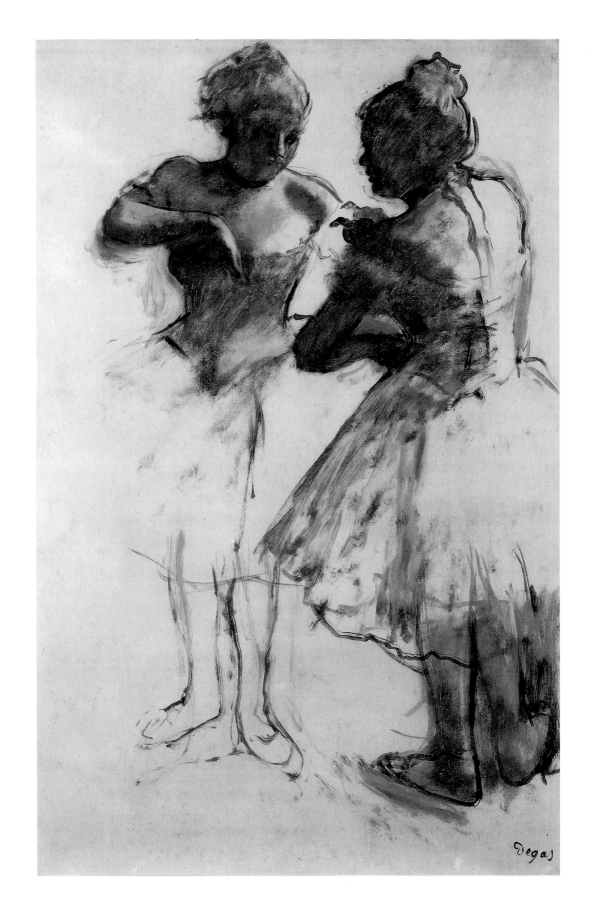

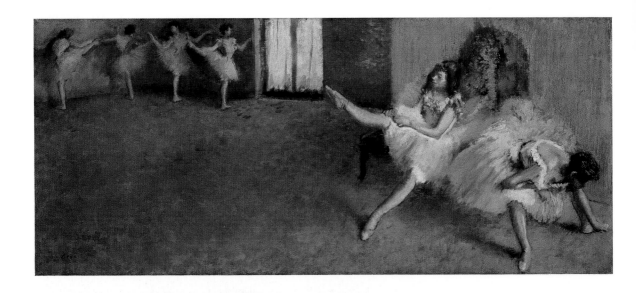

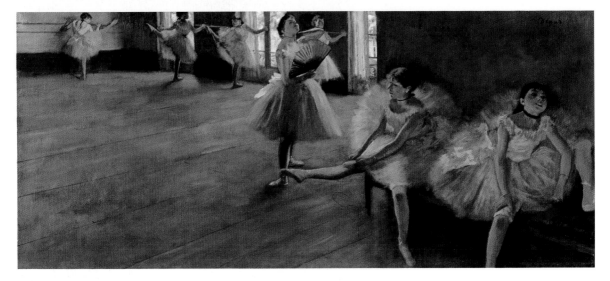

116. EDGAR DEGAS
BEFORE THE BALLET, 1888

117. EDGAR DEGAS
THE DANCING LESSON, CA. 1880

118. EDGAR DEGAS
THE REHEARSAL, 1874

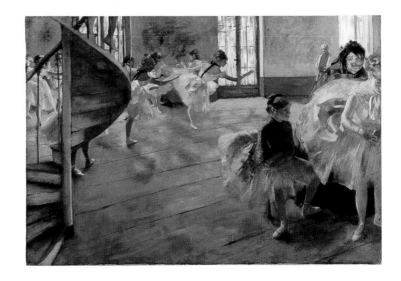

119. EDGAR DEGAS
BALLET DANCERS IN THE WINGS
CA. 1900

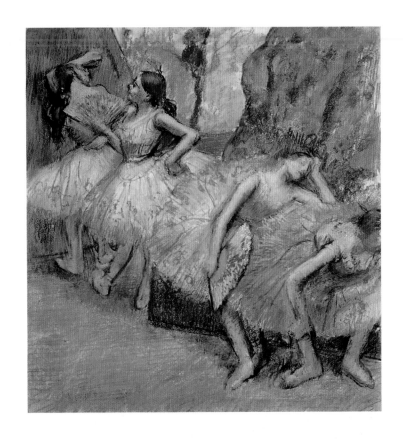

120. EDGAR DEGAS
DANCERS IN BLUE, CA. 1890

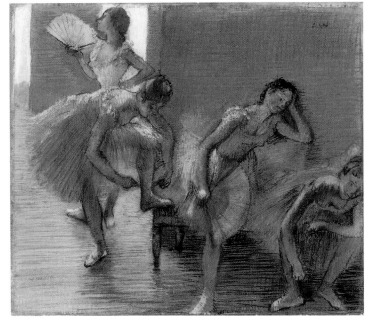

existing world infallible clues to hidden orders. But the process Degas's art followed was one of building up an artificial world, whose meaning lay in its own visible order. His "fragmentary" scenes were not cut out of a better organized whole. They were concocted to convey a sense of the partial, in the same fashion as the innovative spatial dramas we analyzed in the preceding chapter: by jury-rigging together various conventions of relative scale, narrative, and so on, into sophisticated new relationships. And the structures of sequential near-repetition in the later imagery (fig. 106, p. 110, and figs. 119 and 120, p. 121) similarly arose from new configurations of old practices: traced and trace-reversed variants on a single figure (figs. 121 and 122, p. 124) and multiple studies of one figure from different vantages (fig. 115, p. 119, and figs. 123 and 124, p. 125).

Forms of representation built by rearranging conventions that were inert or borrowed from other tasks obviously do not satisfy a nineteenth-century positivist's thirst for accurate indices, like the "found" snippet of a telltale gesture, that have a transparent relation to observed natural truth. But that does not mean they are just empty stylistic inflections. It means that these forms are like the elements of any language: for it is an essential part of modern thinking about human communication that the basic elements of a language—sounds, syllables, words—do not have an essential meaning encrypted in them, but attain their meaning from the way they are used.

Degas's innovative, dispersed-focus, noncumulative compositions, for example, do not serve just to disguise a message about another hierarchical kind of order; they impose an order of their own. And one of its key effects is to give bit players (in, say, the dance classes) an untoward prominence that helps make them, as few painters had made such figures before, salient individuals (figs. 116 and 117, p. 120, and figs. 125 and 126, p. 128). The breakup of narrative cohesion similarly leaves these "drones" far from perfectly tied to the purposes at hand. As a result, the dance classes, like many other Degas images ostensibly devoted to disciplined work or performance, give unprecedented vividness to the zones of semianarchic liberty that lie "between the beats" of organization—during the breaks, behind the curtains, before the race, between strokes of the iron—where the disjointed play of individual manners of idleness, distraction, and absentminded boredom asserts itself.

Just as these working-class scenes feature stubborn individuality amid the humdrum of specialized routines, the upper-class group in the *Place de la Concorde* (see fig. 104, p. 109) shows, by the rhymes of clothes and carriage that make the girls little echoes of their dapper father, traditional patterns persisting amid the disruptions of urban life. Rather

than a simpler view of society's organism shaping each part to its special function, Degas consistently presents such both/and situations, with their evident play of oppositions. Even within his single figures, the same confrontations can continue unresolved. The knobby adolescent body of *The Little Fourteen-Year-Old Dancer* (fig. 127, p. 129) and the acquired architecture of her pose are set knowingly out of synch; and her tilted profile evokes both an amusingly snooty pretension and a slightly simian hint of atavism, to suggest high ambitions fused with low origins. Degas gives form to subtle dialogues like this—between individual and type, between inheritance and acquisition, between the errant and the fixed—in ways that are often witty, sometimes cruel, but never reductive. Whatever reactionary social views its author may have held in other spheres, this art is—legitimately, and not by misunderstanding—as accessible and useful to art historians who lament the exploitation of the dancers as to little girls who aspire to be like them.

Duranty's idea of science involved an oversimplified view of society, and of representation; Degas's art belies both. And the comparison between his work and the chronophotographs also belies the corollary idea, still shared by many, that each epoch is a distinct environment, whose pressures call forth new forms to fit the new facts of its social order. This way of thinking mirrors a false idea about natural evolution. What Darwin saw about change in nature, as opposed to what contemporary social thinkers wrongly made of his ideas, was that new forms arose independently of the environment. They then prospered, or stagnated, or died off, according to their ability to keep adjusting their utility (not their repertoire of basic equipment) to changing situations. The maintenance of experiment and variety, rather than the narrowing drive to a defined goal, was the engine of long-term success.

In this latter sense Darwin might well offer us, by analogy, a guide to understanding how Degas's art worked—not because he was a contemporary or an influence, or because the art obeys some "natural law," but because Darwin's view of evolution contains a key insight into the way innovations occur and take hold in the history of populations. Degas's new structures of composition were successful adaptations in the sense that they were rearrangements of available forms that opened new possibilities—like the panda bear's "thumb," which the biologist Stephen Jay Gould has shown us is no thumb at all, but a toe pressed into new service. And the art made with them survived and prospered, not because these were ideally apt encodings of the world of their place and time, but because the fictional world they made was rich enough in possibilities to be meaningful to diverse people, in different places and times.

121. EDGAR DEGAS
DANCERS, NUDE STUDY,
CA. 1895–1900

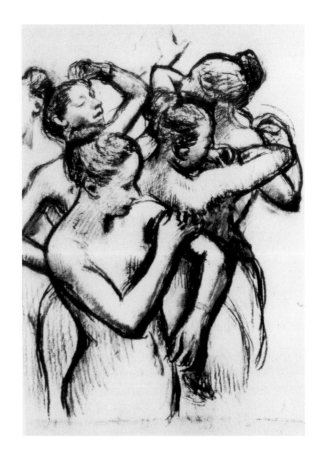

122. EDGAR DEGAS
DANCERS, NUDE STUDY, CA. 1897

123. EDGAR DEGAS
THREE STUDIES OF A DANCER IN
FOURTH POSITION, CA. 1879–80

124. EDGAR DEGAS
FRIEZE OF DANCERS, CA. 1895

In the broader picture, too, devices like fragmentation and repetition "succeed" and proliferate when they prove able to do different things in different contexts. These contexts may be other cultures and times, but also other parts of a culture, or the work of other artists, at the same place and moment. The resemblances between Marey and Degas, or Degas and Rodin, are thus not evidence for the dominance of one governing situation or idea, or for the "reflecting" role of forms of representation. Exactly the contrary. Almost any context, whether it is the intellectual field of nineteenth-century science, or Darwin's ideas, or Paris in the 1880s—or for that matter, a given café at a given moment—offers an indefinably broad latitude for response. And any epoch's repertoire of available conventions of representation contains a similarly untidy variety of possible forms. Resemblances like these show how open-ended, rather than constrained, this situation is; how similar forms can serve widely varying uses in virtually the same time and place; and how these uses can yield independent, sharply different insights into the complex truths of the same epoch and culture.

In producing this variety of meanings, the immediate framework of expectations in which new forms occur can have a much more emphatic effect than the broader intellectual or social context. Though Rodin and Degas were compatriots and contemporaries, for example, painting and sculpture around 1880 were mediums with different traditions, and similar innovations had distinctly dissimilar effects in these two arenas. Rodin's subjects were, true to the memorial purposes of statuary, far more traditional, and drawn from literature, history, or myth; but his new forms were, given the nature of sculpture, more acutely disruptive to tradition. Bronze bodies with parts torn away do not just suggest interruption, the way a figure cropped at the canvas's edge does; and identical sculptures set in a huddle do not share a common narrative base like a row of dancers in a painted image. Such physical, literal instances of sculptural fragmentation and repetition in Rodin negated basic conventions of wholeness, illusionism, and narration much more aggressively than the segmentations and reiterations in Degas, which at least appeared to serve a "photographic" Realism.

In one way of thinking, it is precisely this split between content and form that makes Rodin's work modern. The comparison between Marey and Degas brought up in germ a version of what we called at the outset an optimist's account: that modern art's progress involved finding one-to-one correspondences between new forms and deeper truths. We saw some of the inadequacies of that vision. But Rodin's forms of fragmentation and repetition seem to make the opposite interpretation—what we called the stoic's credo—more

plausible: that new forms emerged in modern art in a way that was independent of, or hostile to, traditional content, and thus announced a rejection of representation in favor of an art that refers only to itself.

It is true that Rodin's art makes overt reference to its own artificiality. When we say that his kind of realism was not seamless, we mean it: his sculptures often exposed the joint lines of the piece molds in which they were cast, as well as the "unfinished" marks of modeling and editing. Fragmentation and repetition functioned in the same way, as instances of the sculptor's processes made evident in his product. Rodin typically made up rafts of "spare parts"—feet, hands, knees, and so on—(fig. 128, p. 130) and put together his figures from these. And once he made a figure, he would often remake it, by recasting multiple versions and variants. By showing these processes in the partial figures and modular recurrences of his exhibited work, he undercut his own virtuosity as a conjurer of stories in flesh and bone, and introduced an evident self-consciousness about the artificiality of art's means.

It is also true that a lot of Rodin's literary and historical themes are inherited, and often evoke a kind of Romantic sentiment that many modern sensibilities find cloying. They seem much less original, or prophetic, than his radical formal devices. Common practice says we can take what we like from a predecessor, and ignore things that we do not; that's the way a lot of fruitful change happens. But in this case, if we simply disregard the stories Rodin's works tell, in order to celebrate his "purely formal" contributions, we are cheating ourselves. By ignoring the immediate arena in which the innovations occurred, we wind up with an impoverished view of what his achievement was, both as a late nineteenth-century artist and as a key innovator in modern art. That achievement involved finding new uses for old things in a double sense: understanding how aspects of sculpture that seemed mute might be made expressive, and also how themes that seemed embalmed in tradition could be revivified, in modern terms, with these very devices.

Broken parts and replicas were a daily part of a sculptor's working apparatus; every studio in Paris was littered with them. But where others would have completed a work in progress, Rodin said "enough"; and where others would have considered a figure made, he made it again—not because he thought these steps would cancel meaning in his work, but because he was willing to see how such decisions might alter the range of meanings he could convey. The truly creative act was to see how such forms could function within—not just independently of, or in antagonism to—his attempts to accord new meaning to the themes he dealt with.

125. EDGAR DEGAS
THE DANCE CLASS, 1874

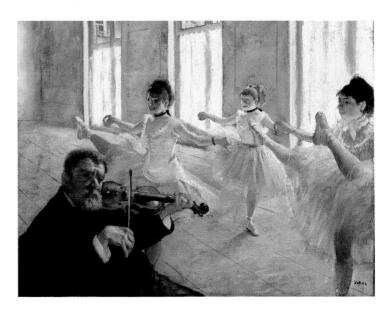

126. EDGAR DEGAS
THE REHEARSAL, CA. 1878–79

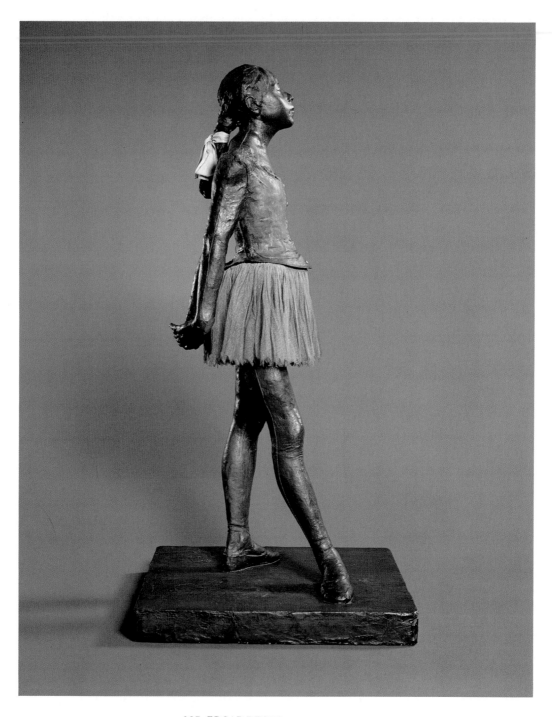

127. EDGAR DEGAS
*THE LITTLE FOURTEEN-YEAR-OLD
DANCER*, 1880–81

In his first major commission, for *The Gates of Hell* (fig. 129), he showed that in foiling expectations of wholeness and variety, he could at the same time make incompletion and monotony expressive. By not reconciling junctures between bodies that had been conceived separately, Rodin left the patched-together "couples" in *The Gates* to collide and claw at each other without any true mutuality (fig. 130, p. 132, and fig. 131, p. 134). Despite their fevered motion, these figures and groups literally cannot pull themselves together, so no actions are resolved, and desires remain unassuaged. And the reuse of identical torsos, figures, and groups, hurtling up and down across this portal, helps deprive this pandemonium of any sense of real change or culmination (fig. 132, p. 135). Fragmentation and repetition, as tools for dismantling one world, became building blocks of another, an antiworld, where frantic, incessant incoherence reigned. They helped reorder the Renaissance topography of *The Gates*' ostensible subject, Dante's *Inferno*, into what would properly be called a living hell—a modern vision of chaos and futility implanted in every alienated existence, without discrimination and without end.

One of the positive lessons that emerges from this gloomy composition is that treating a form as a movable cipher, and shifting it around from one context to another, is a fruitful way of extending the range of meanings it can carry. The same head works differently with different bodies, the same foot or hand expresses something different in combination with alternative legs or arms, the same figure yields a different emotion in combination with a series of other bodies—or for that matter, in combination with itself, as the unrelenting pathos of the *Shades*' three-beat dirge demonstrates.

128. DRAWER FROM RODIN'S STUDIO IN MEUDON, 1977

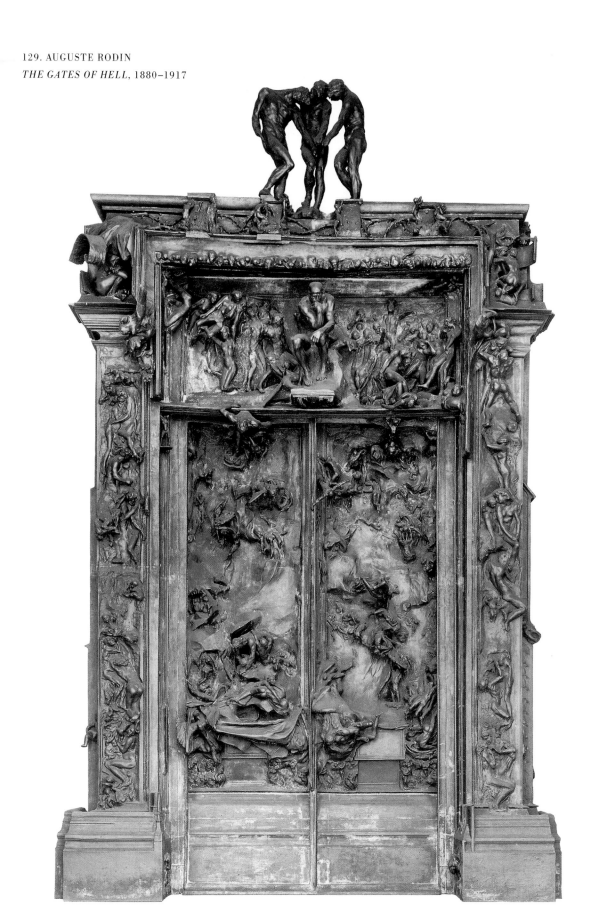

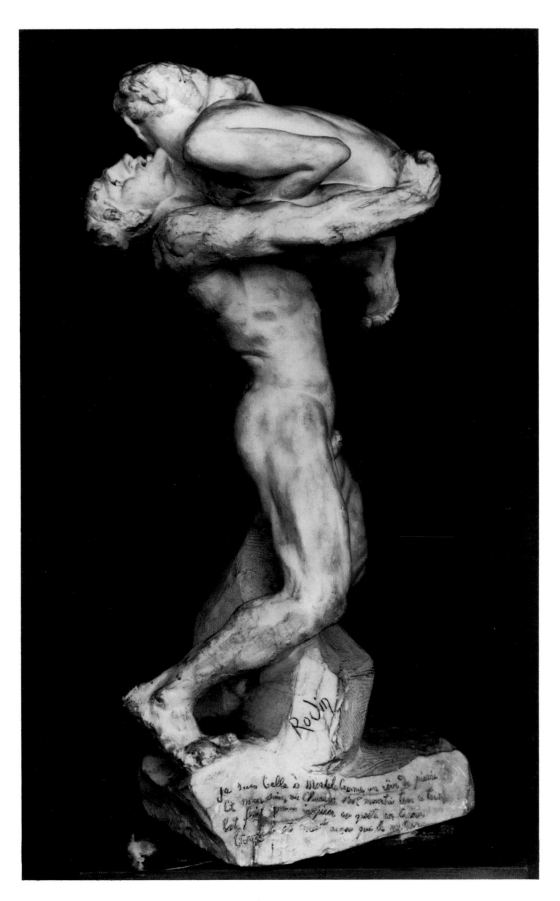

130. AUGUSTE RODIN
JE SUIS BELLE, 1882

This mobility of meaning operated on a particular level with units in one work, and also in the larger way Rodin used fragmentation and repetition in different contexts within his work as a whole. Making evident his piecemeal bodies and modular compositions proved to be a way to give newly expressive form both to the psychological torments of fictive worlds, in *The Gates*, and to complex dilemmas of social order, in *The Burghers of Calais* (fig. 133, p. 136).

In his monument to *The Burghers*, Rodin revivified a medieval story every French schoolchild knew, of six citizens who had volunteered as sacrificial hostages to an English king in a deal to end a wasting wartime siege. Dissatisfied with old conventions of summing up such a story in one hero or rhetorical gesture, he decided that, to get at the truth of what happened, the monument should treat all six equally. And to do that, he followed an analytic process we have seen before: imagining the cusp moment of commitment when the victims prepared to march out to what seemed certain death, he decomposed the event, conceptually and practically, into its smallest bits.

He studied not just every man, but every arm, every hand, and even every finger, as an individual entity, in order to build up an atomized repertoire of discrete units of expression (figs. 134–36, p. 137). Then when he built the monument from this lavish palette of recombinant possibilities, he exercised an odd kind of economy. Two of the final figures have the same head, and a third bears that same face only slightly altered (figs. 137–39, pp. 138–39). Identical fingers, hands, and feet also keep reappearing on different bodies, in different orientations, or modified only by flexions (fig. 140, p. 140). Moreover, when the time came to put the six figures together, Rodin did not—at least not in any conventional sense of unity. He established no shared glances or reciprocal gestures to link them, and, most blatantly, he did not smooth over the evidence of the disparate bases on which he made them (fig. 141, p. 141). He made their heads all level—a radical gesture against the expected pyramidal elevation of a hero—but he left them literally without a common ground, standing on separate axes of balance.

All these formal decisions were directly tied to his conception of the meaning of the event. The subtle disaccords between the various limbs and expressions of the individual figures, and the variety of inflections among them, suggested the different stages of unresolved inner struggles. And the disjoined bases underlined the isolation, one from the other, of these private agonies of regret and resignation, denial and decision. But the recurrent parts, along with the steady cadence of the ponderous sackcloth, conveyed that these victims were also a collective, in aspects similar and interchangeable. In this assembled but estranged group, the

131. AUGUSTE RODIN
FUGIT AMOR, CA. 1887

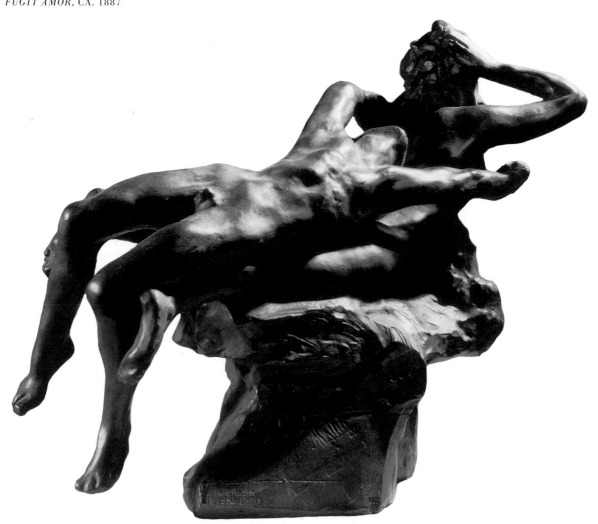

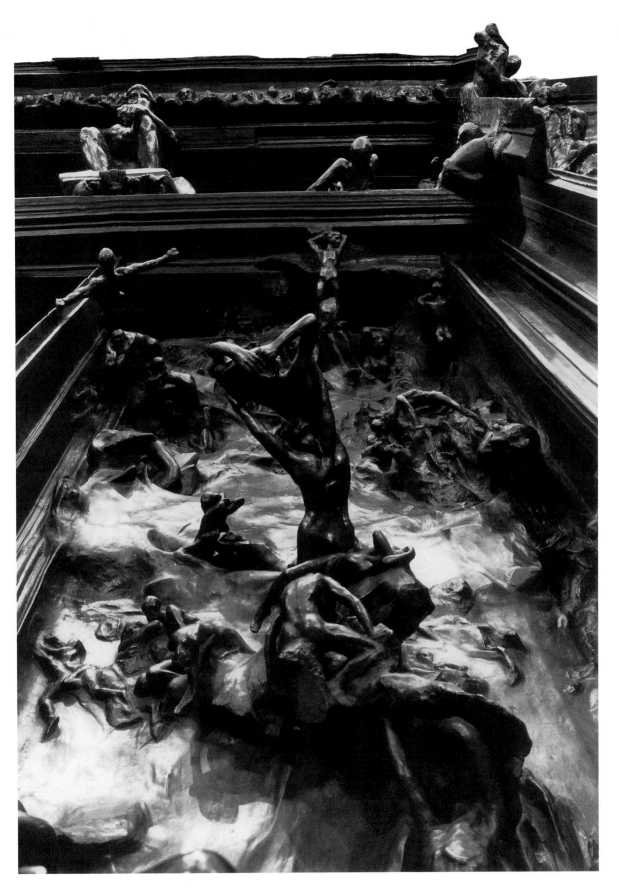

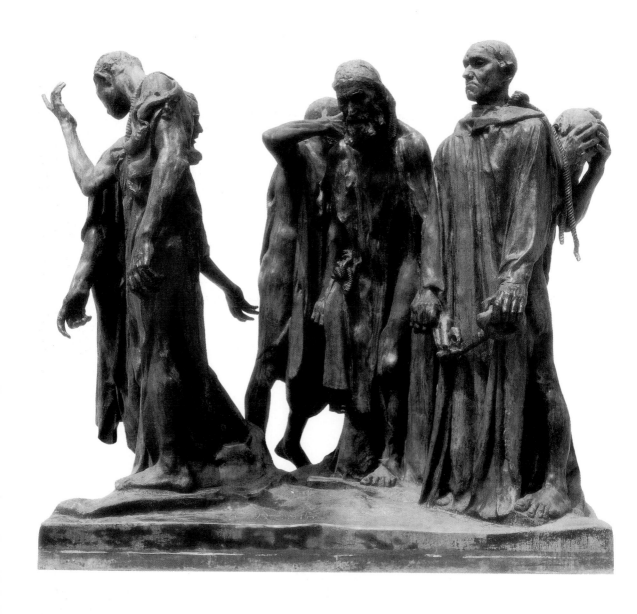

134. AUGUSTE RODIN
THE BURGHERS OF CALAIS
RIGHT-HAND STUDY FOR PIERRE
AND JACQUES DE WISSANT, 1885–86

135. AUGUSTE RODIN
THE BURGHERS OF CALAIS
RIGHT-HAND STUDY FOR PIERRE
AND JACQUES DE WISSANT, 1885–86

136. AUGUSTE RODIN
THE BURGHERS OF CALAIS
LEFT-HAND STUDY FOR EUSTACHE DE
SAINT-PIERRE, 1885–86

137. AUGUSTE RODIN
THE BURGHERS OF CALAIS
DETAIL OF FACE, 1884–86

138. AUGUSTE RODIN
THE BURGHERS OF CALAIS
DETAIL OF FACE, 1884–86

139. AUGUSTE RODIN
THE BURGHERS OF CALAIS
DETAIL OF FACE, 1884–86

weight of common destiny and public duty on the one hand, and the tug of individual wills on the other, are kept in perpetual tension by the play between the rhythms of repetition and the centrifugal energies of fragmentation.

The Burghers are not a professional or occupational group of the kind Degas favored, and their gestures have less to do with the eroding force of habit than with the engulfing force of emotion. They form a community of wills—voluntarist in every sense—driven by the sparks of diverse individual actions, pushing against the resistance of self-interest. This ad hoc polity, in its sacrifice for a larger civic good, lives by a different mix of the same forms and the same energies that made *The Gates* hellish: private psychic struggles are the elements, and their conflicted nature is expressed as undissolved in the whole. The turn-of-the-century German sociologist Georg Simmel's parallel vision of society as a continually negotiated dispute reads like a meditation on this monument. "Man has the capacity," said Simmel, "to decompose himself into parts and to feel any one of those as his proper self. Yet each part may collide with each other and may struggle for dominion over the individual's actions. This capacity places man, insofar as he feels himself to be a social being, into an often contradictory relation with those among his impulses and interests that are *not* preempted by his social character. In other words, the conflict between society and the individual is continued in the individual himself as the conflict among his component parts. Thus the basic struggle between society and individual inheres in the general form of individual life."

140. AUGUSTE RODIN
THE BURGHERS OF CALAIS
DETAIL, 1884–86

141. AUGUSTE RODIN
THE BURGHERS OF CALAIS
DETAIL OF ONE OF THE BASES
WITHIN THE MONUMENT, 1884–86

Medieval Calais is remote from modern Paris, and even further from Leland Stanford's horse farm. Yet the use of fragmentation and repetition in *The Burghers* does connect with the appearance of parallel forms in Degas, and even in the work of the chronophotographers, in basic ways that go beyond simple visual coincidence. In all these instances, the forms arose initially out of a dissatisfaction with the accuracy or usefulness of inherited conventions of representing truth—about running gaits, about society, about history—and out of a determination to analytically decompose the phenomena at issue into newly particular parts. And in all cases, traditional notions of legible continuity or wholeness were deemed less important, in building up new representations, than preserving the specificity of these parts.

In Marey's science, the resulting forms of fragmentation and repetition were linked by the experimental method, and by a belief in the necessary interlock between changing moments and the fixed patterns that bound them to natural laws. But in dealing with human nature and society, Degas and Rodin used the same pairing to convey a very different, unresolved give-and-take between the variety of individuals and the forces of society that acted to shape them collectively. That dialogue is a subject the dancers and *The Burghers* both embody; and the language of fragmentation and repetition served to condense, without simplifying or schematizing, these tensions. When these tensions were more decisively resolved, as in the we-are-all-brothers vision of natural law at work that emerged a little later in the Symbolist art of Ferdinand Hodler (fig. 142) or George Minne (fig. 143), the art seems drearily didactic—more clarified in its forms, but less potently modern.

142. FERDINAND HODLER
THOSE WHO ARE WEARY OF LIFE
1892

143. GEORGE MINNE
*THE FOUNTAIN OF THE KNEELING
YOUTHS*, 1898–1906

If there is a general lesson to carry away from studying the emergence of these various uses of fragmentation and repetition in early modern art, it must have to do, not with the drive to newly absolute simplicities of certainty or negation, but with play, in the serious sense of the word: the play between observed particularities and hidden orders, between individuals and societies, and especially between mobile forms and changing contexts of use, as the engine to produce the variety of particular meanings we have seen underlying these resemblances. That play of "meaningless" forms, from which arise new ways to model the world, is a key way social meaning is produced. In what we have seen of the forms of fragmentation and repetition in chronophotography, Degas, and Rodin, we can see—at least as tellingly as in contemporary laws, or texts—a raft of realities of the final decades of the last century: the hopes and fallacies of positivist science, materialism and the revolt against it, the rise of new ideas of the working classes, the tensions between a new sense of individualism and new collectivist political thinking, the pathos-tinged nationalism of Third Republic France, a fascination with dynamism, a rebuke of Vitalism, a sense of the amusements and the alienations of modern existence, and so on and on. These forms are windows onto all of that; and by the way they emerged, and bore meaning, they at the same time announce a new way of making art, and of art making worlds, that would shape the visual culture of the next century.

THE TWENTIETH CENTURY

Invention is a challenge to explain, but diffusion might seem
relatively easy. Once a new idea or form is initiated, it can
spread and prosper in what appear to be obvious ways. The
continuation of our story in the work of the Italian Futurist
artists Giacomo Balla and Umberto Boccioni (figs. 144 and
145), for example, looks like an open-and-shut case of simple
influence: they borrowed their forms straight from Marey's
chronophotographs. And we are hardly lacking in manifestoes,
from critics or from the artists themselves, to explain the
meanings of early geometric abstraction, or Minimalism, or

Pop. But these various explanations often contradict one another. And we need to understand not just why fragmentation and repetition reappeared in the twentieth century, but also why they disappeared—why this pairing sometimes did *not* seem to belong to modern art. To do that, we have to rethink some of the issues of science, of communication, and of social order raised by their initial appearances. The same forms, and the same related issues, took on altered inflections after 1900.

The Futurists did not just imitate Marey, for instance. They responded to a side of his work we have slighted up till now. The ultimate aim of his photo studies was to allow humans to master nature's principles—understanding birds would lead to planes; understanding air flow would lead to better bullets. Marey lamented, though, that just as our senses were inadequate to discern such hidden principles, so

145. UMBERTO BOCCIONI
MUSCULAR DYNAMISM, 1913

146. ETIENNE-JULES MAREY
*MAN IN BLACK SUIT WITH WHITE
STRIPE DOWN SIDE FOR
CHRONOPHOTOGRAPH MOTION
EXPERIMENT*, 1883

147. ETIENNE-JULES MAREY
MAN WALKING IN BLACK SUIT WITH
WHITE STRIPE DOWN SIDES, 1883

traditional languages, written or visual, could not communicate them with absolute accuracy and clarity. Thus he used tricks like black running suits with white points and skeletal stripes to thwart photography's appetite for surface appearance, and make it focus only on essential lines of motion that could make clear diagrams (figs. 146 and 147). Ultimately he did not want a staccato array of information about diverse instants, but a binding vector that tracked the essential line of force.

Like a lot of positivist science, Marey's program of observation connected to a utopian plan for greater control over nature. And his particular concern for representation involved a matching hunger for a universal language, inscribed directly by nature's order in forms that would have the same, unmistakably clear meaning for everyone. These were ambitions that dovetailed with the Futurists' bellicose belief in human dynamism reshaping the world, and with their desire to have new art forms that would lay waste to tradition and find their authority in territory beyond the realm of the senses.

Other, more practical-minded people also interpreted Marey's kind of science as heralding a new age of scientific control and purified form, and applied the lessons directly to shaping human behavior. Frederick Winslow Taylor, the pioneer of time management, took Bernard's and Marey's principles into the workshops and factories of the twentieth century. Breaking each task into its component steps and measuring individual performances by stopwatch, he determined ideal standards of efficiency by which to measure (and eventually improve) each worker's productiveness. His disciple Frank Gilbreth drew even more directly on Marey's model, to similar ends. Gilbreth thought that by

149. FRANK B. GILBRETH
WIRE MODELS OF THE PATHS OF
MOTION FOR ENABLING BLIND AND
ALSO SIGHTED WORKERS TO
VISUALIZE THE ONE BEST WAY TO
DO WORK, N.D.

photographing people performing various tasks with lights attached to their arms, he could extract universally optimal lines of efficient motion (figs. 148–150). Diagrams, or even wire models, of these lines served as instructional aids: brickworkers, for example, would be encouraged to run their arms through the model of an ideal bricklaying curve, to learn what Gilbreth championed as "the One Best Way."

In the original chronophoto projects, when the immediate goal was to describe how the world worked, standardized repetition had been a framing method: the shutter's regular intervals made the variety of individual moments salient. But when the emphasis shifted to prescribing how the world worked best, standardized repetition became a shaping procedure: the shop manager's training drills suppressed variety, and enforced a fixed ideal. Habituation, which Edmond Duranty's generation observed as a force underlying the complexities of behavior, was seized on by Taylor's followers as a tool to impose new uniformity.

Their more aggressive notion of applied mechanics, and the altered idea of representation it entailed, looked beyond the complementary relationship of fragmentation and repetition in the original chronophotographs. The coexistence of decomposed bits and standardized intervals, as laid out in imagery like that of Muybridge, was but the vestigial sign of analysis. The vector in Marey, or the binding curve of Gilbreth's loops, represented the affirmative new synthesis that fused all the broken variety of particulars into new, artificially clarified, forms of unity. The former pair was the mark of probing investigation, but the emergent line was the mark of controlling certainty.

150. FRANK B. GILBRETH
STRETCHED CHRONOCYCLEGRAPH OF THE MOTIONS OF A GIRL FOLDING HANDKERCHIEFS, N.D.

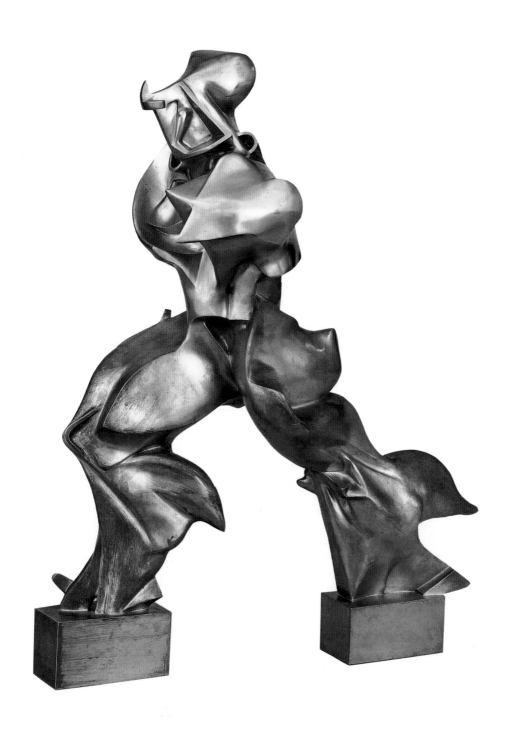

152. GIACOMO BALLA
SPEEDING AUTOMOBILE, 1912

153. GIACOMO BALLA
SWIFTS: PATHS OF MOVEMENT +
DYNAMIC SEQUENCES, 1913

This supplanting of fragmentation and repetition by lines of consolidation and unity had social implications, related to the rise of new ideas of mass society and "scientific" collective politics. We can perhaps read them into the (still cinematically fragmented, and willfully violent) work of the Futurists (figs. 152 and 153, p. 151); for their imagery of speeding blurs and all-binding vectors of force (fig. 151, p. 150) paralleled their ideals of a new social order that would sweep individuals into a vast collective will—eventually, as it turned out in their case, fascism. The implications are more direct, though, in the case of Taylor and Gilbreth, and in the period just following World War One. Taylorization, as this kind of work management was generally known, was heralded by virtually all points on the political spectrum, from Detroit to Moscow, as a major tool for social reform. In Europe especially, the war had provoked revulsion against the era of liberal capitalism that had led up to it. And a technique to help eliminate the waste and conflict of that era's laissez-faire individualism initially seemed a salutary step toward shaping a society that would be more harmonious as well as more productive.

Those ideals of efficient collectivity, in turn, affected art. By the late 'teens, the device of fragmentation had lost its connections with former ideas of clinical analysis. Its newly extreme forms had become—in the hands of Dada photocollagists, for example—a way to conjure a world of abrupt surprise, unexpected conjunctions, and revolutionary incoherence, as a subversive alternative to what many perceived as a stifling excess of mechanistic rationalism in a corrupt social order. For these artists, true reason lay in pointing up the contradictions in the world around them; and the imposition of any cohesion in art—of narrative, of scale, of material—was a form of collaboration with the enemy (fig. 154, p. 153). Yet many others with an ambition to be form givers for their time—architects like Le Corbusier, painters like Fernand Léger (fig. 156, p. 155), sculptors like Vladimir Tatlin—hailed efforts at the rationalization of society, and felt that modern art should respond to the same new principles. They posited the notion of an artist-engineer, or mechanic-hero, who would align art with progress away from divisive social hierarchies, toward a new, commonly shared, and functionally based objectivity.

Advocates of this latter idea believed that modern machines were in synchrony with the higher laws of economy in nature (as Taylor's methods were with laws of optimal physical efficiency), and that there was also a fraternal harmony between the newest mechanical forms and unpretentious shapes that had arisen from popular use. For example, the painter Amedée Ozenfant (fig. 155, p. 154) asserted that everyday utilitarian items like the café soda siphon had "evolved" to a state of simplicity that made them

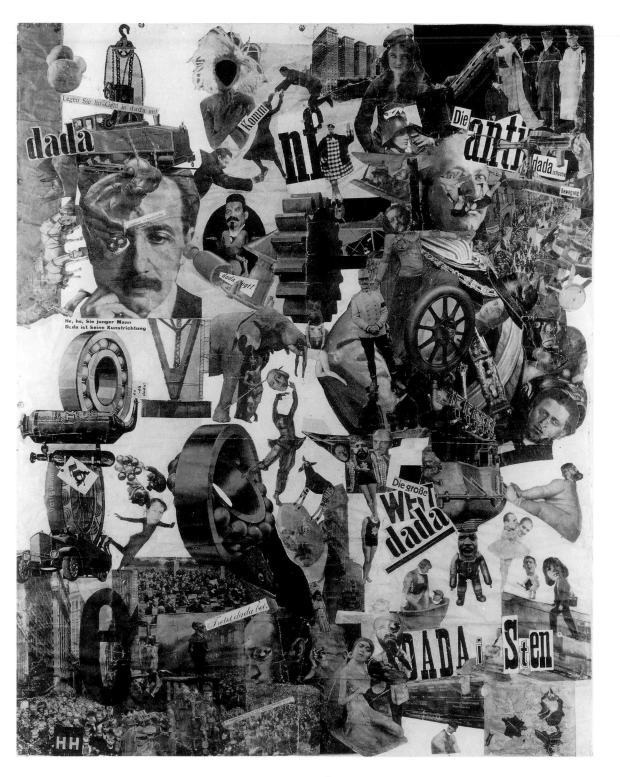

154. HANNAH HÖCH
CUT WITH THE KITCHEN KNIFE
CA. 1919

155. AMÉDÉE OZENFANT
THE VASES, 1925

the modern equivalents of classical forms, and apt models for new creativity. Just as the time managers reinterpreted Marey as the prophet of smooth efficiency, Ozenfant saw evolutionary theory as revealing, not a world of struggle and conflict, but a refining progress that eventually ground away unproductive variety to hone organisms down to their best, most economically functional design. The anonymous forces of mass utility worked in a similar way, he felt, to shape the same kind of inevitable, necessary forms. Thus reductive streamlining emerged as the proper expression of mechanical, natural, and social laws together; and the same basic sources of authority—experimental science and evolutionary biology—that had incited nineteenth-century artists to reveal the strata of social types underlying the variety of individual appearances now incited their twentieth-century counterparts to impose the vision of ideal forms that best fit the coming unified society.

These artists and thinkers felt that the imaginations of modern cultural creators could be in touch with the same essential laws that determined mechanistic efficiency.

156. FERNAND LÉGER
THE SIPHON, 1924

55. JOAN MIRO: Composition. Oil on Sand-paper, 1935. Detail.
(*Courtesy Pierre Matisse Gallery, New York*)

56. FRANK B. GILBRETH: Chronocyclograph of a Motion.
(*Courtesy Lillian M. Gilbreth*)

Every age has known the impact upon feeling of lines, curves, signs. All good ornament stands witness to this.

And this is no less true of movement in space; it too can be experienced as an absolute, likewise disengaged from the performer.

Is not the endless flow of movement in skating more significant than the body of the skater? As we watch a fireworks display, is it merely the luminous trajectory against the dark background that arrests us? Is it not rather the disembodied movement of the rockets through space that so appeals to our imagination?

What occurs in painting around 1920 is but the artistic extension of this faculty. For a work process to be understandable, it must be made visible; for he who performs it does not know his own movement. And this holds good for our subconscious processes.

These symbols of movement are spontaneous condensations, like the sound-poems of the Dadaists and, later, the Surrealists' quest for an 'automatic

writing' (1924). A poet such as Paul Eluard confirms this (1939), as he comments on the 'integral truth' (*vérité totale*) sought by Picasso and every real artist of the time. 'Picasso has created fetishes, but fetishes possessing a life of their own. Not mere intermediary signs but signs in motion. Their motion makes them concrete things.' [56]

Signs in movement, movement in signs. Paul Klee, perhaps the boldest explorer of the subconscious, held that 'pictorial art springs from movement, is in itself interrupted motion and is conceived as motion.' [57]

Klee's *Pedagogical Sketchbook* emerges ever more clearly as a key to contemporary art. This pithily worded notebook summarizes his teaching at the Weimar Bauhaus. Here the master does more than teach; he admits us into the workshop.

57. JOAN MIRO: 'Ecritures, Paysages et Têtes d'Hommes,' 1935. Detail. *Miro, whom Klee regarded as the painter closest to himself, uses movement in signs and symbols to achieve an astonishingly direct expression, without interposition of philosophical or reflective motifs. (Courtesy Pierre Matisse Gallery, New York)*

[56] Paul Eluard, *Picasso*, London Bulletin 15, 1939.
[57] W. Grohmann, *The Drawings of Paul Klee*, New York, 1944.

157. PAGES OF COMPARISONS FROM SIGFRIED GIEDION
MECHANIZATION TAKES COMMAND
1948

Resemblances between new art forms and the structures of the machine age would thus be evidence of a profoundly shared partnership. In *Mechanization Takes Command*, the Swiss architectural historian Sigfried Giedion even made the linkage direct, by incorporating abstract art into his history of the assembly line and other modern improvements in functional design, and by proposing one-to-one comparisons between works by Joan Miró, Wassily Kandinsky, and Picasso and the curves of Gilbreth's labor-management studies (figs. 157 and 158). These juxtapositions may seem peculiar now. But you do not have to follow the specifics of the argument, or even to accept the veneration of technology and industry, to see that they do touch on hopes for a new objectivity in modern art that were shared by many who supported that art, and many who made it.

Piet Mondrian, for example, clearly rejected the details of naturalism and the subjective "confusions" of Cubism in an effort to arrive at an art of impersonal authority, in touch with basic truths; and though his avowed sources of inspiration were in theosophical mysticism, many felt the results were as spare and "necessary" as open-span steel frame construction (fig. 159, p. 158). Similarly, Brancusi eliminated all trace of gestural touch or spontaneity in sculpture, and his

polished purity of shape and surface seemed to unite folk intuition with the sleekness of modern machines. A certain ideal of modernism in the 1920s and '30s would have found not just a resemblance, but a deeper kinship, between Brancusi's *Bird in Space* (fig. 162, p. 160)—which the artist said embodied the spirit of a magic bird from a Romanian folk tale—and artifacts of the new engineering like propellers (fig. 163, p. 161), as twin instances of austere, "objective" beauty. In the utopian vision of modernism shared by Giedion, Ozenfant, and countless artists as well, such innovations of the modern imagination would naturally synchronize in this way with those of science and engineering; and the work of the enlightened individual would express both underlying truths of nature and the progressive impetus toward new, rational social collectives. The pairing of fragmentation and repetition as the previous century saw it would submerge and disappear, because the oppositions it embodied—between particular instances and general laws, between individual wills and collective order— would have been dissolved.

158. PAGE OF COMPARISONS FROM
SIGFRIED GIEDION
MECHANIZATION TAKES COMMAND
1948

53.
Black Arrow.' 1925. *Better perhaps than any other painter, Paul Klee has the secret of projecting psychological movement. In Klee's work the pointer arrow in the shape of a rectangle headed by a triangle first appeared — an artistic symbol before it became internationally familiar in ordinary use. 'The given white is accepted by the eye as customary, but the contrasting strangeness of action (black), sharpens vividness of vision for the climax, or end.' (Klee, Pedagogical Sketchbook, tr. Sybil Peech, Courtesy Nierendorf Gallery, New York)*

54. FRANK B. GILBRETH: Perfect Movement. Wire Model, *c.*1912.
(Courtesy Lillian M. Gilbreth)

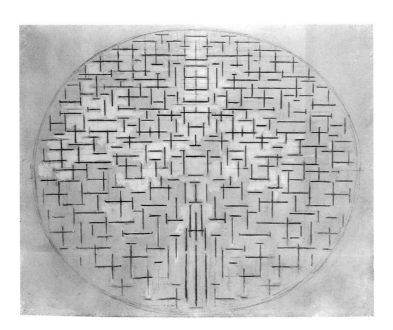

159. PIET MONDRIAN
PIER AND OCEAN, 1914

160. PIET MONDRIAN
COMPOSITION WITH BLUE AND
YELLOW, 1935

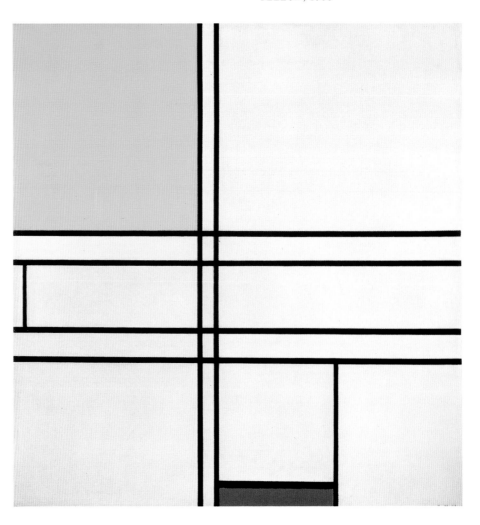

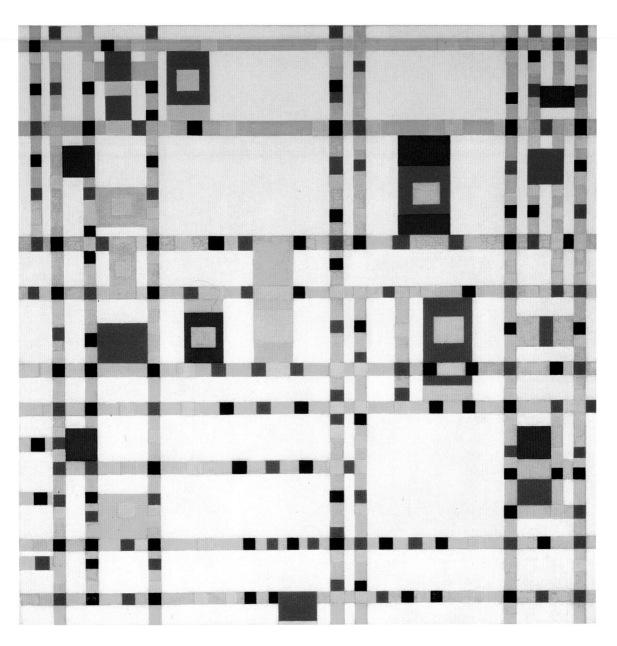

161. PIET MONDRIAN
BROADWAY BOOGIE WOOGIE, 1942–43

162. CONSTANTIN BRANCUSI
BIRD IN SPACE, 1928

163. ST. REGIS PAPER COMPANY
PROPELLER BLADE, CA. 1943

164. CONSTANTIN BRANCUSI
CHIMERA, 1918

165. CONSTANTIN BRANCUSI
VIEW OF BASES IN STUDIO, CA. 1922

166. CONSTANTIN BRANCUSI
ENDLESS COLUMN, 1937

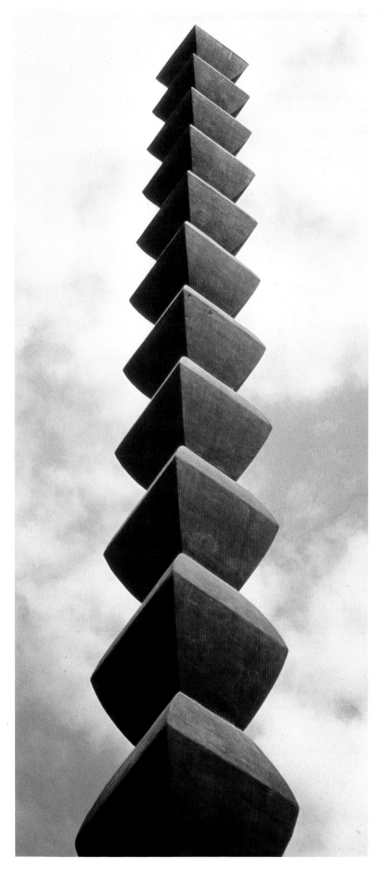

This is in many ways a thrilling vision, and it does help explain how the world of analyzed natural forms in Marey and Muybridge was linked to, and then superseded by, the world of idealized abstract forms in Taylor and Gilbreth. But at best, it tells a half-truth. "Pure" abstraction, as the extreme case, does not occur in the history of modernism simply as a final product, distilling reality in the way Gilbreth distilled out ideal curves. It is also an initial premise, and a foundation stone. When Cézanne and Seurat transformed their art and made it modern, it was not by reducing what they observed to an idealized schema, but by taking inert, system-bound modules—parallel, regularized units of paint in rectangles or dots—as the starting point from which to build a picture of nature. And later, in the development of Cubism by Picasso and Braque, the process of breaking observed forms down into abstract pieces rebounded, as it approached near-total abstraction, into a complementary strategy of building up images from odd-shaped pieces of paper, clippings of newsprint, scraps of wallpaper, and so on. In these generative moments of modern art, meaning arose from, rather than being reduced to, the assertion of innovative languages of abstract form.

This does not mean that the ideal of a relation between modern art and modern science is wholly delusory. Recent thinking holds that science provides our best measure of truth, not because of its particular hold on some set of indisputable facts of nature (we have too often seen that these are subject to drastic change and reinterpretation), but because as a discipline it has a highly developed tradition of proposition and criticism—what the philosopher Karl Popper called "conjecture and refutation." In this regard, the process of constructing models of unseen things is recognized as a primary means of discovery, at least as important as the procedures of tracking nature's traces that guided positivist science: a large part of both molecular and cosmic physics consists of virtually nothing but such conjectural modeling. And these models then take hold and serve the expansion of knowledge, not so much because of their unshakable connection to demonstrable fact, as because a community of critical peers recognizes them as opening fruitful new sets of questions, and as organizing experience in a freshly challenging way. The development of modern art seems more legitimately aligned with this kind of generative speculation than with the flawed notions of truth to nature inherent in the reductive conceptions of science that fired the imaginations of the Futurists or Ozenfant.

Even within a "simplified" art like that of Mondrian or Brancusi, the paring down of the variety of basic forms can serve this companion purpose of building diverse models of

varied worlds. When we stand in a gallery full of Mondrian paintings, we see a universe of experience, not as boiled down to ideal stability, but as lived: a world that, by the repetition and permutation of one kind of right-angle relation and a sharply curtailed palette, goes from country to city, atmosphere to architecture, from the clarity of Dutch churches in the manner of Pieter Saenredam (fig. 160, p. 158) to the jazzy grid of New York in the manner of Satchmo (fig. 161, p. 159). Brancusi, similarly, can take a simple pyramidal form and permute it through roles as part of a base, part of a table, and part of a sculpture (figs. 164–66, pp. 162–63), in recognition that each combination, or even strict multiplication, yields a different function and possible meaning. The reduced formal vocabulary in such cases is not an end, but a point of departure into a subsequent expansion of meanings. If we find such worlds of form initially narrow, it is because we are being led by the art to extend our sense of the potential in things we may commonly ignore or take for granted. Such art constricts our field of view in order to enlarge our horizons.

A crowning embodiment of that particular process in Brancusi, the *Endless Column* in his park at Tîrgu Jiu, represents a major instance of pure repetition in modern art; and its meaning, within the complex, reaffirms some of the major themes we have been following. The park has three components, all of which involve repetition as their basic formal strategy: the *Gate of the Kiss*, in which kissing pairs recur on both the columns and the lintel (fig. 167, p. 166); the *Table of Silence*, in which identical disk-topped chair forms surround a central disk (fig. 168, p. 167); and the column itself, with a basic double-pyramid module stacked again and again on top of itself. Each time the recurrences serve different motifs. The doubling in each couple's symmetry in the *Kiss* reinforces the idea of fusion of the sexes in love; the repeated chair modules create the analog of a unified community centered on the material need of sustenance; and the vertical stack of the column can be taken to refer either to the vertical descendancy through time that links one person to his or her ancestors, or to the vertical ascendancy that links each person upward, by extension of the self, to higher religious aspirations.

The park for which these works were commissioned was a monument to military dead, in an age (the 1930s) of steadily more oppressive visions of mass social control. But the repetitions in the sculptures are not the emblem of regimented conformity. They constitute a system for producing variety from and within unity, where individual modules are coupled, grouped, and aligned with like units to produce a model of the private and public dimensions of life in human society. In this sense, the three-part model is an apt

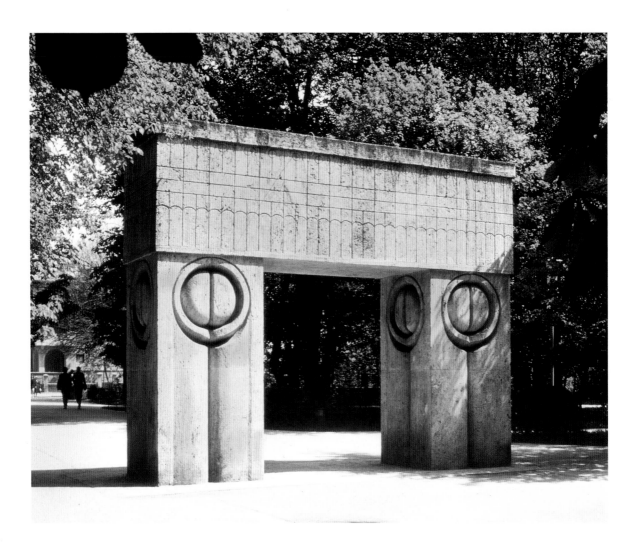

167. CONSTANTIN BRANCUSI
GATE OF THE KISS, 1938

twentieth-century successor to Degas's dance classes and Rodin's *Burghers* as a formal metaphor: the table speaks of a more leveled, conflict-free, and centrally organized society, but it is flanked by emblems of the erotic (the gate) and the aspirational (the column), which add dimensions of inner life absent from the secular social complexities of the other works. And though the park is public, the symbolism is drawn not from any reservoir of shared tradition, but from the sculptor's imagination. None of the park's forms was freighted with such meaning before Brancusi arranged them in this way; they are basically an arrangement of available conventions—the gate, the column, the table—made up of a small repertoire of sculptures and bases pirated from elsewhere in Brancusi's history, and an even smaller stock of basic geometric modules. The structures of repetition themselves were similarly long-established in his work, both in major and in minor motifs, partly as a reflection of his interests in the patterns of folk ornament and tribal sculpture.

The Minimalist artists of the 1960s, such as Donald Judd

168. CONSTANTIN BRANCUSI
TABLE OF SILENCE, 1937–38

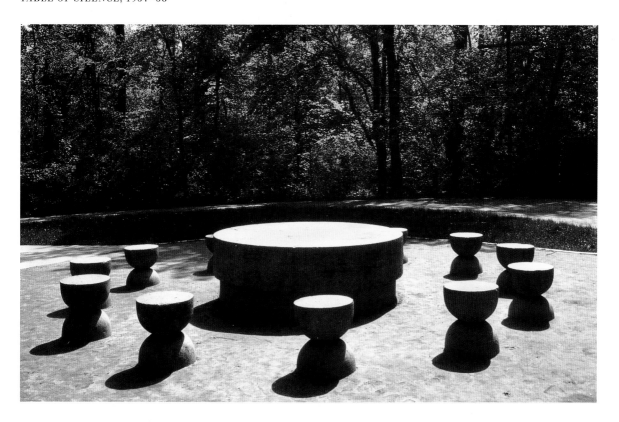

169. DONALD JUDD
UNTITLED, 1968

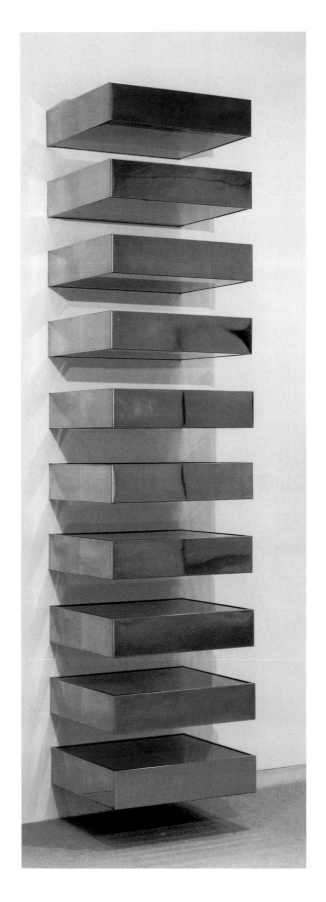

170. CARL ANDRE
REEF, 1966
(RECONSTRUCTION 1969–70)

or Carl Andre (figs. 169 and 170) or Sol LeWitt (fig. 171, p. 170), inherited from Brancusi not only a system of forms, but also this set of possibilities as to what such basic forms, including repetition, could do. These artists and their advocates insisted that their work had no pretensions to cosmic meaning, and that this new geometry—post–World War Two, post-Hitler, post-Stalin, post-bomb—had disabused itself of the faith of its elders. Ascetically skeptical about the possibilities of art's communication, they argued that the willful voiding of any metaphor or associative meaning in their forms would focus the viewer, with therapeutic cleansing effect, on the realities of present-tense experience of the work, and the clean rigors of its structural logic. But this aesthetic program concentrated on an ideal of an individual's experience of the art object in isolation, and tended to dismiss or ignore other kinds of results that would obtain when a wide range of different viewers, in a changing society, turned the art to their own purposes. The past two decades have shown that Minimalist form could in fact generate a broad range of meanings, and serve as the basis for diverse kinds of art.

171. SOL LEWITT
VARIATIONS OF INCOMPLETE OPEN
CUBES, 1974

The repetition of modular units has been the key in
LeWitt's career for an art whose interests and associations
have ranged from the step-back zoning rules of New York
skyscrapers to the perspective systems of Renaissance frescos
(figs. 173 and 174, p. 172); and in Andre's a point of contact
both with the gravestone industries of his childhood home,
and with prehistoric boulder alignments (fig. 175, p. 172). In
music, where the Minimalist dedication to repetition was
perhaps strictest, these structures have not been hermetic
enclosures, but bridges to other cultures, via Philip Glass's
work with Indian ragas, or Steve Reich's study of African
drumming patterns. A reduction to bare bones often served,
in their music as throughout the history of modern art, as the
starting point for a new art of monumental ambition, and
even Baroque or operatic complexity.

Glass's music reminds us, too, that repetition can be a
device of intensification and contemplative focus as much as
one of leveling and monotony—as much mantra as
mathematics. And the many forms of semishamanistic art of
the 1970s, which drew on Minimalist forms as the core of
more personal, earthy expression, demonstrated that repetition
is a form basic not only to clinical rationalism but also to
fetishism and private ritual. Even the revival of interest in
Muybridge himself showed this bifurcation: for LeWitt the
chronophotos provided structures of organized beauty that
could be extended, in his work with the choreographer
Lucinda Childs, into an ethereal dance of form in time (fig.
172); but Glass, in the opera he based on Muybridge's life,
made the leitmotif a woman ceaselessly bathing, and stressed
the irrational, obsessive aspect of the work.

Repetition, in short, does not stop. The dream of
reductive form that keeps cropping up in modern art is that
such forms achieve finality, as absolute signs. But the lesson

173. SOL LEWITT
ZIGGURATS, 1966

174. SOL LEWITT
MULTIPLE PYRAMIDS, 1986

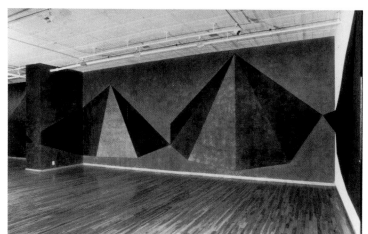

175. CARL ANDRE
STONE FIELD SCULPTURE, 1977

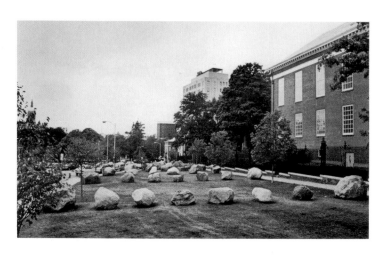

of modern art, Minimalism included, is that in a society of different people with different ideas, artists keep reclaiming the same forms, no matter how basic, as a component of diverse private languages, and as the building blocks of an open-ended variety of worlds of meaning.

As a final consideration of the life of repetition, though, we need to go back to the question of resemblances among contemporaries with which we began, looking this time — eighty years and a whole history of modernism later—at the parallel structures of repetition that occur in Pop Art and Minimalism. In Pop works like Warhol's *32 Soup Cans* or *Green Coca-Cola Bottles* (figs. 176 and 177, p. 174), we seem to be looking at the direct expression of mass-production, consumer society. All the relentless, mechanical abundance of such an economic structure, and all the lethally numbing sameness of its replications, seem laid bare by these importations of commercial designs, and forms of display, into painting. If work like Judd's or Andre's appears to insist on the prerogatives of the artist to isolate himself in a hermetically purified world independent of social orders, Warhol's holds out the image of the artist and his work revealing, in its putative individuality, the deadening pervasiveness of modern industrial commerce. The juxtaposition between untitled stacks of rectangles (fig. 169, p. 168) or rows of modules (fig. 170, p. 169) and Warhol's *Brillo Boxes* (fig. 178, p. 175) thus seems to crystallize oppositions we have been considering all through this discussion, between the idea of forms that appear devoid of content, and the idea of forms that are direct transcriptions of worldly orders.

When we see how parallel these opposites are, two explanations suggest themselves: one, that Pop was really just a dressed-up version of the abstract formal vocabulary of its time; and the other, that Minimalism was really just a disguised expression of the society of its time. In the first view, Warhol's boxes are like Judd's stacks because they both rejected the loosely handled, gestural language of 1950s painting and sculpture in favor of more impersonal, hard-edged forms; the binding element between the two was a matter of shared aesthetics. But in the second view, Judd's stacks were like Warhol's boxes in that they, too, incorporated the materials and forms of America in the late industrial age; both artists made their work look like assembly-line items, and the binding element was the common social reference.

Both these interpretations have elements of truth, but each by itself misses the mark. Minimalism did belong to its epoch and place, as we have seen—but not just as a simple, passive reflection of that context. That shared aesthetic offered a repertoire of flexible formal tools by which a great many artists built systems of meanings from a wide range of aspects of the time, from impersonality to private psychic

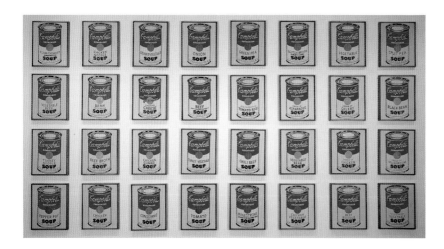

176. ANDY WARHOL
32 SOUP CANS, 1961–62

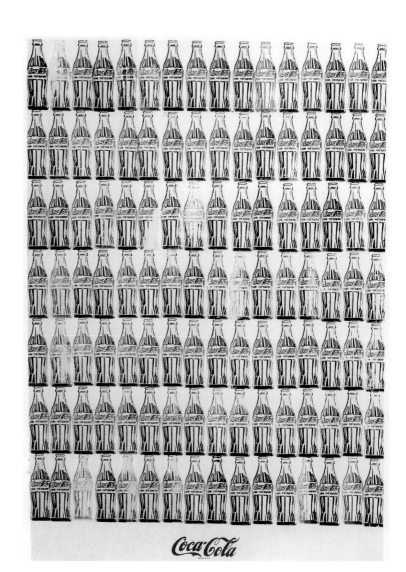

177. ANDY WARHOL
GREEN COCA-COLA BOTTLES, 1962

178. ANDY WARHOL
BRILLO BOXES, 1964

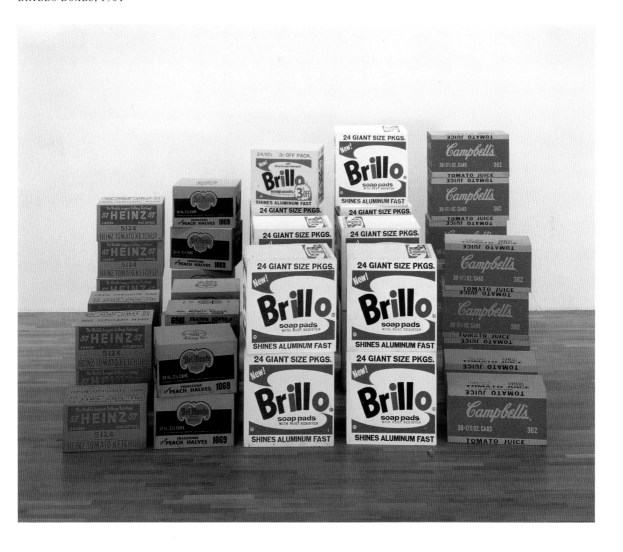

exploration, urban fabrics to atavistic architecture, and on and on. And if Pop did find its forms ready-made in the world, it selected them with an eye trained by art, and used them with signal aesthetic effect: it is still not agreed, and likely never will be, whether Warhol's use of repetition is a relentlessly intensifying device that speaks about jumpy energy with disturbing insistence, or whether it is a vehicle of oppressive homogenization. The strange, archaically stylized world of experience he invented melds both.

The Minimalist and Pop artists were aware of each other's work, and of the choices posed, in a knowing and sophisticated way. And the Pop artists often referred to the situation in works of art that punned on the close resemblance between abstract form and subjects from commercial society. Just as Andy Warhol's *Yellow Close Cover Before Striking* (fig. 179), for example, clearly lampoons hard-edged abstract painting like that of Barnett Newman (fig. 180), or Roy Lichtenstein's *Keds* jabs slyly at the abstract patterns of painters like Victor Vasarely (figs. 181 and 182, p. 179), so Claes Oldenburg's *Proposal for a Skyscraper in the Form of a Chicago Fireplug: Inverted Version* deliberately recalls Brancusi (figs. 183 and 184, pp. 180–81)—and the *Brillo Boxes* were doubtless in part intentional send-ups of Minimalist sculpture. These jokes are worth taking seriously, because they get close to the heart of the matter.

One thing the satire of these coincidental resemblances insists on is that modern art does not draw its forms from some sacred domain or elite tradition, but from a common pool of possibilities that is open to all. Another is that when modern artists narrow the variety of forms they use, and cut back toward simplicity, they can wind up increasing, rather than delimiting, the volatility of possible meanings and associations that can attach to such a vocabulary. In combination, these two situations mean that as the highest acts of artistic imagination aspire to more basic, elemental expression, the possibility of coincidence with mundane, functional productions of commerce becomes if anything more, rather than less, likely. The comparison between the Brancusi *Bird in Space* and the propeller implied that reductive modern form expressed a spirit of austere, refined efficiency. The pun between the Brancusi *Torso of a Young Man* and the fireplug suggests that such modern forms live— in ways that often surpass their initiator's intentions—a richer, more complex life: conjoined cylinders that initially conjured torsos and phalluses simultaneously can educate other eyes to see the same meanings, plus a potential system of artistic form, in commonplace objects.

Oldenburg's fireplug, Lichtenstein's sneakers, and Warhol's boxes raise essentially the same issues as did Ozenfant's café siphon, about how the forms of modern art fit with those of

179. ANDY WARHOL
YELLOW CLOSE COVER BEFORE STRIKING, 1962

180. BARNETT NEWMAN
VIR HEROICUS SUBLIMUS, 1950–51

modern society, but in a quite different spirit. Their pithy wit says that in modern art, high individual creation and anonymous industry can be partners under the skin, not because of a utopian unity or a common rule of function, but because of a give-and-take that is basic to the way we think, and the way our society works. The point is not that the hierarchy dividing these different things is somehow false. The resemblances simply drive home again the fact that the hierarchy of meaning is not inherent in the basic form, but is a contingent factor of use and context: it depends on what is done with these forms, by whom, and to what end.

Some artists and critics have taken this premise to mean that there is something sinister and fallacious (or commercially conspiratorial) in any attempt to maintain a separate category of "art" that sets certain uses of forms, or objects, apart. The enterprise of critiquing and trying to demoralize that category has in fact sustained whole careers. But the idea that the meaning of something—a box or a bicycle wheel—is dependent on its use and context is, as we said before, simply a fact about all human communication, in Periclean Athens as much as now; and the recognition that forms in modern art carry meaning as a function of malleable social conventions is cause more for wonder than suspicion or cynicism. Without a framework of expectations, or a decorum, we have no way to recognize cultural innovations as such. With a too stable and certain framework, we tend to see innovations only as errors. Modern art involves an expanding and malleable set of frameworks of understanding which alternately define, and let themselves be defined by, individual innovations. In this play, our fixed repertoire of forms can become the ground for new arenas of meaning, and individual changes can regenerate and renew terms of larger consensus.

These formal innovations, however serious, tend to begin by being, (in the fashion of the sophisticated Pop puns), "in-jokes": they speak a slang accessible only to a small circle of initiates. Since they do not draw on an established consensus, they must build their own—first perhaps among other artists who find the new forms useful, then among critics, or dealers, or collectors—until the slang is a dialect, and eventually an assimilated idiom, which a broad range of people use with different intents. The branching life of such forms constitutes the complex family tree of modern art: a descendancy in which changing communities within a pluralist society have come to look to the artistic imagination as a transforming generator that proposes changing sets of meaning for forms that others see as fixed, functional, or just banal.

Like all good satire, then, the Pop-abstract jokes undermine pretension; but they also have the effect of refocusing admiration, on the significance individual artists can cause to be invested in formal orders that are otherwise

181. ROY LICHTENSTEIN
KEDS, 1961

182. VICTOR VASARELY
MIZZAR, CA. 1956–60

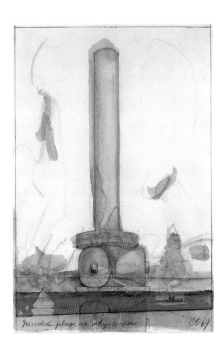

183. CLAES OLDENBURG
PROPOSAL FOR A SKYSCRAPER IN
THE FORM OF A CHICAGO FIREPLUG:
INVERTED VERSION, 1969

inert or commonplace, and on the system that depends on their doing so. The puns turn in part on the nature of our cognitive system, which wants to derive meaning everywhere—to see animals in clouds, landscapes in marble veins, and (once abstract artists provide the model) abstract art in Keds treads. That way of imparting significance, by organizing inchoate experience in terms of surface resemblances with known things, is a long-standing part of human nature. So, too, is the complementary desire to extract clarified signs of meaning—mandalas, circle charts, divine ratios, and so on—from the confusions of the world. But modern art operates in a different way: it invests individually generated meaning in forms whose significance seems either nil, like rectangular solids, or overdetermined, like Brillo boxes. And that activity depends less on cognitive systems than on social systems, that open room for, and attend to, individual play with established conventions.

The forms we have been particularly concerned with have had a rich and prolonged life within that social system. Fragmentation and repetition have served as the signs of new certainties, at once utopian and deeply constraining. But their history in modern art has made them signs of a different actuality that involves the mobility of meaning and the variety of human behavior. Certainly part of the reason these forms have survived and recurred in the way artists build versions of the modern world is the same reason the parallel terms have been so often used by writers to describe modern experience. Fragmentation and repetition are metaphors of modernity, in its unresolved complexity. On the one hand, the thing ripped from its former integral context, and given independent life, as indicative of the disruptions of new individual freedom; and on the other, the form recurring in exact or near-exact identity, as indicative of new conceptions of collective order. Each pole has had its euphorias of liberty or equality, and its attendant torments of alienated distance from organic wholeness, or stultifying conformity. The condition of an open society involves the self-conscious, never resolved—and for artistic innovation, fruitful—dialogue between these poles of free play and constructed consensuses. Though modern art has often dreamed of a closed society, it can function only in an open one.

184. CONSTANTIN BRANCUSI
TORSO OF A YOUNG MAN, 1924

FOUR
PRIMITIVISM

Two of the favorite stories of modern art's beginnings involve a trip to the islands, and a visit to the museum. First Gauguin, cursing Western decadence, sailed away to Polynesia in 1891 — to, as he said, "immerse myself in virgin nature, see no one but savages, live their life, with no other thought in mind but to render, the way a child would, the concepts formed in my brain, and to do this with nothing but the primitive means of art, the only means that are good and true." His irritated urges to regression and attraction to tribal art (fig. 185, p. 184) announced a distinctively modern impatience with all "civilized" standards of beauty and decorum.

Then, just three years after Gauguin's death, in the late spring or summer of 1907, Picasso experienced a shock of revelation on seeing the tribal masks and totems from Africa and Polynesia in Paris's Trocadéro museum. Returning to the unfinished *Demoiselles d'Avignon* in his studio, he painted new passages that — especially in the torqued features of the gorgon at the lower right (figs. 186 and 187, p. 185) — shattered, not just the aesthetic, but also the psychic, constraints of Western culture. This picture opened, as André Salmon said, the "still-incandescent crater from which present art's fire emerged"; and established a visual language that has served, for more than eighty years, as a prime conduit to areas beyond our ken, in the most irrational wellsprings of human nature. In twentieth-century painting, this picture's "savagery" is the heart of darkness.

These stories are about primitivism. We know it when we see it, as in that uncanny and fearsome face, yet critics and historians disagree on what it is. One traditional idea held that primitivism in twentieth-century art was a *re*-discovery, shucking worn-out European traditions to get back to the "timeless" forms of prehistoric and tribal imagery. In this view, violently crude deformations like those in the *Demoiselles*' faces expressed an essential hunger, spawned by the oppressiveness of modern life — the Romantic yearning for return to a primal, raw form of truth, beyond the taint of all our acquired cultural conventions. Drawing its force from this malaise, and from the potency of foreign style, primitivism was both alien in source and alienated in tenor; but as a release for repressed psychic energies, it could also be a saving compensation for our society's separation from nature.

More recently, though, other accounts have described primitivism, not as a cure for the ills of modern Western culture, but as part of its sickness. These critics see all the talk about a "natural" refuge from civilized corruptions as a self-serving hoax utilized by Western artists to romanticize their work. They indict "borrowing" from non-Western styles as an attempt, like any other form of imperialist thievery, to fuel our society with the resources of less developed parts of the globe. And they view the old notion of finding shared

185. PAUL GAUGUIN
WE GREET THEE, MARY (IA ORANA MARIA), CA. 1891–92

185. PAUL GAUGUIN
WE GREET THEE, MARY (IA ORANA MARIA), CA. 1891–92

roots of creativity as a smokescreen for the West's desire to ignore the real differences between cultures, and impose its own values globally.

Both of these assessments have evidence behind them. The desire for raw truth and the search for universal basics is expressed in countless artists' statements; and the cynicism about those motives has solid ground in histories of the West's colonizing suppression of tribal cultures. But as morals to be drawn from the innovations of Gauguin and Picasso, both these views of primitivism are false. To use the history of modern art as evidence in the debate about primitivism, we should first get these stories straight. There are very large and basic questions at issue, about how our minds, and our ways of representing, can come to terms with other minds and other, foreign ways of constructing the world. Gauguin and Picasso, accurately understood, speak directly to these questions: they demonstrate an important way change within our own culture intertwines with information about what lies outside it to generate innovative reform. But neither the dream of some universal form-language, nor pessimism about the futile self-

186. PABLO PICASSO
LES DEMOISELLES D'AVIGNON, 1907

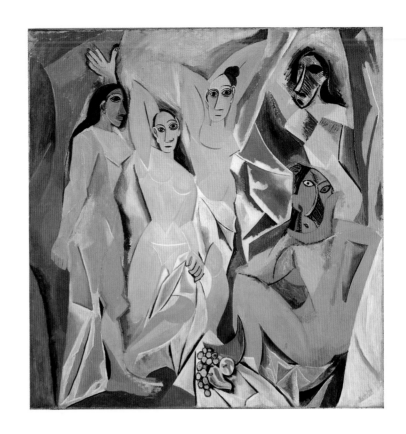

187. PABLO PICASSO
LES DEMOISELLES D'AVIGNON
DETAIL, 1907

enclosure of Western values, will help us understand how that works. And neither idea really accords with the way primitivism has worked in Western society, before and since. If we want a better idea of what primitivism is, we should try sidestepping the grand theories for the moment, and just look harder at what we see of it in the trip to the islands and the visit to the museum.

Gauguin and Picasso were, first of all, part of a much broader history of Western encounter with tribal cultures. The starting point in discussions of Western appreciation for primitive societies is traditionally Michel Montaigne's essay "On Cannibals" of 1580; and the classic formative period for what we now think of as primitivism was the seventeenth and eighteenth centuries, when a series of explorers' discoveries of tribal societies (such as Samuel Wallis's and Antoine-Louis Bougainville's initial landfalls at Tahiti in the 1760's) provided new fuel for philosophical and political debates about man's essential nature. From the speculation on these matters, especially in the eighteenth century, two opposed ideas about tribal peoples emerged, each problematic in its own way.

One attitude, based in Rationalist ideals, stressed that all human minds were capable of the same structures of reason: despite the strangeness of their customs, South Seas natives and American Indians were taken to share the fundaments of Enlightenment intelligence. This vision was generous, but potentially tyrannical. It spurred the French "civilizing" mission, an imperialist campaign which presumed to measure all cultures according to its own standards of what constituted reason. In that context, ideals of universal brotherhood swiftly translated into inequality and intolerance, as the self-styled purveyors of the Enlightenment pursued the goal of organizing all European cultures, along their lines.

In the face of this juggernaut, resistant Europeans then embraced a contrary set of ideals, associated with Romanticism's reaction against the Enlightenment. Influential Romantic thinkers of the early nineteenth century, like the German Johann von Herder, held that the various peoples of the earth were permanently divided into organic cultures, whose different customs could never be brought under any one set of rules. This outlook promised a true, pluralist tolerance; and it encouraged serious attention to all those diversities (such as the variety of the world's languages) that had formerly been reckoned merely imperfect versions of a basic universal ideal. But a noxious side became evident, when such comparative research was used to establish scales of relative ranking, among more and less "advanced" languages, political orders, or peoples. Especially when joined to notions of progressive evolution, the idea that separate cultures were "naturally" different from each other could be used to lend an air of scientific sanction to racial stereotyping.

The choice seems simple: either some fundamental, shared capacity of mind is the ultimate, most important aspect of human affairs; or cultural differences are more determining. People are alike in reason, or distinct in spirit—each of these basic philosophical notions has fueled and then betrayed, in their different ways, Western modes of understanding non-Western societies. Gauguin's initiation of modern artistic primitivism belongs within this bifurcated tradition—but not in the manner we might expect. His flight to Tahiti, and the claims he repeatedly made about his "barbarous" and "savage" nature, have almost always been associated with the escapist heritage of Romanticism. But his deeper ideals, and the major themes of his art, belonged to a Rationalist lineage.

"*Primitif*" in French denotes underdeveloped, but also original, basic, or irreducible; somewhat like "native" in English, it can apply both to people out there and to capacities (like instinctual intelligence) resident within us. In Gauguin's case, both senses were at work. "Primitives" fascinated him because they were exotic, but also because he felt part of them lived in him. He saw their ways of thinking as windows on to the primal powers of the mind. Their behavior, and their cultures, reinforced his belief that inner imagination, rather than mere sensory impression or imitation, was the first principle of art.

"Primitives," Gauguin felt, lived literally in a charmed world. Where a modern man saw a tree, they would see a spirit. He thought this kept them in touch with the earliest, most basic ways the mind constructed a world of symbols. All of his major paintings on the theme of superstitious hallucinations, such as *The Vision After the Sermon* (fig. 191, p. 191) in Brittany (where peasant women "see" an angel after hearing a sermon) or *The Spirit of the Dead Watching* and *Words of the Devil* (figs. 188 and 189, p. 188) in Tahiti (where natives imagine spooks in the night), treat this theme. These images "explain" religion as a figment of the mind, and "propose" (as rationalizing philosophers had for generations before) that the universal origins of such human symbol systems lie in the primal projection of imagination over mere perception.

When he wrote a text to accompany *The Spirit of the Dead Watching*, Gauguin made explicit the connection he saw between these primal origins and his own way of creating. *The Spirit* shows how Gauguin's young mistress, frightened in the dark, imagined a phantom, in the form of a little old woman, crouching by her bed. When he described the way he transformed his initial glimpse of this girl into the final painting's symbolic array of colors and forms (purple is deployed to suggest terror, for example), he made his creative processes an analog of these most deep-seated origins of

189. PAUL GAUGUIN
WORDS OF THE DEVIL, 1892

human culture—by detailing a stepped progress away from brute sensory reaction to the imposition of independent, invented systems of meaning.

So when Gauguin called himself a "primitive," he meant, in part, that he created his pictures the way early humans created the first representations. Intent on repudiating Impressionism's feathery atmosphere and complex rainbow palette, he sought to validate his simplified lines and unnatural colors as the triumph of the mind over the eye, and thus as the resurgence of something universal, and primordial. His art was based, he said, on the ways people of all cultures are essentially similar, in shared structures of the mind. Such a notion of cross-cultural universals clearly runs counter to the Romantic tradition. It puts him more in the descent of the Enlightenment—and thus into a distinctive contemporary context. The revival of a strain of eighteenth-century Rationalist thought, against the grain of Romantic differentiation, had a prime importance all over the intellectual landscape of the late nineteenth century. In linguistics, it involved abandoning ranked hierarchies of more and less developed languages, and etymological explanations of meaning, in favor of examining language itself as an innate human capacity; and in anthropology, it meant ceasing to rank external differences among peoples (such as the shape of the cranium or the weight of the brain), and focusing instead on basic properties of mind underlying disparate cultures.

Gauguin's art does not depend on illustrating such ideas, and his philosophizing smacks of the autodidact's pastiche of scholarship and quackery. But if we want to understand how his attitudes toward the primitive prepare us for the advent of modern culture, these Rationalist ideals of a revival of Enlightenment principles help refute the too familiar picture of him as a simple Romantic escapist, and change some of our ideas of what gave modern artistic primitivism its initial energies.

Far from pessimistically damning the rationalism of Western modernity, for example, Gauguin in his writings stressed high hopes for the future offered by, of all things, science—"this luminous spread of science," as he called it, "which today from East to West lights up all the modern world in a way so arresting, so prodigious in its effects." His vision of science was influenced by the then trendy tenets of theosophy, but the basic notion he embraced has a distinguished ancestry. It is the idea that future progress may cure the West of the damage past progress has inflicted on it. In this view, new gains in science need not continue to divide societies, and alienate us still further from the deepest human traditions, but may instead hold out the promise of recovering the grounds of communality between cultures. We might now scorn such utopian dreams (of which Marshall McLuhan's

high-tech "global village" was one recent manifestation), but they—not simple wild-man rebellion—were what informed Gauguin's estimation of the relation between his world and that of the primitive.

If we continue to fault Gauguin for not doing what we expect he should have, we will miss what he was really up to. It has long been recognized, for example, that his Polynesian pictures are not eyewitness reports, but concoctions patched together from museum visits and art photos. He painted the Tahitians in poses borrowed from diverse sources in the art of several ages and countries, and showed them surrounded by god-figures that were either invented wholecloth or "imported" from other cultures (fig. 190). That eclecticism, usually just seen as chicanery, was more likely a kind of homespun anthropology. Gauguin's speculations about the enigmatic origins of the Tahitians, part Thor Heyerdahl and part Shirley MacLaine, followed his belief that all the great cultural systems were originally related. When he showed them with Christian halos (fig. 185, p. 184) or gestures from Javanese sculpture or Egyptian painting (fig. 192, p. 192), there is reason to believe he did so to suggest a deep, lost connection between their culture and those traditions.

190. PAUL GAUGUIN
THE DAY OF THE GOD, 1894

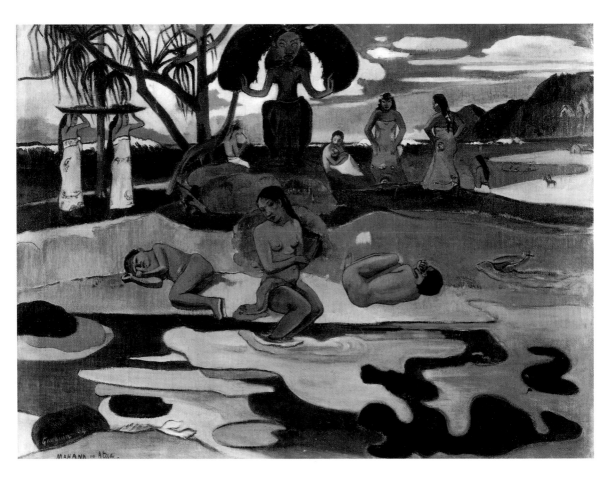

191. PAUL GAUGUIN
*THE VISION AFTER THE SERMON
(JACOB WRESTLING WITH THE
ANGEL), 1888* (FOR COLOR SEE P. 16)

A similar logic underlay his seemingly opportunistic poaching on various stylistic models. When he pasted together in one album reproductions of work by Hokusai, Giotto, and Daumier, he explained that "because they appear different," he wanted to show that they were essentially similar—that the simple economy of their draftsmanship reflected a shared dependence on conceptual schemata wired into all minds. He saw all these characters—the foreign barbarian, the archaic precursor, and the court jester—as flag-bearers of the same suppressed truth, opposed to the then-dominant reign of a naturalistic art based on miming appearances.

If we are to see Gauguin as a representative Western figure of his time, then, we might look for parallels less in Arthur Rimbaud (the young "cursed" poet who fled Paris for Africa, with whom Gauguin is often compared) and more in Aby Warburg (the idiosyncratic German scholar who founded iconographic studies in art history, with whom Gauguin is *never* compared). Warburg changed the way people thought about art, not just by analyzing the survival of certain key antique motifs in Renaissance painting, but by considering such survivals as evidence for the persistence of basic psychic investments that linked the high Western tradition to the art of primitive cultures, and also to other previously belittled expressions like children's art and popular ads. All these things (which Warburg, like Gauguin, collected in quirky pasted-up albums) were held to reflect essential forms of the human imagination. And one of the crucial experiences in forming these views was Warburg's voyage among the native Americans of the Southwest in the 1890s. His experience with Indian ritual strongly catalyzed his idea of cultural memory, and helped confirm his belief that high European art should be studied not in terms of its superior distance from

such things, but in terms of root similarities. The diverse human cultures, including Europe of the Renaissance and the twentieth century, were only truly to be understood, he reckoned, in terms of their contending with the same basic forces and issues; art history was to be a key to this investigation.

It is useful to reposition Gauguin, in this way, out of the Romantic tradition, and to associate him with some other, very different pioneers. But if all that this involved was paying attention to the artist's own rhetoric, we would have demolished one myth only to set up another. After all, no matter how sincerely Gauguin (or Warburg) may have believed in universal mental constants, nothing compels *us* to accept that notion, either as a fact or as a validation of what he did. In fact, it is not primarily these high ideals of purity, but the nuts and bolts of eclectic practice, which served those ideals, that make Gauguin a telling precursor of modern primitivism.

Gauguin was an artistic magpie ("Gauguin is always poaching on someone else's land," said Pissarro bitterly when he first saw the Tahitian canvases. "Now he's pillaging the savages of Oceania") and often a *poseur*. The eyewitness account of him first descending the gangplank in Tahiti—wearing shoulder-length hair and a cowboy hat, and carrying a Winchester, in apparent emulation of Buffalo Bill, whose show he had seen at the Paris World's Fair of 1889—by itself tempts one to swear off taking seriously anything he did there. But it is precisely this impure eclecticism that got him where he was going.

When the slide of *The Vision After the Sermon*, for instance, comes on the screen, we art historians are prone to

talk about it in two contradictory ways. On the one hand, we rehearse all the things Gauguin and his supporters said about it, and pay homage to their view that the picture's forms exemplify the power of a new art drawn more from imagination than imitation. The simplifications and unnatural color are hailed as a step away from the perceptual world toward a conceptual one, and a crucial inspiration for that move is ascribed to Gauguin's general openness to the qualities of naïve or untutored art making, as found in folk prints and provincial religious sculptures. This, the lecture often concludes, is the basis of primitivism.

On the other hand, we invariably take a knowing delight in pulling the picture apart in terms of its catholic array of debts. As we saw in chapter 2, the wrestling angel is lifted from Hokusai's *mangwa* sketchbook; the strong physiognomy of line in the women's heads was picked up from Daumier's caricatures; the striking tree branch echoes Hiroshige; the cropped foreground and collapsed space are directly modeled on Degas's theater views of the early 1880s; and both the thumb-thick outlines and the overall level of simplification doubtless owe a great deal to the "cloisonnist" style then being pursued by Gauguin's younger associate Emile Bernard.

Both these descriptions cannot be equally right. The message of the motif and the rhetoric are that art wells up from within, and that primitivism obliterates cultural walls to forge a link between what is primal inside us and what is foreign to our conventions. The observable message of the canvas, though, is that both art and primitivism can get innovative power from jury-rigging together a patchwork of borrowings. This picture is not an advertisement for purity, and if there is something "raw" or "crude" in it, it is the baling-wire and paper-clip splicing of the disparate parts. *This*, we should argue, is the real basis of primitivism.

We have seen, too, that the Tahitian scenes are similarly trumped up with borrowed elements—including even the details of "local color," such as the patterned fabrics evident in *The Spirit of the Dead Watching* (fig. 188, p. 188) and the *Ia Orana Maria* (fig. 185, p. 184). These were actually textiles made in places like Manchester and Frankfurt, with designs thought to echo South Seas style (based perhaps on what colonials had seen of indigenous dye-printed bark-cloth garments, by then all but disappeared), but considered too crude for European tastes. Regardless of whether Gauguin knew it (how could he not have?), what his pictures transmitted back to Paris as alien crafts were in fact products of a marginal strain of European design, previously thought unfit for local consumption.

But this ruse worked. Gauguin's emphasis on these vividly colored floral prints, in prominent decorative passages, directly encouraged Matisse's own still bolder use of flat pattern; just

as Gauguin's archaizing fantasies of Polynesian sculpture helped open the eyes of painters like André Derain and Picasso to the broader powers in the forms of tribal art. The evidence of these textiles, like the cobbled-together nature of *The Vision*, and all the borrowed "Tahitian" poses, might seem to prove Gauguin a corrupt forebear; and we could choose simply to exclude such episodes from discussions about genuine modern primitivism. But that would be a mistake. We are dealing with false choices here, rather than with a false prophet. It is just what seem most adulterated in Gauguin— including even those textile patterns—that are the most interesting indications of what primitivism has really been about, in a positive and authentic sense.

If we ignore what Gauguin did just because it is not what it was propagandized to be, we neglect some important lessons, to our detriment. Jury-rigging, after all, is a respectable and often very potent way to come up with something new (as we have seen in preceding chapters, a lot of modern art proves that). And we know that the modern "discovery" of non-Western art was linked in some way—we usually assume as cause to effect—with upsets in the established hierarchies of Western style. Gauguin's scrapbook alliance of Hokusai, Daumier, and Giotto involved precisely such a rearrangement of hierarchies. As a working manual—for the strategy underlying innovative pictures like *The Vision*, for example— that scrapbook might be worth holding on to. We do not have to endorse the supporting argument about shared mental constants to see that these paste-ups propose some fruitful connection between a new appreciation for strange things from far away and an altered assessment of marginal things from home. More than all his posturing "barbarity," and beyond any particular appropriation of motifs from tribal objects, this way of working itself provides the strongest links between Gauguin's role as precursor and the seemingly more authoritative, and authentic, emergence of primitivism in Picasso's art.

Of course, if an introductory student or occasional gallery visitor knows one thing about modern painting, it is likely to be that tribal art provoked the radical changes in Picasso's art around 1906–7. And anyone with slightly more acquaintance will be able to recite the full account. While painting *Les Demoiselles d'Avignon* as a bordello scene (the women are prostitutes, and figures of a sailor and a male medical student were initially involved), Picasso visited the ethnographic displays at the Trocadéro museum. Though he had likely seen African sculpture before, this particular occasion brought a stunning revelation about the magical power of such art, which in turn catalyzed a partial reworking of the picture, and yielded its most "savage" deformations, in the figures on the right side.

193. PABLO PICASSO
PORTRAIT OF GERTRUDE STEIN, 1906

194. PABLO PICASSO
SHEET OF CARICATURES, 1900

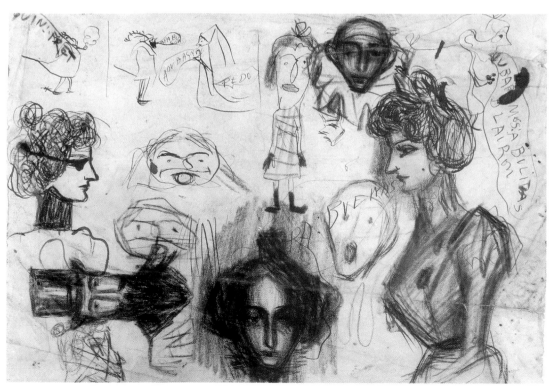

This is a wonderfully dramatic story, with terrific explanatory power, simple and demonstrable. It involves a cause-and-effect sequence, like a billiard ball hitting a pack; and for the primitive cause, the marks of primitive effect seem so shockingly self-evident that we have been incredulous at Picasso's cheek in later protesting that there was none of what he called "*art nègre*" (the then common term for African and Oceanic tribal art) in the *Demoiselles*. The story satisfies, too, some of the most cherished notions about how primitivism should work if it is authentic: by crises of emotive sympathy, to dramatically discredit and then explode Western conventions. Yet the evidence has been mounting for a number of years that this is not an adequate account of what happened—before, after, or during the conception of the *Demoiselles*.

The crucial pre-*Demoiselles* instance of primitivizing, for example, is the masklike face of the 1905–6 *Portrait of Gertrude Stein* (fig. 193, p. 195). We know that its simplifications came late in the portrait's development, without the sitter present; and the changes have usually been ascribed to influence from the crude features of ancient Iberian stone heads then in Picasso's possession. But in 1983, Adam Gopnik pointed out how closely the stylizations in Gertrude's face resemble those of caricature in general, and particularly those in the aggressive, often scurrilous caricatures that filled Picasso's sketchbooks all through his early career (fig. 194, p. 195). For Gopnik, the Stein portrait was less the ground on which primitive style conquered Western sophistication, and more the site of a psychomachia between Picasso's easel and his sketchbook—a tussle in which the energies of the painter's "low" art were allowed to rise up and transform the look of his "high" art.

A changed attitude about caricature and a new appreciation for Iberian style would have been mutually reinforcing. The question of which came first is secondary to the basic principle: what Picasso found in primitive art was not wholly new and foreign, but something that related to neglected aspects of his own work. The understanding of an alien style was fostered by reestimation of a familiar one, and vice versa. Gopnik's article was not just about the way primitivizing looks like caricature. It was about the larger proposition that we learn new things by rethinking those we already know. And one of the signal virtues of his story is that it did not treat either primitivizing styles or primitivism in general as one-way reductive moves toward essential simplicity.

The billiard-ball idea about tribal art's influence on Picasso does not allow for this kind of complexity, nor does it account for the central instances where the evidence seemed unassailable in its favor. For years, historians used to propose

one or another African mask type that most closely matched—and therefore presumably inspired—the various facial deformations in the *Demoiselles*; *quart-de-brie* (cheese-wedge) noses were identified as the source of *quart-de-brie* noses, scar patterns were found to match scar patterns, and so on (figs. 195–98, pp. 198–99). But in 1984, in connection with an exhibition on primitivism at The Museum of Modern Art, William Rubin rebuffed each of these theories one by one, demonstrating that (according to the history of exploration in and export from the particular tribal regions) none of the proposed masks could have been known by Picasso when he painted the picture.

The story could still hold up, of course, with these props gone. An influence does not have to be mimic-specific to be profound. (And even while he took some edge off the African influence, Rubin also showed, by correlations with the acrid coloring and emotional tenor of the *Demoiselles'* faces, that South Seas objects at the Trocadéro may have had more relevance.) But other evidence, in Picasso's preparatory studies for the *Demoiselles*, calls for a more substantial change in our thinking about what took place in that spring and summer of 1907.

There are three drawings that seem especially telling with regard to the masklike facial stylizations. The first is a study for the medical student, from the early stages, that has been known for some time (fig. 199, p. 199). Its scrawling, slapdash looseness sets features adrift in a manner that has as yet no inkling of any specific African influence, and that is (by the clue of the distinctive scroll ear) usually put under the umbrella of Iberian influence. One of the key aspects of the face, though, as pointed out by Rubin, has no outside source; it arises from conjunctions among the marks themselves, in the process of setting them down. The fan of lines that denotes shadow, to the left of the nose, makes an apparently untoward splice with the "profile" zig of the nose line itself, to define between them a pie-wedge shape. This wedge is a direct premonition of the *quart-de-brie* nose that, in the face at the *Demoiselles'* upper right, seemed so like the stylizations of certain African masks. And the shadow lines themselves, baldly crude as they are, are just a notch away from resembling the barred "scarification" strokes on that same face.

The same scarification is even more prominent among the studies on the second, miscellaneous sheet of drawings (fig. 200, p. 200). Here a simple little set of configurations—Vs, Ys, and enclosing ovals—is used to play a game of metamorphosis and double-entendre. The Y-configuration at the bottom seems, with its pot, to represent a plant; but then, with the enclosing line and the suggestion of lips, it is also the features of a face. Similarly, the herringbone structure at

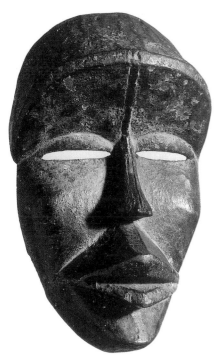

195. MASK
IVORY COAST/LIBERIA

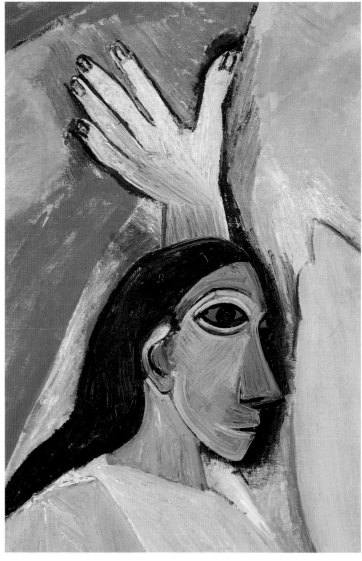

196. PABLO PICASSO
LES DEMOISELLES D'AVIGNON
DETAIL, 1907

197. PABLO PICASSO
LES DEMOISELLES D'AVIGNON
DETAIL, 1907

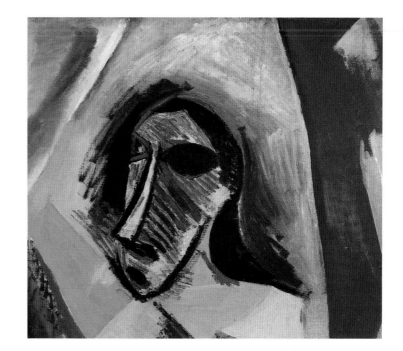

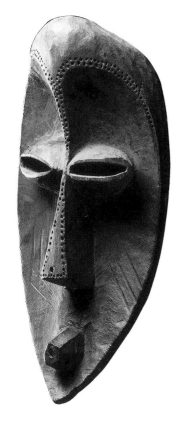

198. DANCE MASK
ETOUMBI REGION, PEOPLE'S
REPUBLIC OF THE CONGO

199. PABLO PICASSO
*HEAD OF THE MEDICAL STUDENT
(STUDY FOR "LES DEMOISELLES
D'AVIGNON")*, 1907

the center and left (which appears in other contemporary drawings as an apparent Africanizing decorative pattern on vaselike forms [fig. 201]) makes both a leaf and, with a few added parts, a face. In the central image, the diagonals of the herringbone become leaf veins, shading strokes, tracks of tears, and scarifications—and help create a face that strongly recalls those of Kota reliquary figures (fig. 202). We know that Picasso could have seen such Kota figures. But when he was asked, much later, about African influences in this particular drawing, he shrugged that these scribbles were just the kind of thing you do while you wait on the phone—doodles.

These drawings suggest how Picasso might have arrived, independently, at some of the facial stylizations formerly associated with African influence. But the most extreme passage in the *Demoiselles*, that wrenched face at the lower right, seems to resist either explanation. No one has ever proposed an African or Oceanic source in which the features were sufficiently disrupted to provide a convincing source of influence; and the tradition of caricatural exaggeration seems to hold no viable precedent. Only with the recent landmark exhibition on the *Demoiselles* at the Picasso museums in Paris and Barcelona have we been able to penetrate part of the mystery in this face, by catching up with something the English art historian John Nash recognized years ago.

200. PABLO PICASSO
MASK AND HEADS, 1907

Looking at a few then unpublished drawings, he saw that the face is really a torso in disguise.

At a crucial moment of reconsideration, Picasso took a preliminary sketch for a torso, and by the addition of a few lines, began to transform what had been the shoulders into eyes, what had been a pony tail and/or dorsal (or ventral?) cleft into a nose line, a crotch into a mouth, and the hip carriage into a jaw (fig. 203, p. 202). This was not a sudden switch, but one that produced some unlikely monsters along the way—especially the remarkable image that seems at once a woman in a two-piece bathing suit, and a face (fig. 204, p. 202). The final addition came through transforming the former line of a hip and arm into the huge claw/hand/mandible that supports the chin, and splicing the whole thing to a torso and arms facing 180 degrees in the other direction (figs. 205 and 206, pp. 202–3).

201. PABLO PICASSO
VASE FORM STUDY
1907

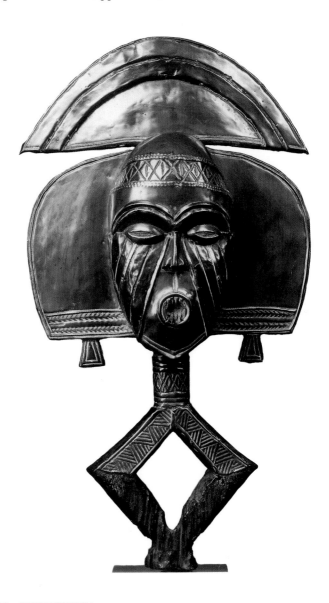

202. RELIQUARY FIGURE
KOTA, GABON

203. PABLO PICASSO
*STUDY FOR THE CROUCHING
DEMOISELLE*, 1907

204. PABLO PICASSO
*STUDY FOR THE CROUCHING
DEMOISELLE*, 1907

205. PABLO PICASSO
*STUDY FOR THE CROUCHING
DEMOISELLE*, 1907

206. PABLO PICASSO
*STUDY FOR THE CROUCHING
DEMOISELLE*, 1907

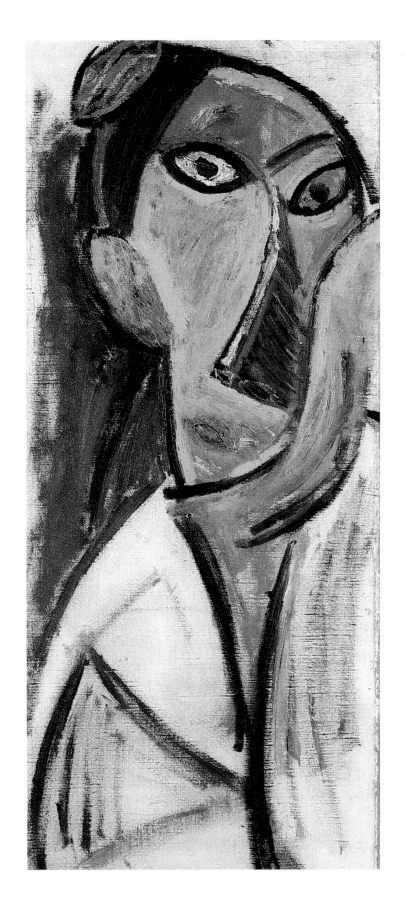

Taken together with all the evidence against any direct borrowings, and with all the other indications (as in the study for the medical student) for alternative sources within his own art, the drawings for this head seem to demand that we take much more seriously Picasso's apparently absurd claim that there was no *art nègre* in the *Demoiselles*. The visual innovations in this painting can all be explained without reference to any formal model in tribal art. Instead, they can be seen to result from his play (in the most serious sense) with the most simple, even banal, conventions of drawing. At the heart of darkness, astonishingly, lies a doodle.

This kind of primitivism is not a matter of one-way influence. It is not about simplification, either, in the sense that its radical acts do not consist in stripping art down to primal absolutes. This is further confirmed by the one formal innovation Picasso himself *did* connect, specifically, to the influence of African art. The sheet-metal *Guitar* of 1912–13 (fig. 208, p. 206) is one of the two or three most seminal works in modern sculpture; and Picasso told his dealer, Daniel-Henry Kahnweiler, that its centerpiece, the cylinder that stands for the guitar's sounding hole, had been inspired by the protruding eyes in a Grebo mask he owned (fig. 207, p. 206). When the mask and the sculpture are side-by-side (as they were in an exhibition at The Museum of Modern Art in 1984), it is plain this "influence" involved no mere form mimicry. Picasso's *hommage* to the mask shows his appreciation for a structural principle of inversion, or contradiction, that allowed something (concave, inner space) to be represented by its opposite (convex, outward protrusion).

It has been noted by Yve-Alain Bois that this structural inversion in the Grebo mask's eyes and the *Guitar*'s solid hole offers a condensed insight into how art (or any other human sign system) works, and that this insight squares with the influential revision of linguistics undertaken in the same period by Ferdinand de Saussure. One of Saussure's key points was that the signs of language, rather than holding to any intrinsic, historically determined "natural" meaning at their base (as nineteenth-century etymology maintained), get their meaning only from the system they are used in at a given time. Any sign, therefore, can be made to carry any meaning, because it is the linguistic context, the surrounding system of differences with other signs, that determines the reading. Black can mean white, a nose can represent an ear, and projecting cylinders can represent sunken eye cavities. The Grebo mask's "simplifications" did not expose for Picasso the bare bones of art's vocabulary, but they showed up, in this way, a certain wantonness at its heart.

External intellectual influence, though, hardly seems needed to explain this line of conjunction between the mask and the guitar, because it fits with the concerns of Picasso's

art over the previous four years. Ambivalence and inversion had been constant points of interest in the Cubist styles Picasso and Braque had been inventing in tandem since 1908. Taking off in part from the spatial ambiguities in the late work of Cézanne, their fractured relief-like images of 1908–9 and atmospheric Analytic Cubist canvases of 1910–11 both played constantly with double-duty marks—edges and corners that seemed both to recede into the picture and to angle out, planes that appeared to lie both behind and in front of their neighbors. And in the process of working out these paradoxical architectures that would balance space and solid, or unify motifs of different scale and distance, Picasso kept himself open to frequent in-process metamorphoses, by which things animate and inanimate could exchange roles, and still lifes become portraits, or vice versa.

This was not just a game of abstract shapes, but one that involved comically swapping physiognomies and physiques. One such interchange became a central aspect of the collage work Picasso began around the same time that he conceived the guitar: the shape play among the face, the body (especially female), and the musical instrument, typically a violin or guitar. Some poets may find that a woman is like a song, but in Picasso's earthier verse the basic curves of the female body had their rhyme in the long-necked, swelling, waist-nipped symmetry of these hand-held objects of play. And the exact same capital-B or figure-8 repeat-curves that denoted stringed instruments would be deployed to conjure, simultaneously, torsos and cheeks (of both kinds), as well as shoulders, ears, and hats, as other collages show (fig. 209, p. 207). This is a special kind of "reductiveness"—the condensed simplicity of punning, where a shape or line could be set to doing multiple tasks and representing three different things at once. It is almost certainly the way in which Picasso first saw a mask as having something to do with a guitar, and the Grebo eyes as models for sounding holes. This crucial conjunction between tribal and modern art was thus prompted by juggling Western conventions in a creative way, rather than by trying to eliminate them; and it involved the kind of simplification that multiplies meanings rather than securing or annihilating them. Here, as in the Stein portrait and the doodles, the world of low jokes intersected the heritage of advanced painting, and opened the way to understanding foreign objects.

What we see in these key Picasso works reverberates backward and forward, with implications for the way we think about the tradition of modernist primitivism that Gauguin and Picasso began, and about its relation to the deep tradition of primitivism, in its broadest philosophical and cultural ramifications. And this kind of evidence may help us get beyond the splits we sketched within primitivism's earlier history.

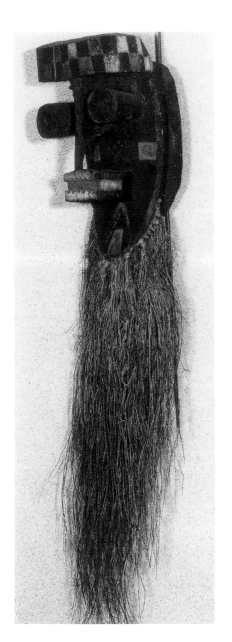

207. MASK
GREBO, IVORY COAST/LIBERIA

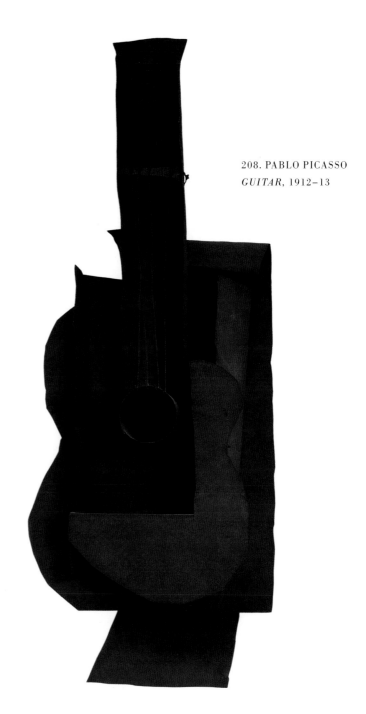

208. PABLO PICASSO
GUITAR, 1912–13

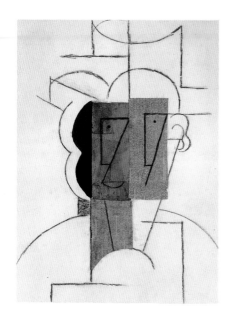

209. PABLO PICASSO
MAN WITH A HAT, 1912–13

Elements of that same Rationalist-Romantic split survive throughout twentieth-century primitivism. Artists like Paul Klee, Adolf Gottlieb, and many others (figs. 210 and 211, p. 208) have been drawn to the forms of primal signs, and the styles of tribal art, as the tokens of a universal language, evidence of common sources underlying all creativity, and signposts for modern culture to regain contact with the most basic and enduring human resources. This essentially Rationalist notion underlies many of the urges toward wholly abstract art over the past century. Conversely, other episodes in modern history have seen the most virulent assertion that art, like all other customs, is essentially the product of a culture, or a race, unique and specific—and that its task is to express the universal only as it manifests itself in the local and particular. This essentially Romantic notion had its most sinister impact on Nazi cultural thought, but is equally discernible in the emphasis on organicism in "shamanistic" work concerned with cultural specificity, like that of Joseph Beuys (fig. 212, p. 208), and in art concerned with other forms of biologically based politics, like that associated with feminism.

The dichotomy has been particularly tellingly revived, though, in theoretical battles of the past two decades. Structuralist thinking, notably in the work of the French anthropologist Claude Lévi-Strauss, took up the Rationalist strain, and looked for comparable logics beneath the behavioral differences that divided Western and tribal cultures. But more recent theories criticize this kind of thinking as shot through with European biases. They stress instead the ways separate cultures are irreconcilable. And they assert that our languages and cultural frameworks constitute prisons that keep us from knowing anything true about the minds and behaviors of others outside our domain.

Specifically in regard to primitivism, this latter outlook rejects what seems to have been the crucial modernist innovation of seeing tribal masks or idols as art—rather than, as they were held in 1906, curiosities or artifacts of natural history. It holds that since art is our own term and not one used in those societies, the "discovery" could only have been an ethnocentric mistake, involving the false appropriation of the Other into our own world view, and yielding no valid truth about these objects. In other words, this time the Romantic appreciation for difference has gone so far in refuting the Rationalist, universalist dreams ascribed to modernism that it no longer even permits us the ideals of sympathetic identification, or the dreams of escape, that were essential to the earlier Romantic view of primitivism.

But for as long as Westerners have thought seriously about tribal cultures, there has been a third tradition, embedded in countless writings of both lofty and popular pedigree, that tends to cut across the either-or choice between the

210. PAUL KLEE
INTENTION, 1938

211. ADOLPH GOTTLIEB
NOSTALGIA FOR ATLANTIS, 1944

212. JOSEPH BEUYS
*I LIKE AMERICA AND AMERICA
LIKES ME*, 1974

Rationalist and Romantic ideals. And it is this other tradition, more pragmatic than theoretically pure, that seems more in accord with what modern primitivism has actually been. Much of the West's veneration of primitive societies has involved something like science fiction, in that it embodied dreams about what humans and their society might be like under different circumstances: hypotheses, like that of the "natural" man as Noble Savage, which extrapolated their forms both from immediate experience and from the evidence of far-flung discoveries. A key genre in which such dreams and such data merged was satire—as in Montaigne's ironic praise for the superior reasonableness of cannibal customs, or in Jonathan Swift's accounts of foreign mores in fantasized lands. In such work, the imagination of the Other was inevitably built on a restructured projection of what the writer thought about his own fellows—but with new license to turn familiar values on their head, and ridicule conventions held dear, for the purpose of getting his readers to rethink themselves from an outside point of view. Throughout this tradition, an increasing tide of new information from beyond the horizon entered a complicated minuet with changing Western ideals and critiques of human nature and society. Ideas of what was in here (the basic nature of Western man) shaped what was understood of what was out there (in Tahiti, among the American Indians, and so on); and the image of what was out there in turn acted as a way to reform our vision of what could be possible locally.

What Gauguin *did* (as opposed to what he said) makes sense in this tradition. The analogizing of foreign alternatives and internal reforms is what his splicings of Java and Giotto were about; and even the boomerang impact of the flower-print cloth—from Manchester to Matisse via Tahiti—has some symptomatic role here. More important, the projection of an image of the alien by the disguised deformation of the familiar is the working strategy behind the faces in the *Demoiselles*. Gauguin and Picasso almost certainly had no awareness of belonging to a lineage of such older satirical strategies. But the way their art elevated these strategies to unprecedented power confirms on yet another level that modern primitivism did not just discover new forces from outside. It also acted to unleash the serious power in areas of Western practice that had existed all along, often as unserious marginalia.

On the most basic level, then, this tradition maintains that primitivism is first and foremost a story about us, not tribal peoples. It is not about our ability to escape our cultural ties, but it is not about being hamstrung by them either. It accepts a set of conventions as given, but sees that set as varied and volatile, and holds that we can do something to it, and with it. If what Picasso did suggests an analogy with

language, for example, it is more as playground than as prison. His work traffics in the promiscuities of puns, neologisms, and nonsense rhymes. Its affinity is with street talk and slang, where language procreates more than it proscribes.

Primitivism similarly takes the link between context and meaning as an engine, not a brake. One of its main tactics has been to use the word "art" as a movable frame that opened up new meanings in things—like tribal art, or caricature—that were stuck in contexts where habituated insensitivity or prejudice had cloistered them. And by framing these things, the idea of "art" changed, too (objects can affect the meaning of contexts, not just vice versa). This became a familiar strategy of modernism—pulling things out of their original context both to transform the way they were seen and to alter thinking about what art is. But then the strategy of dislodging things from their original environment, in order to compare and contrast them with things from other environments, is a key way science, and modern thought in general, work to gain knowledge and reform ideas.

The big question that remains, though, is what this primitivism tells us, if anything, about the tribal objects themselves. How can our representations touch any authentic truth about the Other—the makers and mentalities behind the objects of primitivism—if these representations are built from local materials and principles? The new evidence on Gauguin and Picasso seems to underline how completely our images of those outsiders are our own phantasms projected onto them. And it would thus appear more justified than ever to associate these artistic and conceptual impositions with other Western impositions, as related instances of our self-serving practice of remaking the Other in our own terms.

A logical end point of that line of thought would be to conclude that there are no possible terms with which a Westerner can represent (or even think about) other cultures truthfully. But when we fault our outsider knowledge for failing to match up with the tribesman's insider knowledge, what we are doing is generally less drastic. It involves measuring one set of terms, like those in this artistic primitivism, against the standards set by another kind of approach, like those of anthropology's field reports. In short, it involves disputes about the different ways we can know things. What modern primitivism proposes is that there is more than one way of communicating, or gaining, valid knowledge—and that the "purely formal" concerns of modern art can be bridges of connection between our sphere and what lies outside it.

Primitivism in modern art often has no grounding in textual information on the societies that produced the tribal objects it admires. It operates on the notion that what the

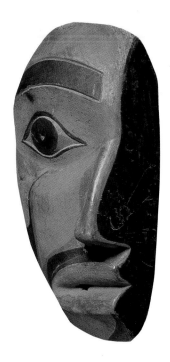

Grebo mask tells us has a validity independent of, and not inferior to, what the Grebo mask maker might say, or the field reporter describe. (The corollary is that Picasso's *Guitar* is as important and consequential a statement about language, and about us, as any lines from Saussure.) Many critics reject these premises, and validate one way of knowing over another—opting for words over forms, for the anthropologist over the artist, and above all for describing and reflecting over doing. But what the *Guitar* tells us, and even more so the experiments that led to the *Demoiselles*' faces, is that there is a valid, exceptionally potent kind of knowledge that resides in forms, and that it can be released by just doing, by attending to the possibilities stirred up by simple praxis.

Consider in this regard the connection between a remarkable split-face mask from the Northwest Coast and the head of Picasso's 1932 *Girl Before a Mirror* (figs. 213 and 214). The relation here has less to do with superficial resemblance (though with the right camera angle the two can look very much alike) than with the essential structural feature, fusing together part of a light frontal face with a darker profile. In Picasso's art, that device has a history

213. MASK
KWAKIUTL REGION, BRITISH
COLUMBIA

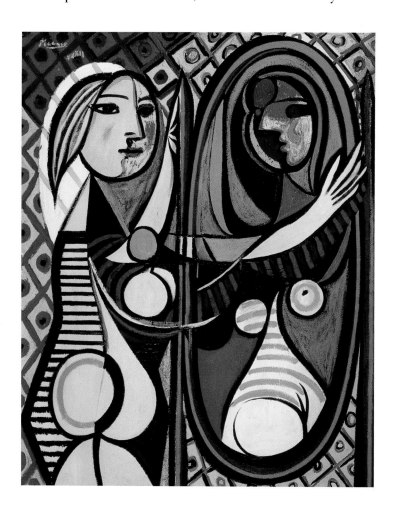

214. PABLO PICASSO
GIRL BEFORE A MIRROR, 1932

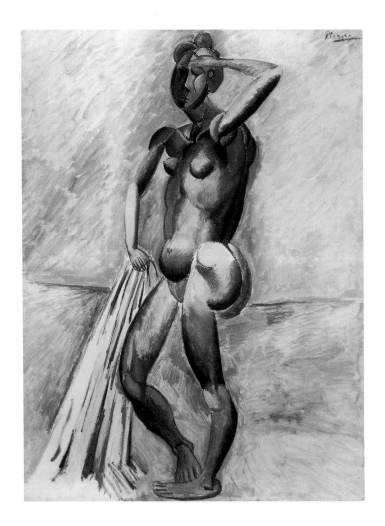

stretching back, as Robert Rosenblum pointed out, to the early stages of Cubism. It first appeared as the side effect of an overschematized division between lit and shaded sides of a head (fig. 215), in the context of the artist's experimental exaggeration and distortion of standard pictorial conventions (the same process we saw at work in the shading lines, for example, in the drawings for the *Demoiselles*).

Picasso then preserved this serendipitous find for his repertoire of new schemata, and pulled it out from time to time over the years, for various purposes (fig. 216, p. 214). The apotheosis of the device came when he saw that it could serve to convey the divided persona of his young mistress, Marie-Thérèse Walter—or more precisely his divided impressions of this girl/woman. On the one hand, she heated up Picasso's sensuality so intensely that he associated her with the yellow-orange radiating force of the sun itself (fig. 217, p. 215); and on the other, her presence was marked by a kind of passive, dreamy detachment that the French refer to as being literally "*dans la lune*" ("in the moon," somewhat like the American "spacy"). In the *Girl Before a Mirror*, the searing heat of the frontal face is bisected by the cooler, more

youthful profile. In a fashion typical of Picasso's art, the intuitions of private existence are elevated into sun-and-moon cosmic symbolism.

The device apparently served a comparable function in the conjunction of red/frontal and black/profile faces in the Northwest Coast mask. It was intended to embody the interplay between between forces of light and darkness, creation and annihilation. The connection between Picasso's painting and the tribal object on the level of representational structure is thus fused with a parallelism on the symbolic level. Yet Picasso never saw this mask, and it seems a virtual impossibility that he ever saw any other example of this quite rare and unusual type. It is also clear that the structure of the split face has a wholly independent history within his own work. Does this coincidence then have anything to do with modern artistic primitivism, and more basically, does it have any valid significance?

This is neither a case of resurfaced primal memories, nor evidence for a collective unconscious wired into all human imaginations. The crucial interest is precisely that the shared structures arose independently of each other, without traffic of influence or shared initial purpose. On one level, we could rationalize the parallels by evoking comparable rules of a game, delimited by the set of possibilities attached to representing a human head, and thus find the resemblance merely coincidental. But put this face together with the faces in the *Demoiselles*, and we have the recurrent phenomenon of exceptionally close approaches to tribal forms, arising, without tribal influence, from within modern art's praxis. They both suggest that we may get closest to the Other, not by imitation or by imaginative sympathy, or by analysis, but via bridges made from forms that arise, without fixed design or model, in the practice of remaking our own resources.

We can have no pure understanding, independent of all our contexts. In this sense, we will certainly never understand tribal objects, or peoples, on their terms. The pessimists are right about that—it is a myth, and we should give up on it. The only terms any humans have with which to understand anything are their own. But those terms are flexible things; we change them, they in turn change us. We understand alternative worlds by constructing new models. Primitivism in modern art did that. What this primitivism arrived at in terms of insight into the Other in some ultimate, god's-eye view is unknowable. But it catalyzed a revolution in our art and thinking that in turn charged with unprecedented intensity Westerners' concern for the questions of both difference and comparability within their relationship to tribal cultures previously deemed merely curious or inferior.

Certainly the Grebo or Northwest Coast mask makers would not hesitate to say that their art was both true to its

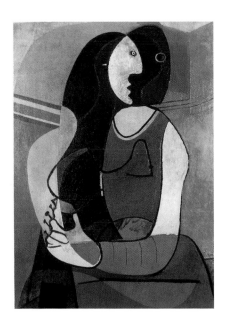

216. PABLO PICASSO
SEATED WOMAN, 1927

society and spoke about larger truths. Are we alone in history in believing that a story about us cannot be about anything else? If we ask more firmly what primitivism says about us, we may get the other answer in the bargain. Consider one final time the face of the *Girl Before a Mirror* and the Northwest Coast mask. Humans made both these things up—one out of private fantasy and abstract play with conventions, the other out of the clear dictates of a tribal belief system. Doesn't the comparison strike to the heart of some basic question we have as to whether what modern people make independently, as individuals and in a secular modern world, can ever approach the spiritual depth of the things made under the sway of the great collective systems, and with the support of stable traditions? Many of the more Romantic notions of primitivism may draw their energy, not only from the general premise that truth is to be reached only by getting outside conventions, but from the specific fear that when we gave up god and organic community, we gave up real truth. The only way to get it back, the argument goes, is by trying to regress, or by mimicking those who are still there. This want is often expressed as a rage for individual freedom, but simultaneously haunted by a desire for escape from the anxiety of openness into tribal unfreedom. Its pangs inform a significant part of the appeal of primitivism, and whole strains of primitivizing creation.

But the evidence we see here seems to say we do remarkable things on our own, precisely because of our rudderless freedom, because we are not constrained to do any one thing, or see things any one way for one fixed purpose. It suggests that we do some of our most remarkable things when a tradition of diverse conventions combines with a social consensus that allows them to be put into play, without defining what the goal is supposed to be. The evidence of this primitivism affirms that modern artists arrive at new and foreign things by reframing and recombining familiar conventions. But the larger complementary lesson, which has to do with the broader impact of these "discoveries," is that we have set up a cultural system—modern art—in which the macroequivalent of doodling, the free play with conventions independent of any fixed purpose, is encouraged because we find that the results challenge and expand us, both by altering our sense of things we thought we knew and by opening up to us avenues toward things we did not know.

It may not be fatuous to say that the *Guitar* and the faces in the *Demoiselles* are our household idols and tribal masks— no more, but no less, successful than their tribal counterparts in projecting as the image of something outside us an amalgam of locally determined conventions and broader human fears, feelings, and concepts; and no less representative, in its public function, of a shared system of beliefs about where the power behind the society lies.

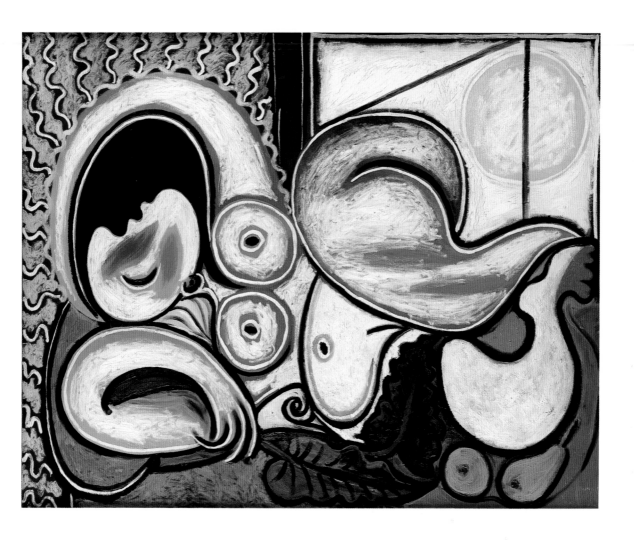

217. PABLO PICASSO
SLEEPING NUDE, 1932

We cannot go back to the certainties of tribal solidarity; reduction and regression cannot arrive at original simplicity. Our only hope for making contact with that state is to work with what we have here, and to make what we can of it. That is how Picasso helped catalyze a transformation of Western art, and of Western ideas about tribal art. When I look at that horrific face in the *Demoiselles* now, I still get shivers, but more complex ones, because it is at once so trivial and so consequential. The new explanation has made it more astonishing, not less, and more equal to the complexities of modern experience. We have had too inflated, and too impoverished, an idea of where primitivism in modern art originated, of how it worked, and of where it leads. It does not transcend modernity or flee outside it, and it is not built on the ethnocentric notion that everything has to be our way. It is grounded in self-criticism, in the recognition that there are valid other ways, and in as true a conception as we can have of Otherness. This self-consciousness, the volatile scrawl found in the heart of darkness, is the token of the losses and the gains of modernity.

215 PRIMITIVISM

FIVE

OVERVIEW:
THE FLIGHT
OF THE MIND

The points I have been trying to make in the previous chapters are simple ones, because I think simplicity is a basic aspect of modern art. When I look at its early innovations, this premise seems affirmed time and again: that between the complex and profound things that enrich our lives, open up experience, and detonate vast changes in culture and the simple things we know that are fundamental and self-evident, there is a relationship of dialogue, or of dance, not one of opposition.

Simple in this case is the opposite of reductive. I have been criticizing reductive explanations, which ascribe the advent of modern art to external influences, or ground its meaning in some arcane knowledge, because they are wrong, and because they betray and deaden one of the new art's key attributes. Simpler accounts work better with the facts, and are ultimately more challenging. It was not a momentary alignment of abstruse social forces, a catastrophic shift in the West's cultural axis, or some shock of alien influence that brought modern art into being. The key innovations were formed predominantly from resources inside our own traditions, by individuals acting on a set of options that are still available.

I should reinvoke here, though, the memory of William Webb Ellis, because his exploit, which I related at the start of this book, reminds us of the axiom that cultural innovation takes two. It requires someone understanding how the rules might be changed, and acting on and transforming those rules; but then it also takes someone standing on the sidelines to value this innovation rather than demeaning or suppressing it. In order for modern art to happen as it did, a diverse cast of spectators—fellow artists, a few collectors, a critic here and there, eventually a public—had to decide not to throw the aberrant players out of the game, but to see that their mischief redefined the way the game might be played.

On the way to dealing with that relationship between a new art and its public, I want to start with a relatively little-known painting by a relatively little-known painter, and with a critic's offhand joke about it. The painting (fig. 218, p. 218) is by the Impressionist artist and admirer of Degas we glimpsed earlier, Gustave Caillebotte, and it was shown at the Impressionist exhibition of 1882, under the title *Boulevard Seen from Above*. By the time of that show, major participants like Monet and Renoir had relaxed the intransigence of their rebel stance and gone back to showing in the official Salon exhibitions; and the public had grown a little weary of the shrill notes of scandal evoked in earlier press tirades against the Impressionists. So most writers, jaded, passed by the *Boulevard Seen from Above* without paying much attention. But one, who was a painter from Norway, looked at this picture and found it curious. This is a picture, he said, that

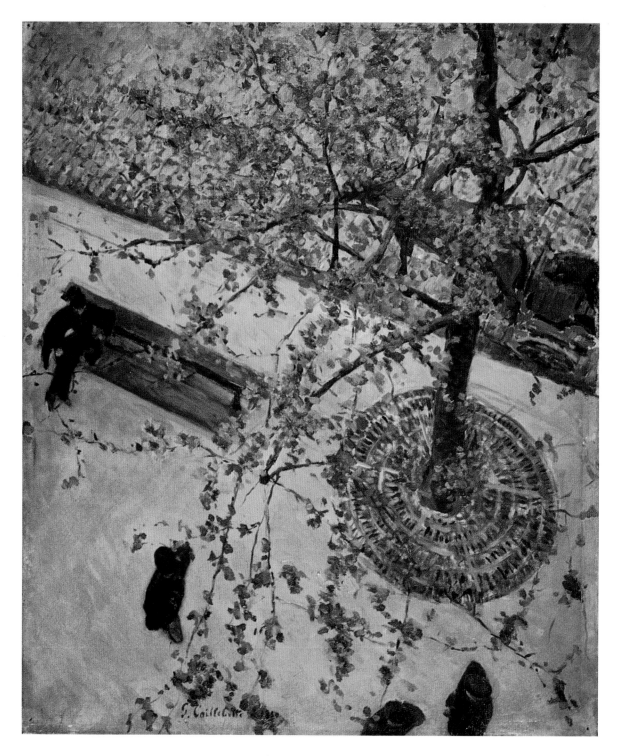

218. GUSTAVE CAILLEBOTTE
BOULEVARD SEEN FROM ABOVE, 1880

219. LÁSZLÓ MOHOLY-NAGY
UNTITLED (LOOKING DOWN FROM
THE WIRELESS TOWER, BERLIN)
1932

220. LÁSZLÓ MOHOLY-NAGY
VIEW FROM THE BERLIN WIRELESS
TOWER, 1928

should be shown on the floor: "I have seen . . . Caillebotte create a neck-breaking panorama in the wall by painting a public square from above—from the fourth or fifth floor—with a tree seen properly from its crown down and a man foreshortened from his hat. Such a thing is ultimately meaningless, if only because to work properly the painting would have to lie on the floor and not hang vertically."

There is something quite true and perceptive about this observation. Normal window-view pictures, and even the radically new pictures of Monet or Cézanne that the critic might have seen before, were continuous with his own space, in that there was an unbroken, direct axis of relation between the ground he stood on and the horizon he looked at in the picture, an axis that invited imagined movement into the picture. In Caillebotte's picture, that axis had been snapped. The picture's depicted scene had been rotated 90 degrees away from the viewer's standing orientation. The only way to imagine ourselves still in an unbroken axial relation to this picture is to see ourselves as floating above it—which the critic could do if the picture were on the floor.

After that little notice the *Boulevard Seen from Above* dropped out of the history of modern art. Caillebotte, who had been one of the most valiant participants in Impressionism's early shows, was at the time profoundly discouraged by infighting among his fellow painters, and by criticism of his work. He stopped showing, and more or less stopped painting, after the 1882 exhibition; and he died young, at forty-five, in 1894. Young, and wealthy. He had never been forced to sell his paintings while he was active, and the *Boulevard Seen from Above*, like most of his work, went back into his descendants' collection after his memorial show in 1894. It remained there, largely unseen and ignored, until the 1960s. Then it began to be shown occasionally, and reproduced; and when it was featured in the Impressionist Centenary Exhibition in 1974, people sat up and took notice. The painting that should have been shown on the floor now looked very much a part of the modern tradition, and in fact seemed way ahead of its time, prefiguring artistic developments to come, even decades later.

Caillebotte's composition seemed to be a dead ringer, for example, for photographs taken around 1930 by artists thought to be under the influence of Constructivist design (figs. 219 and 220, p. 219). There is an uncanny similarity between the 1882 painting and André Kertész's *Avenue de l'Opéra* in 1928 (fig. 221), without the slightest possibility Kertész ever knew of the painting. But Caillebotte also seemed to anticipate the kinds of pictures that his Impressionist colleague Pissarro began painting around 1898, of Paris boulevards seen from upper-story windows (fig. 222, p. 222). Pissarro's pictures had become famous for something Caillebotte had done first, and

even more aggressively: eliminating the horizon in a way that produced a "float" of shapes in the field of view. In a downward-looking view, the familiar landscape-format distribution of visual "weight"—that set heavy, earthward things low on the canvas, and made forms closer to the viewer bigger—was negated. The elements of the scene could thus be dispersed without regard for gravity or recession. This reorientation, credited to Pissarro, had been seen as foretelling the specifically modern idea of "allover," edge-to-edge composition, that reached its apotheosis in works like Jackson Pollock's drip paintings around 1950 (fig. 223, p. 223). Thus Caillebotte's precociously "photographic" picture also seemed to have taken an early, front-running step on what we referred to in chapter 2 as the Road to Flatness.

But the question these "protophotographic" and "proto-Pollock" explanations do not sufficiently address is why this innovation suddenly happened around 1880. It is the kind of childlike, fundamental question that asks why art has a history, why human representations change; because there is

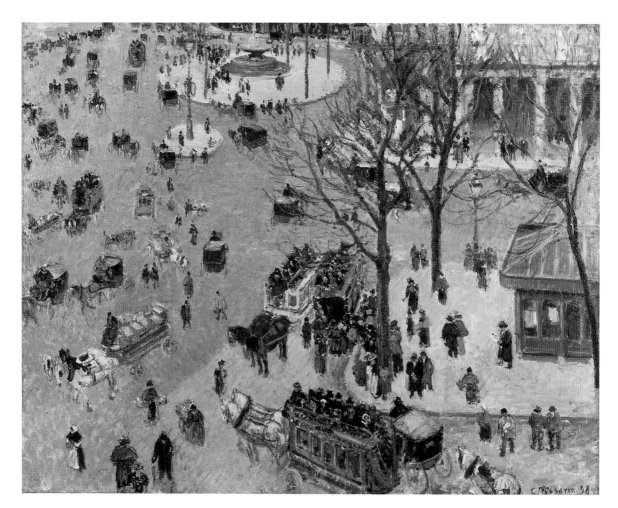

222. CAMILLE PISSARRO
LA PLACE DU THÉÂTRE FRANÇAIS
1898

nothing about this view that could not have been seen by anybody who climbed a bell tower in any medieval village, or for that matter a battlement in Babylon. Ever since there have been cliffs and people, this kind of view has been there for the taking. Why does it seem to appear out of nowhere in painting in 1880? And why does this lone spark then catch, and turn over some larger cultural engine that makes it run as a major theme in photography between the two World Wars?

Asking myself this simpleminded question led me to realize that, in fact, people did not even need cliffs to make such a picture. The basic idea of the eye in the sky is primordial, as old as the human imagination. It goes back to the Cerne Abbas Giant, in the chalk of England, or the Serpent Mound in Ohio (figs. 224 and 226, p. 224)—representations that were made by people on the ground as if they were to be seen from the heavens. Of course, these designs—theories of prehistoric spacemen not withstanding—could never actually have been seen from above. And here, as also on the Nazca plains (fig. 225, p. 224), they are not conceived as overhead views in the same sense Caillebotte's image is. The giant, laid on his back, is shown in a clearly legible, frontal fashion; and since the Ohio serpent, or the spider at Nazca, are animals that people normally look down upon, they, too, are only represented in their most legible, characteristic form.

223. JACKSON POLLOCK
NUMBER 1, 1948, 1948

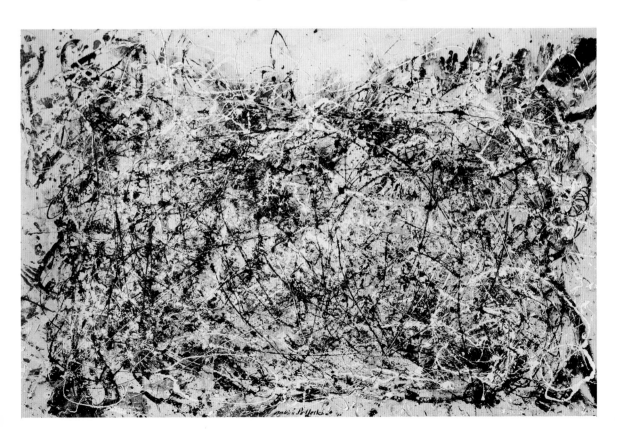

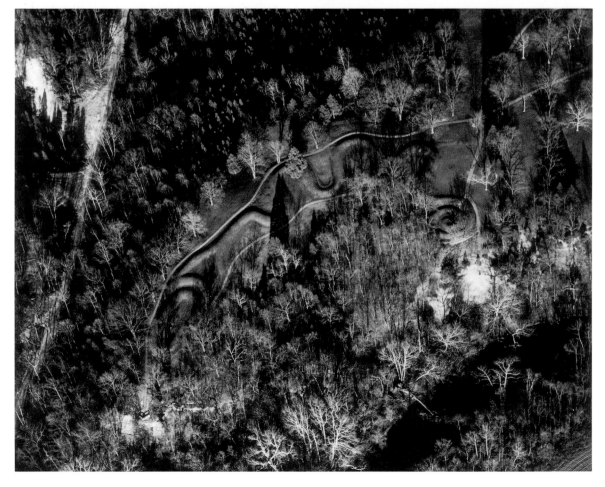

While that kind of imagined view from above is older than recorded time, the fully foreshortened overhead viewpoint—the kind that compresses a person into a hat and a set of shoulders—is a separate way of representing, with a briefer history. When we ask where Caillebotte's view came from, what is really at issue is the survival of the primordial, god's-eye vantage in this more limited context, within the history of perspectival images. Painting before perspective could include overhead views. Egyptian tomb painting did, for example—but only as part of a system of representing all things in their most characteristic, most easily legible, schematic view (fig. 227, p. 226). A pool could be drawn as in an architect's floor plan, while the trees around, and the workers within, were laid down flat, in profile—without any worry about inconsistency. It was the invention of perspective, with its mandate that everything in the picture be shown as if seen from one fixed point of view, that ruled out this kind of mix, and made the overhead conception problematic.

Perspective, as analyzed by Erwin Panofsky in a classic essay decades ago, does two different things. On the one hand it is a rational system, concerned with parsing the world out objectively, as in the gridded system of coordinates followed by the artists trying out perspective in Dürer's woodcuts (figs. 228 and 229, p. 226). But as all its coordinates are determined by one viewpoint, it also makes the form of everything depend on the way we look at it, literally—so that nothing about the views it provides is independent of subjectivity. A tension between these two impulses, to rationalize and objectify the world, and to bend it to our subjective perception at the same time, is built into perspectival representations.

At the marginal extremes of perspective's uses through the centuries—in the odd experiments that can produce strange foreshortenings akin to the people in Caillebotte's overhead view—we find, exaggerated, these two opposing strains. When Piero della Francesca drew the proportions of the head, for example, he wanted to go beyond the more familiar profile and frontal aspects, to do a fuller inventory, including the "guillotined" view from underneath (fig. 230, p. 227). No matter how strange a configuration this yielded, he wanted to demonstrate that his science, with its ability to map even the most unfamiliar configurations, had a global power of rationalization. Such exercises recur in perspective studies in the years and centuries that follow (fig. 231, p. 227).

But this quasi-scientific side of perspectival mapping is matched by another strain, evident in Mannerist works like Tintoretto's *Saint Mark Freeing a Christian Slave* (fig. 232, p. 228) or Baroque ceilings like Pozzo's *Entrance of Saint Ignatius into Paradise* (fig. 233, p. 229). Here the foreshortened people all have to do with the irrational—with

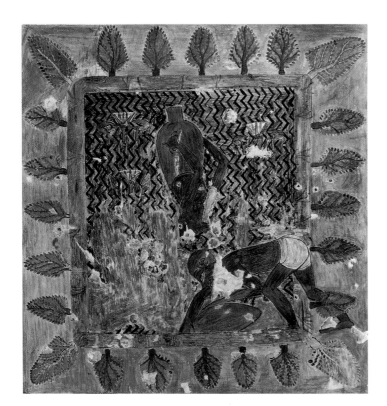

227. *DRAWING WATER FROM A POND FOR BRICKMAKING*
TOMB OF REKHMIRA, 18TH DYNASTY
EGYPT

228. ALBRECHT DÜRER
DRAFTSMAN DRAWING A LUTE, 1525

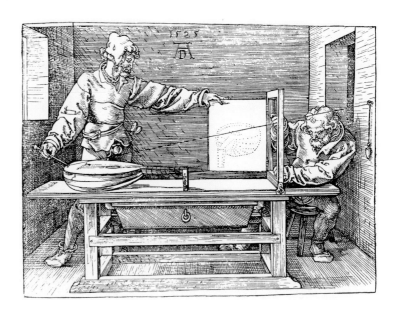

229. ALBRECHT DÜRER
DRAFTSMAN DRAWING A WOMAN
1532

230. PIERO DELLA FRANCESCA
*GEOMETRIC HEAD DESIGNS, FRONT
AND PROFILE,* CA. 1480

231. JEAN COUSIN
*METHOD OF DRAWING THE HEAD IN
THREE-QUARTER VIEW,* 1685

232. TINTORETTO
SAINT MARK FREEING A CHRISTIAN SLAVE, 1548

the drama of surprise and the flights of fantasy, the sport of grotesquerie in Mannerism and the sense of revelation in the Baroque opening to the heavens.

In the two cases, similar foreshortenings serve opposed ends, Piero exemplifying the urge to totally dominate and rationalize every point of view, and the later artists exploiting self-conscious drama, willful perversity, and the idea of the unearthly. What is special about the overhead view is the particular way it can go to both extremes at once. A plan view provides one of the very best ways to rationalize complex things, like coastlines or big buildings or odd complexes of city streets, into forms that make them instantly, easily understandable. But that same plan view, when applied to other things, like trees and human beings, produces forms that are hard to make sense of.

It is worth a small sidetrack to think about how perspective representations work, not just as a system of rendering an illusion, but as a way of thinking. Making the world intelligible, presenting it to our mind in a graspable form, is one of the things we ask representations to do for us, and it is one of the things perspective proposed to do better. Perspective's systematic coherence allows our mind to process a variety of odd shapes into regular, ordered mental schemata. When we see a funneling array of rhomboids of different sizes, the perspective system allows us to understand that what is represented is a checkerboard configuration of squares all alike: a floor receding into space (fig. 234, p. 230). Similarly, when we look at an ellipse in perspective (fig. 235, p. 230), we understand that it is the top of a cylinder, and actually has the form of circle. Perspective is in this sense a transformational system that lets our minds turn weird shapes into known schemata.

233. ANDREA POZZO
ENTRANCE OF SAINT IGNATIUS INTO PARADISE, 1691–94

229 OVERVIEW: THE FLIGHT OF THE MIND

234. IL PARADOSSO
(GIULIO TROILI DA SPILAMBERTO)
POSITION OF FIGURES IN RELATION
TO THE HORIZON, 1672

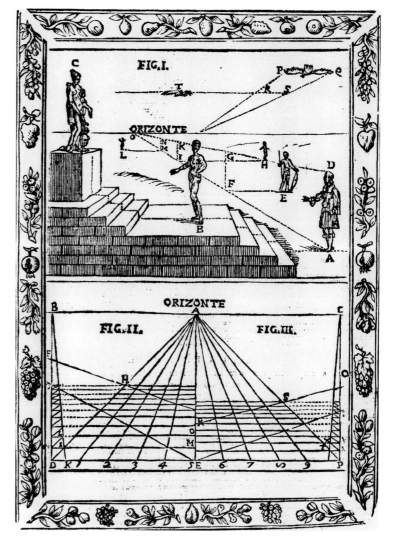

235. *PROJECTION OF A CIRCLE*
PARALLEL TO PLANE OF SPACE
DIAGRAM FROM ARMAND CASSAGNE
TRAITÉ PRATIQUE DE PERSPECTIVE
1858

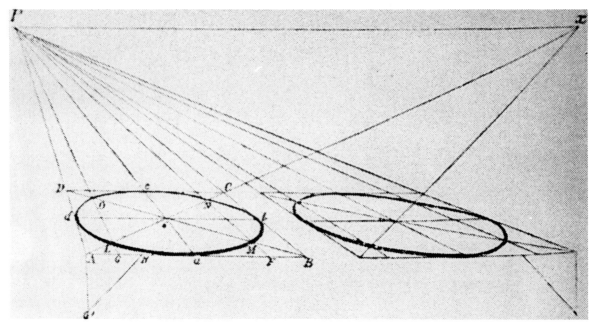

236. UMBO (OTTO UMBEHR)
SINISTER STREET, 1928

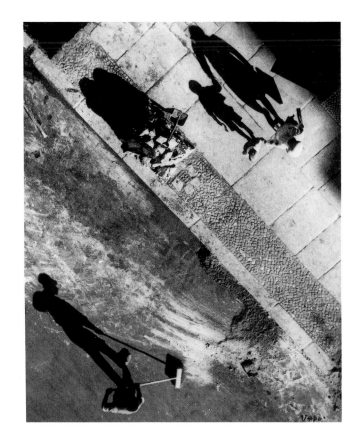

237. COVER OF WERNER GRÄFF, *ES
KOMMT DER NEUE FOTOGRAF!*, 1929

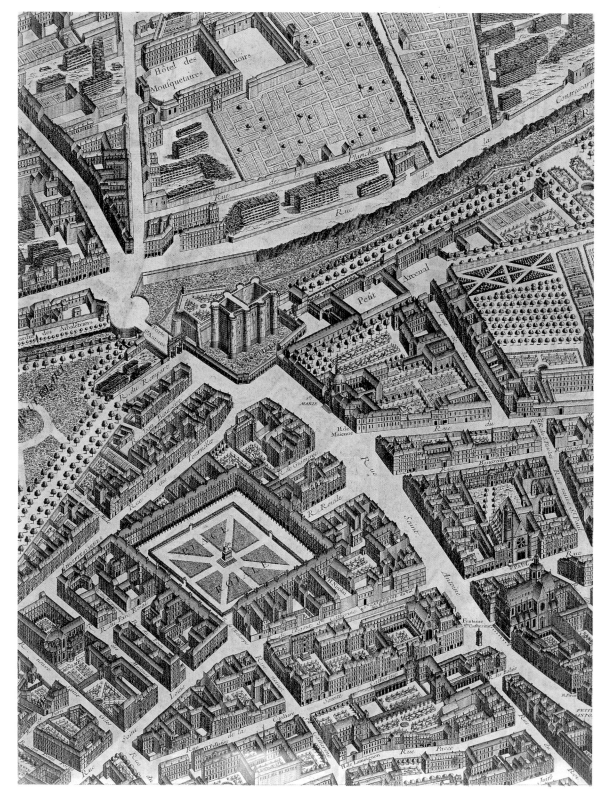

238. LOUIS BRETEZ

PLAN OF PARIS: DETAIL, 1740

239. EDOUARD-AUGUSTE VILLAIN
*PLAN FOR THE BOURSE (STOCK
EXCHANGE)*, 1849

240. EMILE BÉNARD
*PLAN FOR A TOWN HOUSE IN PARIS
FOR A RICH BANKER*, 1866

An overhead view can both intensify and subvert this function simultaneously. Dealing with a complicated building or a variegated coastline, the plan view encapsulates it for the mind, and makes the totality instantly clear in a way that triumphs over the confusions of firsthand, ground-level looking. But if that viewpoint is applied to something we habitually recognize by a profile or frontal schema—like the people we pass in the street (figs. 236 and 237, p. 231)—the result makes the mind's work of recognition more difficult, rather than less. So, while it is an excellent tool of rationalization, which helps us gain knowledge by showing things with superior economy, the overhead viewpoint is also a device for making things strange and unfamiliar in a way that opposes the brain's attempt to get a hold on them.

In order for it to be a meaningful aspect of artistic representation, these two apparently irreconcilable potentials had to find a way to come together. It is not that bird's-eye perspectives do not exist prior to Caillebotte. Relatively accurate elevated views, done wholly from imagination and perspectival plotting, were a staple of city representations from the sixteenth century on (fig. 238). And much earlier in

the nineteenth century, every academic architecture student had been required, as an act of imagination, to produce direct overhead views of buildings, both extant and fictive (figs. 239 and 240, p. 233). Within these drawings, the viewer is invited to discriminate between levels of abstraction—distinguishing, from clues like the shadows, between elements that are ideal, sectioned schemata (like columns inside) and elements that are perspectival deformations of things imagined as standing in the sunshine (like obelisks outside). This kind of clarifying vista, with its little foreshortenings as minor notes, was a perfectly banal, commonplace exercise every student did repeatedly.

The overhead view also existed elsewhere on the margins of science and art. Marey, the chronophotographer we looked at in chapter 3, recorded a running man from an overhead camera (fig. 241) as part of a program that essentially continued what we saw in Dürer's proportional drawings: charting the human form from every point of view, in order to penetrate the order of its structure. And Rodin, studying all aspects of Victor Hugo's skull in the process of making a bust, did a little sketch of the venerable literary lion seen from the top down (fig. 242; Hugo, who would not pose but allowed Rodin to observe him around the house, was doubtless a little flabbergasted when the sculptor stood over his head while he was eating dinner; and Rodin ran into more determined opposition late in life when he tried to study the papal cranium of Benedict XV the same way, from a ladder—the cardinals protested that no one was allowed to look down on the pontiff!).

The overhead view served less serious purposes, too: the other side of its possibilities, involving the unfamiliar and surprising aspect of things, had its occasional comic uses in nineteenth-century cartoons (figs. 243 and 244, p. 236). But what is missing in all these various instances, scientific or humorous, is some coming together of the two different potentials of the overhead view in such a way that the weird deformations could be, not just useful or amusing, but meaningful—in such a way that the strange could in fact have its own kind of rationality. My candidate for the first person to realize that special conjunction is a humorist and caricaturist, Jean-Ignace-Isidore Gérard, called Grandville.

Grandville published an illustrated book of satire in 1844 entitled *Un Autre Monde*—literally, "another world." In the frontispiece, the caricaturist's pen leads a fair damsel (and by implication all his readers) out of the ruins of this decrepit world. The voyages that then transpire have become justly celebrated as prefigurations of Surrealist fantasy, since the artist shows objects and plants metamorphosed into living characters in astonishing ways. Most interesting for our present concerns, though, is the way Grandville grounds some

241. ETIENNE-JULES MAREY
MAN SEEN FROM ABOVE: DETAIL
1887

242. AUGUSTE RODIN
STUDIES OF VICTOR HUGO'S HEAD
1883

243. ANONYMOUS
A BANQUET, CA. 1853

244. E. COTTIN
UNE! DEUSSE! FROM LE SIFFLET, 1874

245. J. J. GRANDVILLE
GRAND PEOPLE. FROM *UN AUTRE MONDE*, 1844

246. J. J. GRANDVILLE
LITTLE PEOPLE. FROM *UN AUTRE MONDE*, 1844

of his fantasies directly in the deformations of optics. In one of the other worlds that his pen shows us, invisible, qualitative differences, like those of rank, become monstrously concrete: people present themselves as walking embodiments of the kind of stretches and compressions we associate with fish-eye lenses or funhouse mirrors (figs. 245 and 246, p. 237). These proportions are frozen into permanent conditions of being, by which the structure of society is instantly legible. Plebeians with little rank and little money are compacted, elegant swells are enormously elongated in their high standing.

In this fantasy Grandville asserts that effects we think of as aberrant and ephemeral can be the rational, logically stable system of another world. These oddities give concrete, easily intelligible form to conditions for which there are no equally obtrusive markers (or which are deliberately veiled) in our society. Like other satires (see also pp. 250–52), this vision transposes our marginal distortions into "their" central norms, in order to make the reader reconceive his or her own world. And among the odd effects Grandville exploits in this way is foreshortening from overhead. In a dream sequence in *Un Autre Monde*, a *néo-dieu*, a kind of self-appointed demigod, flies over Paris in a balloon, and looks down. His viewpoint becomes a metaphor for what it is like to get above it all. Things that normally stand in the way of his gaze, like walls, no longer obtrude, and he is allowed an omniscient ability to see things on both sides—to his chagrin. Grandville's aeronaut sees a caped passerby outside a garden, and at the same time he sees his beloved cousin (on whom he has a crush) stealing a kiss from another lover within (fig. 247); he is hurt and disappointed.

The accompanying text deals with the feelings evoked by this elevation, as the overhead perspective becomes the emblem of a kind of moral consciousness, or literally of an outlook upon the world. It is an outlook whose detachment brings its quotients of sadness, but also the demystifying satisfactions of superior knowledge. So that when our friend drifts over the Vendôme Column and perceives Napoleon telescoped down toward the level of all the passing traffic (fig. 248), he is led to muse on the transience of glory, and the vanity of aspirations. He concludes, in a conversation with the birds, that they are correct in what they have seen all along: humans are lowly and flat.

Grandville saw that this odd way of conceiving a view, which previously had a limited set of meanings in marginal places, could serve as the expression of a particular, complex feeling for the world. He began to see that the unfamiliar and the true, the aberrant and the rational, could have a partnership in such imagery. But it took another artist to bring this kind of eccentric viewpoint further, out of the

247. J. J. GRANDVILLE
*GERTRUDE KISSING A MAN IN THE
GARDEN. FROM UN AUTRE MONDE*
1844

248. J. J. GRANDVILLE
*VENDÔME COLUMN. FROM UN AUTRE
MONDE*, 1844

domain of comedy or fantasy, into the realm of the central interests of art in the nineteenth century. That artist, it may not surprise you at all, was Degas.

On a page from his sketchbook, Degas wrote: "No one has ever done monuments or houses from below, underneath, up close as you see them when you pass by in the street." And to illustrate his point, he drew a little sketch of the Panthéon, in which the dome was diminished by the bulk of the lower part of the building as he saw it from street level (fig. 249). Obviously, this is an underview, not an overview; but the thinking it represents, about the uses of unusual viewpoints and perspectives, is crucial to the story at hand. What Degas reminds himself of in this note and this drawing is that possibilities for a new art are to be found simply by reconsidering everyday sights, and by exploiting the neglected uses of familiar systems like perspective. The conventions of depiction have falsely limited the range of what art can show about human experience, the little reminder insists; and to defeat them, we need only pay attention as we walk through the street and as we set our scenes on the canvas, instead of keeping our mind on where we are going or where we have been.

It is that determination to bring marginal and neglected aspects of experience closer to the center of art that led Degas to images such as *Miss La La, at the Cirque Fernando* of 1879 (fig. 250)—a picture that should be shown on the ceiling, or at least high on the wall. The pioneer of Realism, Gustave Courbet, had made the famous pronouncement that he would paint an angel only if he could see one; *Miss La La* can be seen as a late-Realist riposte. She is somewhat of a fallen angel, an ancillary figure from the ceiling heavens of Pozzo or Tiepolo, come out of the clouds (and out of the margins of perspective's usages) to take center stage above the sawdust. Degas moves us directly underneath this amazing performer, who hung by her teeth, and forces the view up into the

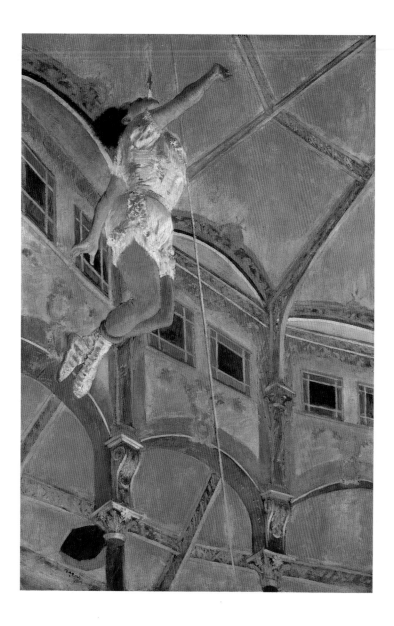

rafters. No one saw Miss La La from the rafters; her act was about ascension, and was seen from below. A Realism true to experience needed this way of showing her, no matter how strange or unconventional the result might appear.

This experimental phase of Realism—a late development that might with justice be called a Mannerist or Baroque phase of what Courbet started—is the immediate artistic context in which we should understand such things as a little sketch by Frédéric Bazille (an early member of the Impressionist group, who died in 1870) of people seen from directly overhead, with their feet poking out of their bellies and their hats wedged onto their shoulders (fig. 251, p. 242). And obviously Degas's exploration of new perspectival structures and viewpoints was a specific, immediate stimulus for Caillebotte's innovation in the *Boulevard Seen from*

Above. Like the Panthéon seen from below, this view could be understood as one of a series of attempts to ferret out the undepicted experiences of urban life in order to refresh Realism and put it in touch with a wider range of experiences.

Certainly, though, this was not just a formal play with a new aesthetic, or a clever slant on illustrating urban sights, for Caillebotte. Its invention came from a need to find the appropriate form for a set of personal meanings as well. The experience it embodied seems to have been precisely that sense of personal disengagement that would soon lead him away from the Paris art scene. The severing of continuity between his position on the balcony and the axis of the street, here and in other works of the same time (fig. 252, p. 244), was a retreat from the head-on drama of the rushing boulevards that had been his trademark just a few years earlier (e.g., fig. 253, p. 245). The view from above is an emotional as well as spatial emblem of distance, detachment, and—certainly no view better embodies the word—estrangement.

The origins of the *Boulevard Seen from Above* are, then, complex and simple. A prehistoric way of conceiving a view, carried for centuries on the peripheries of perspective, is brought to new life because an artist, cued by the formal innovations of his contemporaries, is able to see in the fabric of his everyday experience (Caillebotte lived in the apartment from whose balcony this painting was made) a motif that could be the vehicle for a specifically personal world view. Explaining the innovation in this way, by its antecedents and its immediate context, satisfies some of the questions we started with. We have seen that the overhead viewpoint has a long history in human imagination, and a special place in the

development of marginal perspectives. Its use by Grandville or by Caillebotte involved the fresh consideration of possibilities that had existed for ages, and brought to the fore a new conjunction of the conceptual and emotional implications lurking in it. But there is another part to this story, involving the way Caillebotte's picture looks forward to twentieth-century art; and it is still not clear how the connection with Nazca earth drawings or Grandville helps explain the resemblance to, say, László Moholy-Nagy's photographs of Berlin in 1928 and 1932. If we explain the *Boulevard Seen from Above* only as the culmination of a long tradition, and as part of Realism's last gasp, we are ignoring the question as to why its viewpoint became so important decades later. What makes this viewpoint not just primordial, or *fin-de-siècle*, or personal, but modern?

There is a standard way to answer this question, and explain the proliferation of the overhead view in early modern art and photography. It has to do with, in the most literal sense, getting high. By this account, the triumph of flight, and photographs taken by people in balloons and airplanes, prompted the spread of the overhead view. Caillebotte's generation looked at Nadar's views from a balloon (fig. 254, p. 246), and Moholy's was even more affected by photographs from airplanes. The overhead view would then be a by-product, following on the heels of new technologies that made it possible. People get higher, people look down, artists make views looking down—it is supposedly a causal connection.

Certainly there is evidence that seems to support this notion. Karl Struss's photographs of New York around 1911, and the famous photograph by Alvin Langdon Coburn called *The Octopus*, also of New York, in 1912 (figs. 255 and 256, pp. 246–47), seem illustrations of rhetoric about the new consciousness of modern man in multistory buildings, after the invention of the elevator. And *Blast*, the British Vorticist periodical, showed paintings of overhead city views based on photographs taken from airplanes (figs. 257 and 258, p. 247), in 1914. It is easy to believe, from such rhetoric and visual evidence, that it is simply the new proliferation of opportunities for aerial views in life that lies behind the new proliferation of aerial views in art.

But if we look at the evidence, for example, of Nadar's balloon photographs, we can see that they do not explain anything about Caillebotte; they are thoroughly and completely banal, no more radical than seventeenth-century town maps and not even as interesting as the Beaux-Arts architecture students' exercises (figs. 238 and 239, pp. 232–33). And if we look at the drawing that Nadar offered of what the world looked like from his balloon, we find that, far from being revealingly original, the scene is stolen, element by element (the passerby

252. GUSTAVE CAILLEBOTTE
RUE HALÉVY, SEEN FROM A SIXTH FLOOR, 1878

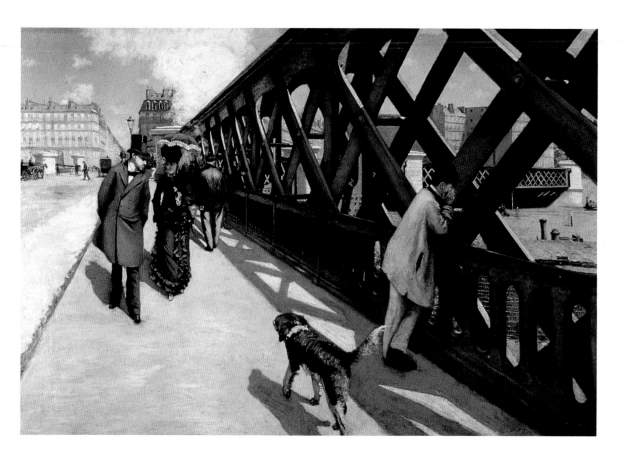

253. GUSTAVE CAILLEBOTTE
LE PONT DE L'EUROPE, 1876

254. NADAR
PARIS FROM A CAPTIVE BALLOON
DETAIL, CA. 1858

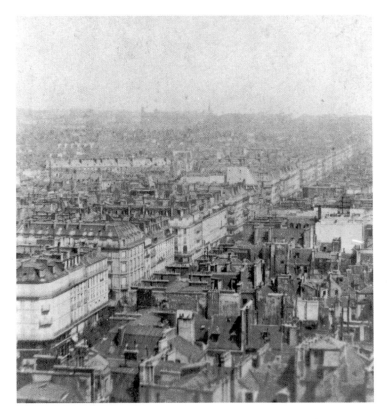

255. KARL STRUSS
OVERHEAD VIEW OF NEW YORK
CITY, CA. 1911

256. ALVIN LANGDON COBURN
THE OCTOPUS, NEW YORK, 1912

257. ANONYMOUS
AERIAL PHOTOGRAPHS OF BELMORE
AND EASTLEIGH JUNCTION, 1914

258. EDWARD WADSWORTH
ROTTERDAM, 1914

259. J. J. GRANDVILLE
STREET PERFORMERS. FROM *UN
AUTRE MONDE,* 1844

260. J. J. GRANDVILLE
VENDÔME COLUMN. FROM *UN AUTRE
MONDE,* 1844

261. NADAR
*WHAT THE WORLD IS LIKE FROM A
BALLOON,* CA. 1858

in the cape, the carriage with the straggler behind, and so on) directly from Grandville's inventions (compare figs. 259 and 260 with fig. 261).

We can forgive Nadar this little deception, but we cannot accept the explanation that he suddenly opened artists' eyes to the view from above. Even much more radically downward-looking balloon views of the 1880s (fig. 262), in their mix of flat, graphic elements and foreshortenings with shadows, essentially offer just a reprise of what we saw in architectural drawings from the 1840s. Photographs like this do not provide anything anyone could not have seen by going up the bell tower of Notre-Dame and looking down. And even as more and more such balloon photographs became available in the 1880s and 1890s, painters paid them no serious attention.

What is missing in the idea that aerial views in life produce aerial views in art is the question of meaning. It is not just the presence of available models for the overhead viewpoint, it is the symbolic meaning of that perspective that is key. We sketched out what its meaning might be for late Realism, and now we need to do the same in connection with its relevance to modernism. For that I turn again to comedy

262. AXEL LINDAHL
IDROTTSPARK FROM A BALLOON, 1898

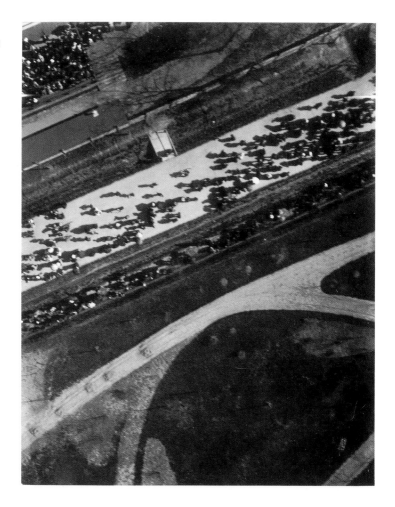

and fable—not to Grandville this time, but to a little book entitled *Flatland*, published nearly contemporaneously with the *Boulevard Seen from Above*, in 1884, by the pseudonymous author "A. Square."

Mr. Square was, in fact, a mathematician from England, Edwin A. Abbott (the doubled As in his name may have been his inspiration for the punning name "A Square"). His tale went through numerous editions in its day, and continues to fascinate mathematicians and scientists today—there is a Flatland society, not to be confused with the Flat Earth Society, that meets regularly and enthusiastically. Subtitled "A Romance of Many Dimensions," Abbott's book described a land where all movement and vision took place only in two dimensions, along a plane. Its acutely class-conscious society consisted of plane-geometric figures who, according to their differences in social rank, had more or fewer angles to them: circles were highest and most powerful, polygons were somewhat lower, and triangles that approached needle-like narrowness were the base forms of women and workers (there is a nasty streak of misogyny in the satire). This strategy of giving vividly concrete form to social differences is a conceptual updating of Grandville's encoding by optical form, or for that matter of Swift's animal societies.

263. MERCHANT AND PHYSICIAN
FROM EDWIN A. ABBOTT, *FLATLAND*
1884

264. SPHERE
FROM EDWIN A. ABBOTT, *FLATLAND*
1884

The great problem in Flatland was recognizing one of these all-important shapes advancing, when the only possible viewpoint was of its edge. Flatlanders depended heavily on fog, because the way in which a form emerged from fog—as a point only slowly widening (a sharp angle), or as a broad edge widening continuously (a sphere)—provided crucial clues (fig. 263). Color coding of fronts and backs was a further aid. To help us imagine what life is like in such a land, Abbott asks us to draw a triangle on a table, and look at it from ever lowering viewpoints until our eye is at the table's edge, and all we can see of the triangle is the breadth of a single line. This is how the Flatlander saw everything.

This limitation on perception demanded all sorts of rules and regulations, about who was allowed to feel whose angles for confirmation of rank, and who was not allowed out at night without running lights (the needle-like workers and women were not, for fear of impaling collisions). But the key event in the tale is one citizen's escape from all this. As this Flatlander related it in retrospect, he saw appearing one day in his house something that seemed to be a circle capable of shrinking and enlarging its size, and even of disappearing at will. This circle then told the befuddled Flatlander that what he was seeing was only one part of his being—that he was in fact a sphere, from Spaceland. The expanding and contracting circles were actually successive sections the 3-D sphere presented as it moved through the plane of the 2-D country (fig. 264).

The sphere tried in vain to get the Flatlander to understand that there was another world beyond his own in which things had height as well as width and depth. Finally, frustrated by the Flatlander's mistrust, the visitor from the third dimension plucked him up into Spaceland. There, miraculously, the Flatlander looked back on his house and its

265. NARRATOR'S HOUSE
FROM EDWIN A. ABBOTT, *FLATLAND*
1884

residents, in plan (fig. 265, p. 251). His entire vision of his world, and of its limitations, was transformed before he was redeposited on the plane, still flat, but with a literally raised consciousness.

Near the end, the poor little Flatlander, in frustration, taunted the sphere by asking how he, in his smug superiority, was sure that there was not a fourth dimension, and some still higher being looking down on him, as well. The sphere, naturally, thought this proposition preposterous. But it is just that possibility that the tale has really been about. Abbott wrote it as an allegory to make the (then brand-new) concepts of n-dimensional physics and the idea of a fourth dimension intelligible to a lay public. An important part of *Flatland*'s enduring appeal is the clever way it makes those abstruse things accessible in simple human terms, showing the connection between truths of experience that seem simple and ongoing and principles that seem revolutionary and timely. *Flatland* brings together Robert Burns's little wish against prideful vanity, that "wad some power the giftie gie us / To see oursels as others see us," with the loftier remark of Sir James Jeans, one of the great physicists of the twentieth century, that "the history of physical science in the twentieth century is one of emancipation from the purely human angle of vision." The ability to see ourselves as others might see us, to posit what the world and its laws might look like if observed from outside our system of references, was, after all, the crucial conceptual factor in Einstein's Theory of Relativity, which altered forever our sense of the order of the physical universe.

Flatland speaks of our bewilderment in the face of the dauntingly counterlogical, and wholly invisible, new world that modern science opens up. But the story is not just about the frustrations imposed by the narrow thresholds of what we can experience. It is also about the power of our imagination to conceive worlds beyond our ken, to put ourselves outside ourselves, and decenter our imaginations, in a way that lets us revolutionize our idea of the world, and of our place in it. The fable itself is witness to one of its central messages—that we can get a handle on very complex and consequential new ideas simply by reorienting some of our most familiar models of experience. Like the ability to look down on the world, this power is a human capacity that can be seen both as a part of a long-standing human endowment, and as a crucial aspect of modern representation. It is in that sense that I find *Flatland* helps me understand the modernity of the overhead view better than does the increased availability of photographs taken from airplanes.

It helps me rethink, for example, abstract art such as El Lissitzky's *Prouns* of around 1920 (fig. 267, p. 254), or Malevich's painting called *Airplane Flying* of around 1915

266. KAZIMIR MALEVICH
SUPREMATIST COMPOSITION:
AIRPLANE FLYING, 1915; DATED 1914

(fig. 266). These images do have something to do with flight, but they involve more than mere mimicry of aerial views: they demand a symbolic rethinking of the basic processes of conceiving a picture in relation to a viewer. When he described the progress he and his fellow artists made toward an abstract art in the 'teens, Lissitzky recalled: "The picture's one perpendicular axis (vis-à-vis the horizon) turns out to have been destroyed. We have made the canvas rotate. And as we rotated it, we saw that we were putting ourselves in space." The basic elements of that discovery—the broken axis, the spatial hovering—take us right back to the picture that should have been shown on the floor. The rotation, and the feeling of being thrown out into space, entail the loss of hierarchy. The size and position of things in a picture are no longer determined by our subjective viewpoint, but seem to float equally in a space suspended in front of us; and instead of imaginatively plummeting into the space of the picture, we

feel ourselves, without an orienting groundline, floating in space outside of it.

These Russian pictures belie simplistic separations of abstraction from content or representation, and they confound the notion that we—or artists—have to choose between attention to formal innovations and reference to the historical context of society and its technologies in which art is made. Certainly the free-floating shapes in Malevich are echoes of aerial photographs. He reproduced such views in his book *The Non-Objective World* (fig. 268) as being part of the natural environment of the abstract artist, and was thrilled by the new sensations flight could provide to man. But it is the altered sense of relationship to the world within the canvas, the immediate feeling of detachment from a given hierarchy in arranging shapes on the canvas, that does more than merely illustrate this admiration. The liberation of working with shapes in all quadrants of the image, and composing without regard to axes, gave a new feeling to the basic activity of making a picture. Translating the sensation of flight into the

268. PHOTOGRAPHS FROM KAZIMIR MALEVICH, *THE NON-OBJECTIVE WORLD* 1927

269. ALEXANDR RODCHENKO
*NON-OBJECTIVE PAINTING: BLACK
ON BLACK*, 1918

terms of a new art, it made the aerial photographs meaningful in an expanded fashion. There is a progression from a reorientation in method of conception, to a metaphoric or symbolic value of flight and liberation, to the appropriation of the evidence of the photographs.

In that attention to aerial photographs, and in the new thinking about flying above the world, we also come back to the same bifurcation we described before, when we contrasted Piero and Pozzo, for example. On the one hand, this notion of flying, or of art moving into abstraction, was expressed in terms of science, or rationalization; and on the other, it was also connected with an appreciation of the revelatory power of the weird, the deformed, and the strange. In Russian avant-garde art of the 1920s, these two poles were pushed so far apart, and exaggerated so intensely, that, in good Einsteinian fashion, they began to approach each other.

When Malevich, after *Airplane Flying*, began to paint the Suprematist pictures of the late 'teens, with their grounds of white and pure geometric shapes, he proclaimed, "I have destroyed the ring of the horizon and got out of the circle of objects . . . comrade aviators, sail on into the depths!" His sense of loosing the bonds of earth for a flight into space was consistent with the science-fiction dreams that proliferated in visionary art and writing around the Russian revolution, and with the utopian hopes that new technologies would bring a new mastery of the universe, liberating human consciousness

from mere materialism. But his detachment from earthly coordinates is so thorough that it may have more to do with Pozzo's heavens than Dürer's charts. Here the dreams of reason, the ideals of modern science's detached, objective knowledge, blur into the white light of mysticism.

Alexandr Rodchenko in his early abstract paintings (fig. 269) shared the cosmological imagery and science-fiction associations of Malevich. But his later interest in the overhead view, in his photographs of the 1920s (fig. 270), stressed an opposite aspect. There, the domains of the weird, the deformed, and the strange were his central concerns, proposed as another kind of logic, in the framework of a different kind of "scientific" analysis of experience. Rodchenko's words on this matter sound familiar:

walking through the street, one sees buildings from below. . . . [In order] to see the street with its cars and passersby. . . . One must look down from the upper stories.

270. ALEXANDR RODCHENKO
AT THE TELEPHONE, 1928

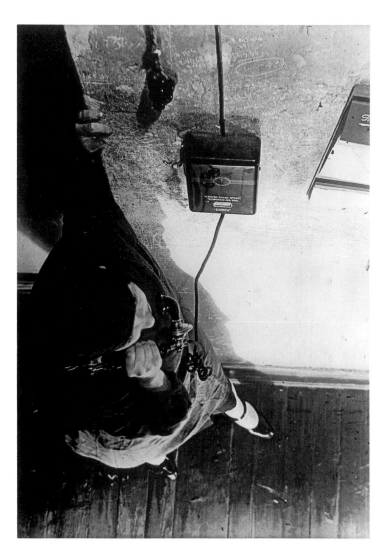

271. ALEXANDR RODCHENKO
BALCONIES, 1926

272. ALEXANDR RODCHENKO
PINE TREES IN PUSHKIN PARK, 1927

 . . . in order to teach man to see from new angles, ordinary subjects should be photographed from unusual positions.

 We do not see the stupendous perspectives, foreshortened images and positions of objects. Accustomed to seeing the usual and the banal, we have to discover the world of the visual. We have to revolutionize our way of seeing.

 Rodchenko denounced what he called "belly-button" photography—the practice of pointing the camera straight ahead from navel height. In the belly-button way of thinking, if you have to depict a fifty-six-story building, you go across the street, up twenty-eight floors, and take the picture from there. Rodchenko preferred the steeply receding perspective seen from street level (figs. 271 and 272). That preference brings us back into the world of Degas—but now with an insistent anti-Realist bent. His emphasis was not on what art could say about reality as we experience it, but on the ways art could change the way we perceive.

 Both Rodchenko and his friend the literary theorist Viktor Shklovski embraced the idea of a willfully difficult art, trafficking in the strange and the peculiar, as an essential part of the modern aesthetic. Writing around 1920, Shklovski asserted that the noblest function of art (and hence the desired goal of a new art) was not to render the world in a more easily intelligible form, but to make the world seem alien, more resistant to our familiar ways of understanding. A strategic estrangement such as forcibly widening the lag time between perceiving and recognizing would oblige us to attend to our own process of perception, and to become self-conscious about the gap between the wider possibilities in the world and the limits imposed by the blinders of our habitual expectations. (Among supporting examples from literature he cites a wonderful passage from Leo Tolstoi, in which a scene of lovemaking in the forest is described through the eyes of the woodland creatures, as if the meaning of the actions were not known.)

 Rodchenko, translating this aesthetic into photography, sought to avoid perspective's ability to make things rationally intelligible. He exploited instead its potential for producing, from familiar sights and objects, surprising, disorienting compositions and shapes. Working with the facts of the world, but remaking them in this way, the new photography (liberated by the advent of light, hand-held cameras, and encouraged by parallel developments in cinema) could be a subversive agent, acting to undermine people's accustomed ways of seeing and thinking. This was not just a recipe for mannerist amusements or perversity; it was a way for the artist to serve society, by awakening people to an expanded sense of possibilities, in the diverse ways of seeing the world, literally,

273. ALEXANDR RODCHENKO
*ASSEMBLING FOR A
DEMONSTRATION*, 1928

274. ANDRÉ KERTÉSZ
AVENUE DE L'OPÉRA, 1929

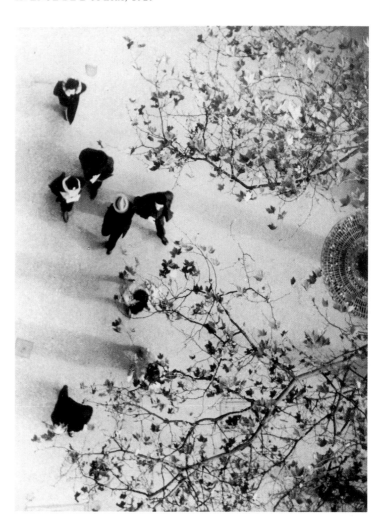

275. PHOTOGRAPH FROM
WERNER GRÄFF
ES KOMMT DER NEUE FOTOGRAF!
1929

from different perspectives. He saw this as the consciousness
of the new man, liberated from tradition, habit, and the
tyranny of conventions, and free to confront all the
possibilities around him. In this sense, a 1920s photograph of
Soviet society by Rodchenko, like *Assembling for a
Demonstration* (fig. 273, p. 260), is tied not only to a broad
history of the human imagination, and to a particular shift in
ideas about photography, but also to a specific moment of
hope and social reorganization.

It is in the context of those ambitions for a new
photography and a new society that we can understand how
something as tiny and quiet as Bazille's little sketchbook man
(fig. 251, p. 242) could become the trumpeted manifesto-
figure that appeared on the cover of a book entitled *Here
Comes the New Photographer!* in 1929 (fig. 237, p. 231). And
it is in this same context, of search for the surprising angle
and the disorienting viewpoint, that we can come to
understand why Kertész decided to picture the *Avenue de
l'Opéra* as he did in 1928 (fig. 274, p. 261). But by seeing the

resurgence of such offbeat perspectives in terms of some later modification of Degas's ideas, we still have not opened up all the meanings that underlie the "coincidental" formal similarities between Kertész's picture and Caillebotte's. We have to think deeper and harder about what Shklovski was saying, and about what the "new photographers" intended.

One of the "new photographers," Moholy-Nagy, whose overhead views of Berlin we saw before (figs. 219 and 220, p. 219), wrote a fuller, more explicit rationale for choosing such radical vantages. He explained that the camera gave renewed access to objective truth, not by showing things as we know they are, but by countering our ways of knowing. Our mind, Moholy argued, processes the world falsely, according to conventional ways of seeing to which we have become so accustomed that they are invisible and preconscious. The lens, as opposed to the eye, will not do this processing for us. If a hand or a foot is pushed toward our face, our knowledge of its

276. PHOTOGRAPH FROM
WERNER GRÄFF
ES KOMMT DER NEUE FOTOGRAF!
1929

277. FIGURE FROM ERNST MACH
*CONTRIBUTIONS TO THE ANALYSIS
OF SENSATIONS*, 1886

true size automatically diminishes the impression it makes, so that we see it in the proper scale in relation to the body. But the camera lens doesn't make this adjustment. It "sees" the approaching limb as enormously enlarged (figs. 275 and 276, pp. 262–63). Moholy asserts that these deformations provide a way for us to glimpse the world free from the filter of our expectations. The camera shows us the rawer data of the world, as we could see it before our reasoning faculties got a hold of it, and constrained it into familiar, learned patterns of comprehension.

There is a familiar ring to this belief that new technology (in this case the hand-held camera) will restore us to a primal state we left behind in the course of our development: the smartest things we do, the argument tells us, put us back in touch with the advantages we had when we did not know anything. This is part of a larger pattern of progressive-primitivist thinking that flourishes in the twentieth century (see pp. 29–32). But this particular kind of cognitive-perceptual primitivism, centered on the idea of contact with raw sensation, needs to be understood in regard to a debate about the mind that centered on the work of the late nineteenth-century philosopher-scientist Ernst Mach.

Mach propounded a doctrine known as "sensationalism," which maintained that the only external reality we can know

is just a chaos of sensations, which our minds package for us to make it manageable. He thought he knew what our brain was good for, and in his book *Contributions to the Analysis of Sensations* of 1886, he made a drawing intended to show where we would be without it. Mach drew himself, sitting in a chair, seen from his own point of view; and he included in the vista not only his hand drawing, but also his cheek, his mustache, the side of his nose, and the arch of his eyebrow above (fig. 277). He forced himself, he said, to set aside the normal way in which his mind would involuntarily frame this vista for him, in order to attend to everything he saw, including the peripheries. This, he said, was closer to what the world would look like if we could see it without our habits—or without using our brain, which for him meant the same thing.

Mach's notion of subjectivism held that the reality we normally experience is a self-edited selection from a much more diverse chaos. When we look out at a room from our chair, we have learned, unconsciously, to ignore the interfering "noise" of our nose and mustache, for example. In this parsimony, Mach finds the germ of the human mind's glory, the core of what it does best and most usefully. Human representations—the ones the brain makes for us, as well as the ones we make—serve to help us understand the world. Scientific, rationalized representations just do this more efficiently. As the mind gives us a view that edits out the nose and mustache, so science provides us with improved, streamlined descriptions of the world that refine and condense it to make its essential workings more evident.

For Mach, the highest cognitive function was a kind of economy that rendered things in shorthand and made understanding easier. Science was the mind's best work, he felt, because it provided formulas and reductive schemata that allowed us to operate on the world. If this sounds familiar, it is because we touched on the same nexus of beliefs when we discussed Duranty's Degas's interest in habit, and the fascination with efficiency and economy that motivated the science of Marey and his followers (see chapter 3). Mach's view was that the mind was like the body: in both, he thought, the friction-force of habit fused and polished disjunctive actions and associations into smoothly functioning, involuntary attributes, like gestures or ways of thinking. From that notion stems the corollary that, as this is nature's way, our goal should be to get a hold on the principle and improve it: hence the isolation of the efficient lines of least resistance is our prime tool for comprehending and manipulating the order of the world.

It is precisely that rule of the "natural" law of habit and economy against which Shklovski, Rodchenko, and Moholy rebelled. Shklovski insisted that shorthand routes to knowing and habituated, automatic patterns of understanding were

forms of enslavement, not of efficiency. Art, he argued, must be aggressively uneconomical, and counter the force of habit at every turn. Only in this way will our representations truly work for us, by rescuing us from the deadening numbness of unreflective patterns of response, and returning us to a fresh awareness of life.

The sounds of the sea vanish for those who live by its shores, as the thousand-voiced roar of the town is vanished for us, as everything familiar, too well-known, disappears from our consciousness.

. . . We are like a violinist who has ceased to feel the bow and the strings. We have ceased to be artists in everyday life. We do not love our houses and clothes, and we easily part from a life of which we are not aware.

. . . Only the creation of new forms of art can return to man the sensation of the world, can resurrect things, or kill pessimism.

. . . Automatization corrodes things. Clothing, furniture, one's wife, one's fear of war. And so that a sense of life may be restirred, that things may be felt, so that stones may be made stony, there exists what we call art.

"A dance," said Shklovski, "is a walk that is structured to be felt." The role of art is literally to bring us back to our senses. Mach's characteristically nineteenth-century idea of economy, as applied to literature, held that art worked to make difficult, complex things easy by reducing their attributes to some familiar term—saying, for example, that the sky is like a bishop's chasuble, in order to make its color vividly comprehensible. This is the opposite of what Shklovski, Rodchenko, and Moholy wanted. They wanted not to make the difficult known by rendering it familiar, but to make the familiar known anew by rendering it difficult.

This was, however, not the only critique of Mach in Russia. The rejection of sensationalist theory advanced by Shklovski and Rodchenko had to do with liberating subjectivity, but the other attack took another position. It was launched by V. I. Lenin, who wrote a book in 1909 specifically against Mach's theories, and their noxious influence. Lenin's objection was that subjectivity, with its implication of a relativity among world views, would not do for a world that needed to grasp absolute, unyielding material truths. A materialist society built on scientific principles cannot tolerate the idea that reality depends wholly on the works of mutable individual perceptions. Instead, the proper triumph of thinking, and of science (and by implication the role of art) should be to confirm the rocklike solidity of objective truths. This is how representations become useful.

It is that line of thinking that reappears in an attack on Rodchenko's odd photographic perspectives in 1928, in the magazine *Sovetskoe Kino* (fig. 278). At first these odd angles,

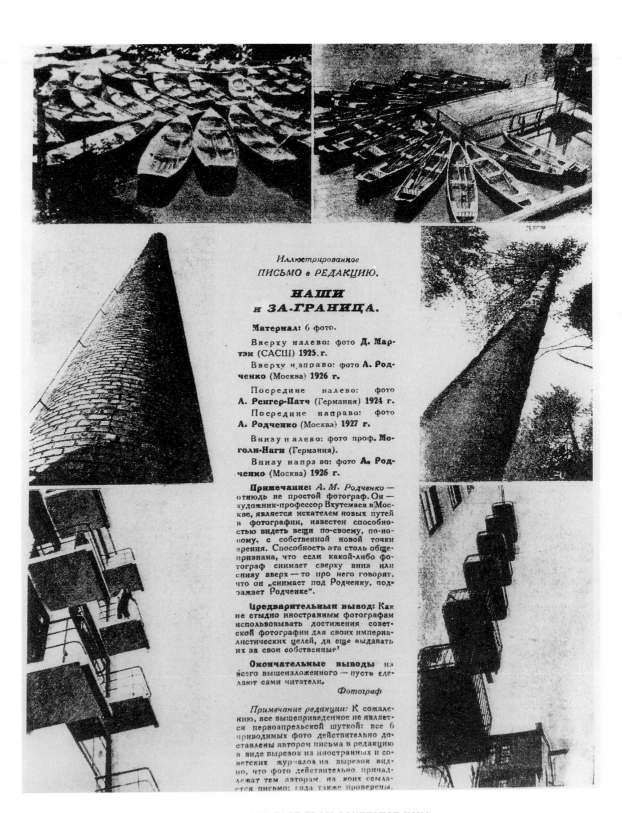

Иллюстрированное
ПИСЬМО в РЕДАКЦИЮ.

НАШИ
и ЗА-ГРАНИЦА.

Материал: 6 фото.

Вверху налево: фото Д. Мартэн (САСШ) 1925. г.

Вверху направо: фото А. Родченко (Москва) 1926 г.

Посредине налево: фото А. Ренгер-Патч (Германия) 1924 г.

Посредине направо: фото А. Родченко (Москва) 1927 г.

Внизу налево: фото проф. Моголи-Наги (Германия).

Внизу направо: фото А. Родченко (Москва) 1926 г.

Примечание: А. М. Родченко — отнюдь не простой фотограф. Он — художник-профессор Вхутемаса в Москве, является искателем новых путей в фотографии, известен способностью видеть вещи по-своему, по-новому, с собственной новой точки зрения. Способность эта столь общепризнана, что если какой-либо фотограф снимает сверху вниз или снизу вверх — то про него говорят, что он „снимает под Родченку, подражает Родченке“.

Предварительный вывод: Как не стыдно иностранным фотографам использовывать достижения советской фотографии для своих империалистических целей, да еще выдавать их за свои собственные!

Окончательные выводы из всего вышеизложенного — пусть сделают сами читатели.
 Фотограф

Примечание редакции: К сожалению, все вышеприведенное не является первоапрельской шуткой: все 6 приводимых фото действительно доставлены автором письма в редакцию в виде вырезок из иностранных и советских журналов на вырезок видно, что фото действительно принадлежат тем авторам, на коих ссылается письмо; года также проверены.

278. PAGE FROM *SOVETSKOE KINO*
1928

of seeing things from above, from below, and on the diagonal, were only sniped at as self-indulgent, and willfully perverse. But very swiftly at the end of the 1920s, they, like other forms of modern art, came to be specifically attacked as bourgeois subjectivism, antithetical to the needs of the collective state. The question of point of view, or application of normative versus marginal perspective, sparked, not only a debate about cognition and representation, but more important, a clash between two different conceptions of the relationship between individual artistic vision and collective ideas of reality. No one can be in doubt as to which side won the debate, in practical terms. Lenin's ideas, here as in other instances rapidly being absorbed into the orthodoxies of Stalin's Russia, dominated. Eventually, Shklovski no longer published, and Rodchenko was called on to photograph the building of the White Sea canal and the gymnastic exercises

279. LÁSZLÓ MOHOLY-NAGY
UNTITLED (LOOKING DOWN FROM
THE WIRELESS TOWER, BERLIN)
1932

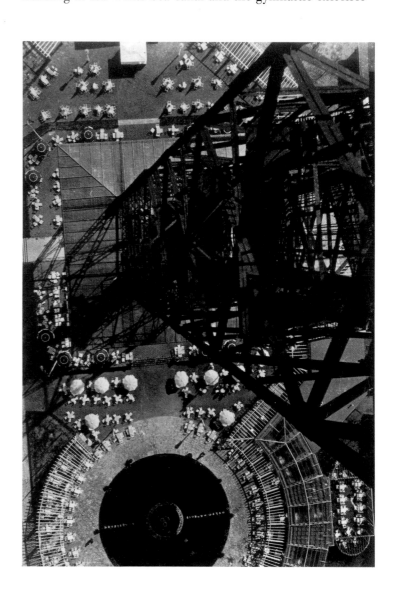

of the Soviet state of the 1930s in a more conventional fashion. The radical overhead viewpoint did not appear in his work after 1930.

This ending of the odyssey of the odd perspective refers us back to *Flatland* again, in a different way. That fable's conclusion was bitterly cautionary. When the Flatlander was redeposited back home, he found that his attempts to speak of other dimensions were held to be heretical, and subversive. He was arrested by the circles, who apparently had been aware of the alternative worlds, and had suppressed all suggestion of them. In his postscript to the tale, written from a prison cell, the Flatlander faces confinement for the rest of his life, prevented from ever communicating his vision of the world seen from outside to others, and thereby undermining the ruling order of the land.

This kind of ending, to the Flatlander's tale or to Shklovski's and Rodchenko's, helps define our focus. It underlines the need, in thinking about the overhead viewpoint as a modern device, to go beyond the formal similarities

between the Caillebotte and the Kertész, or between abstract art and new photography, and consider deeper connections that have to do with the broader spirit, and function, of modern art. Looked at in one way, a picture like Moholy's view from the Berlin wireless tower (figs. 279 and 280, pp. 268 and 269) is an emblem of all the flaws of an overzealous early modernism's "false high." Its viewpoint embodies the dream of an overweening omnipotence, of a rationalizing outlook in which science puts man in the god's-eye seat; and the rhetoric that accompanied it touts, as we have seen, the ideal of a primal purity free of all conventions—a true dream of escape, from traditions as well as mere worldly concerns.

But the history of this kind of view as we have traced it has another set of meanings, not about omnipotence, purity, and escape, but about the force of impure, secondhand things, and freedom in a different sense. In the transformation of the overhead view from an emblem of detachment and disillusionment in Grandville and Caillebotte, to one of aggressive adventure in the young artists of the 'teens and twenties, there is a capsule history of the departure from one idea of art and the arrival at another—a transition in which the negative resonances surrounding terms like self-consciousness, artificiality, and distance from nature are replaced by new positive associations. There is also a story about how a form, or a device, can have a life in art that cuts across the accepted barriers between realist and abstract representations—a life of unfolding, in which different applications reveal different potentials, each user seeing in it some variation on its possibilities.

If the story of the overhead view is about a metaphor for flight and freedom, it is clearly not about gaining the new by breaking wholly with tradition, or about abandoning all earthly concerns. This history is about how the new is made from the elements of a tradition, and about how by rethinking what we have at hand we reattach ourselves to earth, by refreshing and expanding our feeling for life's possibilities. And its central, simple metaphor, of getting outside oneself and looking back with an altered perspective, is, I think, also key to the broader symbolic meaning of the innovation of airplane flight itself for the artists of early modernism. In this sense, the overhead view as modern device, and the specific idea of modern flight, lurks within a broader domain of innovative art, even where it leaves no recognizable formal trace.

In 1912, for example, a few months before the Cubists began to reach out to include scraps of daily newspapers in their collages and assemblages, Picasso painted a still life in which a brochure proclaimed *"Not[re] Ave[nir] est dans l'A[ir]"* ("Our future is in the air" [fig. 282, p. 272]). The tricolor

brochure was a plea for France to form an air army, but its title evoked the more general sense of opened possibilities that attended the achievement of the immemorial human dream of flying. The enthusiasm for aviation affected Picasso and Braque directly. When they were working on the central, crucial inventions of modern art, in the Cubist years around 1910–12, they occasionally called each other Wilbur and Orville, taking up the (to the French quite exotic) names of the Wright brothers. This jest apparently got its start because Braque had shared adjoining newspaper billing, in 1908, with Wilbur Wright's visit to Paris to demonstrate the airplane (fig. 281). (French planes had also gotten off the ground, and gone reasonable distances, by then; but when observers saw Wilbur turn his flyer around the Le Mans racetrack, they realized that he had solved the problem of control they had not. *"Nous sommes battus"* ["We are beaten"], they said immediately: this man was able to navigate in three dimensions simultaneously, as no one had ever done before.)

What these artists, and many other people of the early twentieth century, found thrilling about the Wright brothers had nothing directly to do with the view their airplane offered from overhead. The truly astonishing thing was that two mechanics from Dayton, Ohio, had solved a problem that had beaten Leonardo da Vinci. A challenge that had fascinated man since before mythology had been licked by two tinkerers who put their machine together using bicycle parts. They not only flew, they flew where they wanted, with a confident mastery over the new technology. And they seemed to have achieved all this selflessly, the two brothers working together without the impediments of ego, in the self-abnegating pursuit of a goal.

281. REVIEW OF THE BRAQUE
EXHIBITION
AT GALERIE KAHNWEILER, 1908

EXPOSITION BRAQUE

Chez Kahn Weiler, 28, rue Vignon. — M. Braque est un jeune homme fort audacieux. L'exemple déroutant de Picasso et de Derain l'a enhardi. Peut-être aussi le style de Cézanne et les ressouvenirs de l'art statique des Egyptiens l'obsèdent-ils outre mesure. Il construit des bonshommes métalliques et déformés et qui sont d'une simplification terrible. Il méprise la forme, réduit tout, sites et figures et maisons, à des schémas géométrique à des cubes. Ne le raillons point, puisqu'il est de bonne foi. Et attendons.

Louis Vauxcelles

La Conquête de l'air

AU MANS

**Wilbur Wright gagne le prix
de la hauteur**

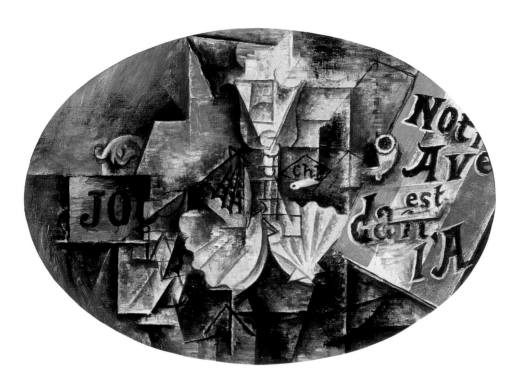

282. PABLO PICASSO
THE SCALLOP SHELL; NOTRE AVENIR
EST DANS L'AIR, 1912

283. HENRI MATISSE
HARMONY IN RED, 1908

Picasso and Braque, collaborating on the elaboration of a radically new style in Cubism, and sometimes abstaining from signing their canvases in recognition of the submerging of individualities in pursuit of a common goal, identified with this fruitful cooperation. And Cubist collage, like the Wright brothers' plane, was conceived in a spirit of invention that worked to transform the world by using what lay at hand, by seeing in parts kicking around the shop the potential that would change everything.

Even further afield, there is a way this notion of flying affected Matisse's work, too, at the time he appropriated a patterned cloth to provide the dominant motif in *Harmony in Red* (fig. 283). The painting was done in 1908, the same year Wilbur came to Paris, and the same year in which Matisse wrote an exposition of his ideas about a new art, the "Notes of a Painter." In that essay he tried to argue that "The simplest means are those which best enable an artist to express himself." And, toward the summation, Matisse allowed that

You will tell me that you could expect from a painter other views on painting, and at the end I have only brought out some commonplaces. To that I will respond that there are no new truths. The role of the artist, like that of the man of knowledge, is based on seizing hold of the familiar truths that have often been repeated to him but which will take on a novelty for him and which he will make his own the day that he senses their profound meaning. If the aviators were called to lay out their researches for us, to explain to us how they were able to leave the earth and launch themselves into space, they would give us simply the confirmation of some very elementary principles of physics that less fortunate inventors have neglected.

I could never conceive a better epilogue for these essays. But it may require insisting that these premises that served Matisse and Picasso can still serve us now. Ours is an age in which flight has come to take on much vaster dimensions, and in which the overhead views available to us (fig. 284, p. 274) can seem, like the technologies that bring them forth, to present more dwarfing visions of what we are. One response to such an age, and such views, has taken form in art works such as Robert Smithson's *Spiral Jetty* of 1969–70, no longer extant, but imprinted on the imagination of a generation by the overhead view of its photographs (fig. 285, p. 275). This large-scale mark in the semilunar vastness of the Western desert, made to be viewed from high above and self-consciously tied in symbolism to the immemorial movements of geology and astronomy, sends us (in a way Smithson was almost certainly aware) back to where we began, with the pre-

Incan lines on the Nazca Plains. This connection suggests that the true relation between modern art and the imagination of the deep past has to do with a common escape from the trivialities of individual style and urban existence into a kind of primordial anonymity of vast, collective form. Pessimistic about the corruptions of modern existence, Smithson evoked the model of the great collectivist societies of the past, and a nostalgia for a semireligious art.

I would contrast that with another kind of art conceived from above. I would think about Jackson Pollock in the late 1940s, working in a barn-like studio on Long Island. Standing over the paint splatters on his floorboards, he decided that if he took the canvas he was working on off the wall and put it down on the floor (fig. 286, p. 276), he could make of his art the kind of dance that was a walk that was felt. He could get into his work a kind of new motion and freedom, and get free of the tangled conflicts of a troubled Surrealism that had marked his work in the years before. Instead, he could produce a new kind of painting that was expansive and lyrical, with a new kind of space to it. What he produced was the kind of painting that would detonate a change in the art of the United States and Europe from thence forward, a new sense of scale and possibilities. Simply by the transformation of his way of working, of his relationship to the picture, by

284. *AFRICA AND OTHER AREAS OF THE EARTH SEEN FROM THE APOLLO 17 SPACECRAFT*, DECEMBER 1972

285. ROBERT SMITHSON
SPIRAL JETTY, 1969–70

286. HANS NAMUTH
JACKSON POLLOCK PAINTING, 1950

the act of newly seeing the possibilities on the floor of his studio as something he could work with, Pollock made an innovation that gave others, including Smithson, a new set of permissions.

But the central kind of permission such art still gives artists, I think, is the permission to pay attention to what they are doing, in the way that Rodin did when he looked at the fragments in his studio, in the way that Degas did when he looked at his drawings and saw the possibility of montage—or in the way William Webb Ellis did when he looked down at the ball.

There is a linkage between Caillebotte in 1882 and Pollock in the 1940s, but it is not just a matter of the Road to Flatness. It involves something deeper, a modernist tradition that has to do with something very simple. It has to do with basic operations of the human mind, that have the effect of making the world anew by bringing us back to familiarity with it, by paying attention to what we are doing. These are the things that I think Pollock activated standing there in the studio in the late '40s, and they are essentially the same things that Caillebotte understood when he walked out onto his balcony around 1880 and looked over. They echo what William Webb Ellis demonstrated in 1823: that if you want to do something really important, the answer is not over the horizon. It is often right under your nose, lying right at your feet. And what the modern tradition says is that you do not get anywhere by kicking that around. You pick it up and run with it.

NOTES

ONE / INTRODUCTION

PAGE 13, LINE 9
within the mind

For the history of Impressionism described in terms of a "discovery" model, see John Rewald, *The History of Impressionism* (New York: The Museum of Modern Art, 1946; 4th, rev. ed., 1973). On the Post-Impressionists' theories of art based on mental (as opposed to perceptual) forms, see Filiz Eda Burhan, "Vision and Visionaries: Nineteenth Century Psychological Theory, the Occult Sciences, and the Formation of the Symbolist Aesthetic in France." Ph.D. dissertation, Princeton University, 1979.

PAGE 14, LINE 2
Western taste

For a general selection of manifestoes and early theoretical arguments for modern art see among other sources: Herschel B. Chipp, with Peter Selz, and Joshua C. Taylor, eds., *Theories of Modern Art: A Source Book by Artists and Critics* (Berkeley and Los Angeles: University of California Press, 1968); *Abstraction; Towards a New Art: Painting 1910–20* (London: The Tate Gallery, 1980); *Towards a New Art: Essays on the Background to Abstract Art, 1910–20* (London: The Tate Gallery, 1980). Specifically on ideas of early modern art's engagement with matters spiritual, see *The Spiritual in Art: Abstract Painting 1890–1985*, organized by Maurice Tuchman with the assistance of Judi Freeman, in collaboration with Carel Blotkamp et al. (Los Angeles: Los Angeles County Museum of Art; New York: Abbeville Press, 1986); and in relation to ideas of higher mathematical and physical order, see Linda Dalrymple Henderson, *The Fourth Dimension and Non-Euclidean Geometry in Modern Art* (Princeton, NJ: Princeton University Press, 1983).

PAGE 14, LINE 17
on a flat plane

The theory of modern painting's progress referred to here is that of the critic Clement Greenberg, summarized most succinctly in his essay "Modernist Painting," in *Arts Yearbook*, 4 (New York: Arts Digest, 1961), pp. 101–8. This same vision of modernism informs many of the essays reprinted in Greenberg's *Art and Culture* (Boston: Beacon Press, 1961). The primary refutation of Greenberg's views is to be found in Leo Steinberg's essay "Other Criteria," in his *Other Criteria* (New York: Oxford University Press, 1972), pp. 55–91. Greenberg's ideas are often taken to have been strongly conditioned by his earlier engagement with a Marxist view of history; and recent writers on art who share a materialist, left-oriented vision have been concerned to chart what they see as the ambitions and failings of Greenberg's intellectual trajectory. See the exchange between Greenberg and T. J. Clark in Benjamin H. D. Buchloh, Serge Guilbaut, and David Solkin, eds., *Modernism and Modernity: The Vancouver Conference Papers* (Halifax, NS: The Press of the Nova Scotia College of Art and Design, 1983).

PAGE 15, LINE 19
rural underclasses

For new views of the social subject matter of Impressionism see Paul Hayes Tucker, *Monet at Argenteuil* (New Haven: Yale University Press, 1981) and Robert L. Herbert, *Impressionism: Art, Leisure and Parisian Life* (New Haven and London: Yale University Press, 1988). On the political realities of Brittany in Gauguin's day, see Fred Orton and Griselda Pollock, "Les Données bretonnantes: La prairie de représentation," *Art History*, 3, no. 3 (September 1980), pp. 314–44.

PAGE 15, LINE 43
middle-class strollers

The analysis of the *Bar* to which I refer is that of T. J. Clark. See his *The Painting of Modern Life: Paris in the Art of Manet and His Followers* (New York: Alfred A. Knopf, 1985). Clark also discusses the Seurat *Grande Jatte*, pp. 261, 263–67. On the Seurat painting, see also Richard Thomson, "*La Grande-Jatte*, the 'Manifesto Painting,'" in *Seurat* (Oxford: Phaidon Press, 1985), pp. 97–126; and the several articles in a special edition of *The Art Institute of Chicago Museum Studies*, 14, 2 (1989).

PAGE 17, LINE 9
interpretive path

For the "failure" of *Olympia*, see T. J. Clark, "Olympia's Choice," in *Painting of Modern Life*, pp. 79–146; and the same author's articles, "Un réalisme du corps: *Olympia* et ses critiques en 1865," *Histoire et Critique des Arts*, no. 4–5 (May 1978), pp. 139–55, and "Preliminaries to a Possible Treatment of *Olympia* in 1865," *Screen*, 21, no. 1 (Spring 1980), pp. 18–41.

PAGE 18, LINE 1
admirers

For arguments regarding the interaction between Pollock's paintings (and Abstract Expressionism in general) and efforts at international self-advertisement by the United States in the 1950s, see "History: Representation and Misrepresentation—The Case of Abstract Expressionism"; articles by Max Kozloff, Eva Cockroft, Serge Guilbaut, et al., in Francis Frascina, ed., *Pollock and After: The Critical Debate* (New York: Harper & Row, 1985), pp. 91–183.

TWO / NEAR AND FAR

PAGE 25, LINE 18
exclusively

Greenberg, "Modernist Painting," pp. 101–8, and the same author's *Art and Culture*. See notes to p. 14, l. 17, above.

PAGE 27, LINE 1
point of view

For treatments of the origins of perspective in Western art, see John White, *The Birth and Rebirth of Pictorial Space*, 3d ed. (Cambridge, MA: Belknap Press of Harvard University Press, 1987); and Samuel Y. Edgerton, Jr., *The Renaissance Rediscovery of Linear Perspective* (New York: Harper & Row, 1976).

PAGE 29, LINE 12
supposedly adopted

Among the volumes devoted to making these and other arguments for the influence of photography on painting, and on modern vision, see Aaron Scharf, *Art and Photography* (London: Allen Lane, 1968); see also Van Deren Coke, *The Painter and the Photograph: From Delacroix to Warhol*, 2d rev. and enl. ed. (Albuquerque: University of New Mexico Press, 1972); and Erika Gysling-Billeter, *Malerei und Photographie im Dialog: von 1840 bis heute* (Bern: Benteli, 1977).

PAGE 29, LINE 26
in the 1860s

The literature treating the influence of Japanese art on Western art is too diverse and extensive to sum up here. See the bibliography provided in Chisaburo F. Yamada, general ed., *Dialogue in Art: Japan and the West* (Tokyo: Kodansha International; New York: Harper & Row, 1976). For an overview of the problems involved and of some recent contributions, see Henry Adams, "New Books on Japonisme," *Art Bulletin*, 65, no. 3 (September 1983), pp. 495–502. A taste of the influence argument in the extreme form can be had in Siegfried Wichmann, *Japonisme: The Japanese Influence on Western Art in the 19th and 20th Centuries* (New York: Harmony Books, 1981). The most recent treatment of the subject is *Le Japonisme* (Paris: Editions de la Réunion des Musées Nationaux, 1988). On Japanese influence specifically on printmakers, see Colta Feller Ives, *The Great Wave: The Influence of Japanese Woodcuts on French Prints* (New York: The Metropolitan Museum of Art, 1974).

PAGE 34, LINE 25
camera devices

On the marginal traditions of perspective usage that prefigure the kind of imagery we associate with photography, see Peter Galassi, *Before Photography: Painting and the Invention of Photography* (New York: The Museum of Modern Art, 1981).

PAGE 34, LINE 34
in themselves

On the camera obscura, see Helmut Gernsheim, *The Origins of Photography*, rev. 3d ed. (New York: Thames and Hudson, 1982). As this present volume goes to press, a new book is about to appear that will more thoroughly treat the history of exceptional optical and perspectival experiments in representation: Wolfgang Kemp, *The Science of Art: Optical Themes. Western Art from Brunelleschi to Seurat* (New Haven: Yale University Press, 1990).

PAGE 34, LINE 45
with its help

For a discussion of Canaletto's use of the camera obscura, see K. T. Parker, *The Drawings of Antonio Canaletto in the Collection of His Majesty the King at Windsor Castle* (Oxford and London: The Phaidon Press, [1948]), pp. 24–26.

PAGE 42, LINE 6
geometric constructions

See Arthur K. Wheelock, Jr., review of *Architectural Painting in Delft*, by Walter A. Liedtke (Doornspijk: Davaco Publishers, 1982), *Art Bulletin*, 68, no. 1 (March 1986), pp. 169–72; and response, Walter A. Liedtke, "Letter about a Review," *Art Bulletin*, 68, no. 4 (December 1986), p. 690.

PAGE 56, LINE 13
Western vision

See note to p. 29, l. 26, above. Also, for a diverse anthology of articles discussing new ideas about Japonisme as a phenomenon in Western art, see Chisaburo F. Yamada, general ed., *Japonisme in Art: An International Symposium* (Tokyo: Committee for the Year 2001 and Kodansha International, 1980).

PAGE 56, LINE 37 *series of prints*	Hiroshige, *One Hundred Famous Views of Edo*. Introductory essays by Henry D. Smith II and Amy G. Poster; commentaries on the plates by Henry D. Smith II; Preface by Robert Buck (New York: George Braziller/The Brooklyn Museum, 1986).
PAGE 57, LINE 14 *optical space*	For a discussion of these early perspective experiments, see Naruse Fujio, "Edo kara Pari e," *Kikan geijutsu*, 11, no. 1 (Winter 1977), pp. 86–105. I am grateful to Henry Smith for steering me to this article.
PAGE 66, LINE 7 *language*	For a full discussion of this extraordinary series of views, see Hokusai, *One Hundred Views of Mt. Fuji*. Introduction and commentaries on the plates by Henry D. Smith II (New York: George Braziller, 1988).
PAGE 71, LINE 8 *sold nearby*	Ibid., commentary accompanying plate 86.
PAGE 73, LINE 4 *of the place*	Ibid., commentary accompanying plate 56.
PAGE 77, LINE 35 *Impressionist"*	John Rewald, ed., *Camille Pissarro: Letters to His Son Lucien* (Santa Barbara and Salt Lake City: Peregrine Smith, 1981), p. 263.
PAGE 80, LINE 24 *every picture*	The comparison of Degas's variants on the rehearsal scene reproduced here was first made by John Rewald, in "The Realism of Degas," *Magazine of Art*, 39, no. 1 (January 1946), pp. 13–17.
PAGE 85, LINE 26 *either norm*	See the latest summary of evidence on the origins and content of Degas's *Woman Leaning Near a Vase of Flowers*, in *Degas* (New York: The Metropolitan Museum of Art; Ottawa: National Gallery of Canada, 1988), pp. 114–16.
PAGE 88, LINE 26 *(fig. 86, p. 91)*	Gauguin's debt to Degas in the *Vision After the Sermon* and elsewhere is elucidated by Mark Roskill in his *Van Gogh, Gauguin and the Impressionist Circle* (Greenwich, CT: New York Graphic Society, 1970).
PAGE 88, LINE 38 *(fig. 89, p. 93)*	See my discussion of Munch's debts to Norwegian naturalist painting of the 1880s in "Christian Krohg and Edvard Munch," *Arts Magazine*, 53, no. 8 (April 1979), pp. 88–95.
PAGE 95, LINE 6 *urgency*	For a discussion of the *Indian Bird* series, see William Rubin, *Frank Stella, 1970–1987* (New York: The Museum of Modern Art, 1987), pp. 59–93.
PAGE 98, LINE 20 *decorative boxes*	My information on Stella's contacts with the decorative boxes made from scrap metal comes from a personal conversation with the artist's host in India, Anan Sarabai.

THREE / FRAGMENTATION AND REPETITION

PAGE 103, LINE 25 *materialism*	My comparison of Degas and Mondrian images is taken from Meyer Schapiro, "Mondrian: Order and Randomness in Abstract Painting (1978)," in *Modern Art, 19th & 20th Centuries: Selected Papers* (New York: George Braziller, 1978), pp. 239ff.
PAGE 103, LINE 37 *illusory appearances*	A representative assertion about Brancusi's art comes from the artist himself: "Those who speak of abstraction when contemplating my sculpture are completely off the track and prove that they have understood nothing and never will. For what my work is aiming at is above all realism: I pursue the inner, hidden reality, the very essence of objects in their own intrinsic fundamental nature; this is my only deep preoccupation." Quoted in Radu Varia, *Brancusi* (New York: Rizzoli, 1986), p. 256. For further texts of this nature, see notes to p. 14, l. 2.

PAGE 103, LINE 46
process

For a taste of the ascetic claims made by and for the Minimalist artists, see Gregory Battcock, ed., *Minimal Art: A Critical Anthology* (New York: E. P. Dutton, 1968); for an overview of modern sculptural history seen through this aesthetic, see Robert Morris, "Notes on Sculpture, Part I," *Artforum*, 4, no. 6 (February 1966), pp. 42–44, and "Notes on Sculpture, Part II," ibid., 5, no. 2 (October 1966), pp. 20–23. A similar aesthetic informs William Tucker, *Early Modern Sculpture* (New York: Oxford University Press, 1974).

PAGE 108, LINE 7
others since

For an old-line Marxist view of modern art forms responding to the new pace and social structures of modernity, see Arnold Hauser, *The Social History of Art* (New York: Alfred A. Knopf, 1951), 2, pp. 869–978. For more recent materialist views, in which the formal innovations of Impressionism are tied to the new social conditions of the day, see the works of T. J. Clark and Robert Herbert, cited in the notes to p. 15, l. 19 and l. 43, above.

PAGE 112, LINE 17
chemistry

Claude Bernard, *Introduction à l'étude de la médecine expérimentale*, (Paris: Baillère, 1865). On the background to Bernard's work, see Leszek Kolakowski, *Positivist Philosophy from Hume to the Vienna Circle*, trans. Norbert Guterman (New York: Penguin, 1972; original Polish edition: Warsaw, 1966); D. G. Charlton, *Positivist Thought in France During the Second Empire 1852–70* (Oxford: Clarendon Press, 1959); Maurice Mandelbaum, *History, Man and Reason: A Study in Nineteenth Century Thought* (Baltimore: The Johns Hopkins Press, [1971]). Specifically on Claude Bernard, see: J. M. D. and E. Harris Olmsted, *Claude Bernard & the Experimental Method in Medicine* (New York: H. Schuman [1952]), and Reino Virtanen, *Claude Bernard and His Place in the History of Ideas* (Lincoln: University of Nebraska Press, 1960).

PAGE 112, LINE 41
motion

On Marey, see: François Dagognet, *Etienne-Jules Marey* (Paris: Hazan, 1987); Michel Frizot, *La Chronophotographie* (Beaune, Côte-d'Or: Chapelle de l'Oratoire, 1984); Frizot, *Etienne-Jules Marey* (Paris: Centre National de la Photographie, 1984); Aaron Scharf, "Marey and Chronophotography," *Artforum*, 15 (September 1976), pp. 62–70. For Marey's role in the history of graph-making, see Edward R. Tufte, *The Visual Display of Quantitative Information* (Cheshire, CT: Graphics Press, 1983).

PAGE 113, LINE 5
conventions

On Muybridge, see: Robert Bartlett Haas, *Muybridge: Man in Motion* (Berkeley: University of California Press, 1976), and Anita Ventura Mozley, *Eadweard Muybridge, the Stanford Years, 1872–1882*, rev. ed. (Stanford, CA: Department of Art, Stanford University, 1973).

PAGE 117, LINE 4
develops"

The quotations here are from "Du roman," *Le Réalisme* (November 15, 1856), p. 6, and from Duranty, *La nouvelle peinture: A propos du groupe d'artistes qui expose dans les galeries Durand-Ruel (1876)*, new ed. Paris: Floury, 1946; English trans. reprinted in Charles S. Moffett, ed., *The New Painting: Impressionism 1874–1886* (San Francisco: The Fine Arts Museums of San Francisco, 1986), pp. 38–47. On Duranty, see: Louis Edouard Tabary, *Duranty 1833–1880: Etude biographique et critique* (Paris: Les Belles Lettres, 1954), and Marcel Crouzet, *Un méconnu du réalisme: Duranty (1833–1880)* (Paris: Nizet, 1964).

PAGE 117, LINE 6
studies

Degas once made a note to himself to "Make of the *tête d'expression* (in academic parlance) a study of modern feelings. It is Lavater, but a Lavater more relative, as it were, with accessory symbols at times. Study the observations of Delsarte on the expressive movements of the eye. Its beauty should be only a certain physiognomy." For original version, see "Notebook 23, p. 44" in Theodore Reff, *The Notebooks of Edgar Degas* (Oxford: Clarendon Press, 1976), 1, p. 117. The statement (in English) is given a full discussion in Theodore Reff, *Degas: The Artist's Mind* (New York: The Metropolitan Museum of Art/Harper & Row, 1976), pp. 217ff.

PAGE 118, LINE 1
(fig. 112, p. 116)

The back view of *The Impresario* reproduced here, while accepted by other Degas scholars, has been attributed to James-Jacques-Joseph Tissot by Richard Thomson. See his "Degas Literature: The Class of 1984," in *Master Drawings*, #4 (1984–86), p. 561. My thanks to Daniel Schulman for this reference.

PAGE 118, LINE 11
patterns

For Degas's programmatic intentions to do organized series of views of various Parisian subjects, see the notes he jotted down in a sketchbook, discussed by Reff as "Notebook 30, pp. 208ff," in *The Notebooks of Edgar Degas*, 1, p. 134. Among other things Degas thought "to do the arms, or the legs, or the back of a dancer; do the slippers; the hands of a hairdresser, the stuffed hairdo, bare feet in dance actions etc.—etc."

PAGE 122, LINE 26
they are used

This basic insight into language as a system of meaning is generally credited to Ferdinand de Saussure, in his *Cours de linguistique générale*, published by Charles Bally and Albert Sechehaye, with Albert Riedlinger (Lausanne: Payot, 1916). See the annotated translation by Roy Harris, *Course in General Linguistics* (La Salle, IL: Open Court, 1986). See also John R. Searle, *Speech Acts: An Essay in the Philosophy of Language* (Cambridge, Eng.: University Press, 1969). For a broader consideration of the impact of linguistic theory on ideas of artistic communication, see Jonathan Culler, *Structuralist Poetics* (Ithaca, NY: Cornell University Press, 1975).

PAGE 123, LINE 10
low origins

For a reading of *The Little Fourteen-Year-Old Dancer*, as exemplary of Degas's interest in naturalist theory, see Douglas W. Druick and Peter Zegers, "Scientific Realism: 1873–1881," in *Degas* (New York, 1988) pp. 197–211.

PAGE 123, LINE 33
long-term success

For a discussion of principles of adaptation and innovative recycling in evolution, see Stephen Jay Gould, "The Wheel of Fortune and the Wedge of Progress," *Natural History*, no. 3 (March 1989), pp. 14–21, and "Tires to Sandals," ibid., no. 4 (April 1989), pp. 8–15.

PAGE 123, LINE 45
service

Stephen Jay Gould, *The Panda's Thumb: More Reflections on Natural History* (New York: Norton, 1980).

PAGE 127, LINE 4
to itself

For assessments of Rodin's contributions to modern sculpture that are based in Minimalist aesthetics, see Tucker, *Early Modern Sculpture*; Morris, "Notes on Sculpture," Parts I and II in *Artforum*; Rosalind E. Krauss, *Passages in Modern Sculpture* (New York: The Viking Press, 1977).

PAGE 127, LINE 49
he dealt with

For a discussion of Rodin's working methods—especially his use and reuse of cast parts—see Albert E. Elsen, "When the Sculptures Were White: Rodin's Work in Plaster," and "Rodin's 'Perfect Collaborator,' Henri Lebossé," in *Rodin Rediscovered* (Washington, DC; National Gallery of Art; Boston: New York Graphic Society, 1981), pp 127–50 and pp. 249–59; Albert E. Elsen, "Rodin and the Partial Figure," in *The Partial Figure in Modern Sculpture from Rodin to 1969* (Baltimore: The Baltimore Museum of Art, 1969), pp. 16–28.

PAGE 130, LINE 21
end

For a detailed discussion of the *Gates*, see Albert E. Elsen *"The Gates of Hell" by Auguste Rodin* (Stanford, CA: Stanford University Press, 1985).

PAGE 133, LINE 20
smallest bits

Claudie Judrin, Monique Laurent, and Dominique Viéville, *Auguste Rodin: le monument des Bourgeois de Calais (1844–1895) dans les collections du musée Rodin et du musée des Beaux-Arts de Calais* (Paris: Edition Musée Rodin, 1977); and *Rodin's Burghers of Calais, Rodin's Sculptural Studies for the Monument to the Burghers of Calais from the Collection of the Cantor, Fitzgerald Group*. Catalogue essays by Mary Jo McNamara and Albert Elsen (Published by the Cantor, Fitzgerald Group, 1977).

PAGE 139, LINE 29
individual life"

Quotations from Georg Simmel, "Individual and Society in Eighteenth- and Nineteenth-Century Views of Life, An Example of Philosophical Sociology," *The Sociology of Georg Simmel*, ed. and trans. by Kurt H. Wolff (New York: The Free Press, 1978), p. 58.

PAGE 142, LINE 31
modern

The rhythmic repetitions in Hodler were expressions of his pseudo-scientific theory of "parallelism," a vision of universal order the artist intuited when he saw natural phenomena such as forests and mountain ranges, or human groups such as gymnastic societies or church groups at prayer. See Sharon L. Hirsch, *Ferdinand Hodler* (New York: George Braziller, 1982). Specifically regarding the image illustrated here, Hodler wrote in a letter (cited in *Le Symbolisme en Europe* [Paris: Réunion des Musées Nationaux, 1976], p. 79):

I aspire to a perfect unity, a religious harmony. I want to show the similarity among human beings, while the contemporary world is entirely penetrated by their differences. . . . In the two canvases I am working on, "Those Who Are Tired of Living" and "The Disappointed Ones," one can remark the uniformity of gestures which expresses the same state of the soul in these personages. . . .

PAGE 147, LINE 2
accuracy and clarity

Marey said: "Science has before it two obstacles that block its advance: these are, first, the defective capacity of our senses for discovering truths, and then the insufficiency of language for expressing and transmitting those that we have acquired. The object of scientific methods is to remove these obstacles." In his *La Méthode graphique dans les sciences expérimentales et principalement en physiologie et en médecine*, 2d ed., enl. (Paris: G. Masson, 1885), p. ii.

PAGE 147, LINE 30
productiveness

Frederick Winslow Taylor, *Scientific Management* (New York: Harper and Brothers, 1947); on Taylor, see Frank B. Copley, *Frederick W. Taylor: Father of Scientific Management*, 2 vols. (New York: Taylor Society, 1923); Hugh G. Aitkin, *Taylorism at the Watertown Arsenal: Scientific Management in Action 1908–1915* (Cambridge, MA: Harvard University Press, 1960); Samuel Haber, *Efficiency and Uplift: Scientific Management in the Progressive Era, 1890–1920* (Chicago: University of Chicago Press, 1964); *Le Taylorisme*, Actes du colloque international sur le taylorisme organisé par l'Université de Paris XIII, 2–4 mai, 1983; sous la direction de Maurice de Montmollin et Olivier Pastre (Paris: Editions la Découverte, 1984).

PAGE 149, LINE 7
Way"

Frank Bunker Gilbreth, *Motion Study, A Method for Increasing the Efficiency of the Workman* (New York: D. Van Nostrand, 1911); Frank Bunker Gilbreth and Lillian M. Gilbreth, *Applied Motion Study: A Collection of Papers on the Efficient Method to Industrial Preparedness* (New York: Sturgis & Walton, 1917). Further material can be found in William R. Spriegel and Clark E. Meyers, eds., *The Writings of the Gilbreths* (Homewood, IL: Richard D. Irwin, 1953). A Gilbreth family memoir is Frank Bunker Gilbreth, Jr., and Ernestine Gilbreth Carey, *Cheaper by the Dozen* (New York: Thomas Y. Crowell, 1948).

PAGE 152, LINE 10
fascism

In 1914 Boccioni said: "It seems clear to me that this *succession* is not to be found in repetition of legs, arms, and faces, as many people have stupidly believed, but is achieved through the intuitive search for the *unique form which gives continuity in space*. It is the form-type which makes an object live in the universal. Therefore, instead of the old-fashioned concept of sharp differentiation of bodies, instead of the modern concept of the Impressionists with their subdivision, their repetition, their rough indications of images, we would substitute a *concept of dynamic continuity* as unique form," quoted in Henderson, *The Fourth Dimension and Non-Euclidean Geometry in Modern Art*, p. 110. On Futurism, see Umbro Apollonio, ed., *Futurist Manifestos*, Documents of 20th-Century Art (New York: Viking, 1973). For recent thinking regarding Futurism and its connections to fascist politics, see Renzo De Felice, "Ideology," in *Futurismo & Futurismi—Futurism & Futurisms*, Venice: Palazzo Grassi; organized by Pontus Hulten (New York: Abbeville Press, 1986), pp. 488–92; Philip V. Cannistraro, "Fascism and Culture in Italy, 1919–1945," and Enrico Crispolti, "Second Futurism," in Emily Braun, ed., *Italian Art in the 20th Century* (Munich: Prestel; London: Royal Academy of Arts, 1989), pp. 147–54 and 165–71. The latter contains valuable bibliography.

PAGE 152, LINE 20
productive

On Taylor, see note to p. 147, l. 30, above; also Mary McLeod, "Le Corbusier and Algiers," *Oppositions*, no. 19/20 (Winter/Spring 1980), pp. 55–85.

PAGE 154, LINE 9
necessary forms

In their tract *Après le cubisme*, Ozenfant and his collaborator, Pierre Jeanneret (Le Corbusier), wrote that the human body was the highest example of evolution as a process of refinement toward efficiency, and demonstrated a "Law of Economy" that fitted organisms to their functional roles. For them it followed that the objects men made to serve them would reflect the same laws. See the discussion by Christopher Green in *Léger and Purist Paris* (London: The Tate Gallery, 1971), p. 51.

PAGE 156, LINE 10
157 and 158)

Sigfried Giedion, *Mechanization Takes Command: A Contribution to Anonymous History* (Oxford and New York: Oxford University Press, 1948).

PAGE 157, LINE 9
"objective" beauty

The archives of The Museum of Modern Art show that, on the occasion of the *Art in Progress* exhibition, held in 1944, the museum exhibited Brancusi's *Bird in Space* alongside two propellers. Some of the early prestige of aeronautics can be sensed in the account by Fernand Léger of the visit paid by Marcel Duchamp and Brancusi to the Salon de l'Aviation in 1913, cited by William A. Camfield in *Marcel Duchamp: Fountain* (Houston: The Menil Collection/Houston Fine Arts Press, 1989), p. 44 and n. 57. Duchamp is said to have remarked of a propeller, "Painting is finished. Who can do better than that propeller? Tell me, can you do that?"

PAGE 164, LINE 42
challenging way

See Karl R. Popper, *Conjectures and Refutations: The Growth of Scientific Knowledge* (New York: Basic Books, 1962); and *The Logic of Scientific Discovery* (New York: Harper & Row, [1968]); and Thomas S. Kuhn, *The Structure of Scientific Revolutions* (Chicago: University of Chicago Press, 1962); as well as International Colloquium in the Philosophy of Science, *Criticism and the Growth of Knowledge*, ed. by Imre Lakatos and Alan Musgrave (Cambridge, Eng.: Cambridge University Press, 1970).

PAGE 165, LINE 40
aspirations

On Brancusi's park at Tîrgu Jiu, see the discussions by Tucker in *Early Modern Sculpture*; by Sidney Geist in *Brancusi: A Study of the Sculpture*, rev. and enl. ed. (New York: Hacker Books, 1983); and by Varia in *Brancusi*.

PAGE 166, LINE 15
basic geometric modules

See the discussion of Brancusi's language of basic geometric elements in Varia, *Brancusi*, pp. 115–23. For a special discussion of Brancusi's bases as sculptures in their own right, see Scott Burton's notes in the brochure *Artist's Choice: Burton on Brancusi* (New York: The Museum of Modern Art, 1989).

PAGE 173, LINE 17
into painting

See Benjamin H. D. Buchloh, "Andy Warhol's One-Dimensional Art: 1956–1966," in Kynaston McShine, ed., *Andy Warhol: A Retrospective* (New York: The Museum of Modern Art, 1989), pp. 39–61.

PAGE 173, LINE 34
of its time

On the resemblances between Pop and abstract art, see Robert Rosenblum, "Pop and Non-Pop: An Essay in Distinction," *Canadian Art*, 23 (January 1966), pp. 50–54.

FOUR / PRIMITIVISM

PAGE 183, LINE 8
true"

Gauguin, quoted by Jules Heuret in "Paul Gauguin Discussing His Paintings," *L'Echo de Paris* (February 23, 1891), reprinted in Daniel Guérin, ed., *The Writings of a Savage, Paul Gauguin* (New York: Viking, 1978), p. 48.

PAGE 183, LINE 26
heart of darkness

The essential source of reference on *Les Demoiselles d'Avignon* is the two-volume exhibition catalogue, with contributions by William Rubin, Hélène Seckel, and Leo Steinberg: *Les Demoiselles d'Avignon* (Paris: Ministère de la Culture et de la Communication; Editions de la Réunion des Musées Nationaux, 1988).

PAGE 184, LINE 3
own values globally

For a sample of recent debate on primitivism in modern art, see Thomas McEvilley's review of the 1984 Museum of Modern Art exhibition *"Primitivism" in 20th Century Art: Affinity of the Tribal and the Modern*: "Doctor, Lawyer, Indian Chief: '"Primitivism" in 20th Century Art' at The Museum of Modern Art in 1984," *Artforum*, 23 (November 1984), pp. 54–61.; and also the exchange of letters among McEvilley, William Rubin, and myself, ibid., 23 (February 1985), pp. 42–51, and (May 1985), pp. 63–71. See also my article "On the Claims and Critics of the 'Primitivism' Show," *Art in America*, 73 (May 1985), pp. 11–21; and James Clifford, "Histories of the Tribal and the Modern," ibid. (April 1985), pp. 164–77 and 215, reprinted in his volume of essays *The Predicament of Culture: Twentieth-Century Ethnography, Literature, and Art* (Cambridge, MA: Harvard University Press, 1988), pp. 189–274; and Hal Foster, "The 'Primitive' Unconscious of Modern Art," *October*, no. 34 (Fall 1985), pp. 45–70; Arthur C. Danto, "Defective Affinities," *The Nation*, 239, no. 18 (December 1, 1984), pp. 590–92.

PAGE 186, LINE 18
essential nature

Bernard W. Smith, *European Vision and the South Pacific*, 2d ed. (New Haven: Yale University Press, 1985); Arthur Lovejoy and George Boas, *Primitivism and Related Ideas in Antiquity* (Baltimore: The Johns Hopkins Press, 1935; New York: Octagon, 1980).

PAGE 187, LINE 40
perception

The idea that the "affect of fear is the beginning of all religion" is traced at least to Hume, and had a strong momentum in Enlightenment thought; see Ernst Cassirer, *The Philosophy of the Enlightenment*, trans. by Fritz C. A. Koellin and James P. Pettegrove (Princeton, NJ: Princeton University Press, 1951), p. 107.

PAGE 189, LINE 3
systems of meaning

Gauguin wrote differing versions of an explanation of his thought process in transforming an experience—his glimpse of his young mistress terrified in the dark—into this painting. See my consideration of this text in my essay, "Gauguin," in William Rubin, ed., *"Primitivism" in 20th Century Art*, 1, pp. 179–200, and p. 208, n. 61.

PAGE 189, LINE 26
disparate cultures

On the revival of Enlightenment concerns in linguistic studies of the late nineteenth century, see Hans Aarsleff, *From Locke to Saussure: Essays on the Study of Language and Intellectual History* (Minneapolis: University of Minnesota Press, 1982). On changes in anthropology, see George W. Stocking, *Race, Culture, and Evolution* (Chicago: University of Chicago Press, 1982); and on the noxious aspects of biometrics in human study, Stephen Jay Gould, *The Mismeasure of Man* (New York: Norton, 1981).

PAGE 189, LINE 41
in its effects"

The Gauguin quote is from his manuscript (now in the collection of the Saint Louis Museum) "L'Esprit moderne et le catholicisme."

PAGE 190, LINE 9
art photos

On Gauguin's borrowing of motifs and poses from other art, see Robert Goldwater, *Paul Gauguin* (New York: Harry N. Abrams, 1957); Bernard Dorival, "Sources of the Art of Gauguin from Java, Egypt, and Ancient Greece," *Burlington Magazine*, 93, no. 577 (April 1951), pp. 118–22; Christopher Gray, *Sculpture and Ceramics of Gauguin* (Baltimore: The Johns Hopkins Press, 1963).

PAGE 190, LINE 22
those traditions

On the syncretist, pseudo-anthropological views held by Gauguin, and their relation to more widely held ideas of Polynesian origins, see Jehanne Teilhet-Fisk, *Paradise Reviewed* (Ann Arbor, MI: UMI Research Press, 1983).

PAGE 191, LINE 7
into all minds

"Because they appear to be different, I want to show they are related," quoted from *Diverses Choses* in Guérin, ed., *The Writings of a Savage*, p. 131.

PAGE 192, LINE 6
investigation

E. H. Gombrich, *Aby Warburg: An Intellectual Biography*, 2d ed. (Chicago: University of Chicago Press, 1986).

PAGE 192, LINE 22
savages of Oceania"

"Il est toujours à braconner sur les terrains d'autrui; aujourd'hui, il pille les sauvages de l'Océanie!" Camille Pissarro to Lucien Pissarro, November 23, 1893, in John Rewald, ed., *Camille Pissarro, Lettres à son fils Lucien* (Paris: Albin Michel, 1950), p. 217.

PAGE 192, LINE 28
there

For the witness account of Gauguin's arrival in Tahiti, see "Le Premier séjour de Gauguin à Tahiti d'après le manuscrit Jenot," in Georges Wildenstein, ed., *Gauguin: sa vie, son oeuvre* (Paris: Gazette des Beaux-Arts, 1958), pp. 117 and 124. On Gauguin and Buffalo Bill, see my discussion in Rubin, ed., *"Primitivism" in 20th Century Art*, 1, p. 206, n. 24.

PAGE 193, LINE 47
local consumption

My knowledge of these textiles is owed to Bengt Danielsson, who discusses them in his *Gauguin in the South Seas* (New York: Doubleday, 1966), p. 85. See further considerations in Rubin, ed., *"Primitivism" in 20th Century Art*, 1, p. 208, n. 60.

PAGE 196, LINE 15
Demoiselles

The notion that the influence of African sculpture is the primary explanation for the stylizations in the faces and anatomies of this painting has been revised, and revised again, in the past two decades. Pierre Daix suggested—based in part on Picasso's assertions to him—that this notion of influence should be debunked, in his article "Il n'y a pas 'd'art nègre' dans *Les Demoiselles d'Avignon*," *Gazette des Beaux-Arts*, 6th series, 76 (October 1970), pp. 247–70. William Rubin

systematically reviewed the possible sources of influence from sculptures in the Trocadéro collection, in Rubin, ed., *"Primitivism" in 20th Century Art*, 1, p. 260 and p. 336, nn. 64–66. His basic conclusion there is that tribal sculptures' primary impact on Picasso at the time had to do with his intuition of their "magical" power. For further consideration of Picasso's response to tribal art, see Yve-Alain Bois, "Kahnweiler's Lesson," *Representations*, 18 (Spring 1987), pp. 33–68.

PAGE 196, LINE 32
his "high" art

Adam Gopnik, "High and Low: Caricature, Primitivism, and the Cubist Portrait," *Art Journal*, 43, no. 4 (Winter 1983), pp. 371–76.

PAGE 197, LINE 12
painted the picture

William Rubin, "Picasso," in Rubin, ed., *"Primitivism" in 20th Century Art*, 1, pp. 262–65.

PAGE 197, LINE 33
setting them down

Ibid., p. 251. See also Rubin's discussion in *Picasso in the Collection of The Museum of Modern Art* (New York: The Museum of Modern Art, 1972), p. 43 and p. 198, n. 1.

PAGE 200, LINE 11
doodles

Picasso's remark that this drawing was the kind of thing one did while waiting on the phone was made to Pierre Daix, and relayed to me by William Rubin, personal communication.

PAGE 201, LINE 2
torso in disguise

See William Rubin, "La Genèse des *Demoiselles d'Avignon*," in *Les Demoiselles d'Avignon*, 2, p. 483, n. 67, where he cites John Nash, "Pygmalion and Medusa" (transcript of a talk recorded Thursday, June 18, 1970, and broadcast on BBC Radio 3, Wednesday, June 24, 1970, pp. 11–12); and John Nash, *Cubism, Futurism and Constructivism* (Woodbury, NY: Barron's, 1978), pp. 12–15.

PAGE 204, LINE 35
Ferdinand de Saussaure

Yve-Alain Bois, "Kahnweiler's Lesson," *Representations*, 18 (Spring 1987), pp. 33–68.

PAGE 207, LINE 27
cultures

Claude Lévi-Strauss, *Tristes tropiques* (Paris: Plon, 1955); *La Pensée sauvage* (Paris: Plon, 1962); *Anthropologie structurale* (Paris: Plon, 1958–73).

PAGE 207, LINE 32
our domain

For a sample of altered visions of anthropology after the 1960s, see Clifford Geertz, *The Interpretation of Cultures: Selected Essays* (New York: Basic Books, 1973) and *Local Knowledge: Further Essays in Interpretive Anthropology* (New York: Basic Books, 1983).

PAGE 211, LINE 17
(figs. 213 and 214)

Rubin, ed., *"Primitivism" in 20th Century Art*, 1, pp. 328–30.

PAGE 212, LINE 2
Cubism

For remarks on the frontal/profile face in Picasso, see Rubin, *Picasso in the Collection of The Museum of Modern Art*, p. 221, n. 2; Rubin credits Robert Rosenblum for pointing out the origin of this device in Picasso's *Bather* of 1908. For further consideration of Picasso's use of this device, see Rosenblum, "Picasso's *Woman with a Book*," *Arts Magazine*, 51, no. 5 (January 1977), pp. 100–105.

PAGE 213, LINE 3
cosmic symbolism

Meyer Schapiro discussed the cosmic symbolism in the *Girl Before the Mirror* in "A *Life* Round Table on Modern Art" (held in the penthouse of The Museum of Modern Art and reported by Russell W. Davenport in collaboration with Winthrop Sargeant), *Life Magazine* (October 11, 1948), p. 64. My thanks to William Rubin for this reference, which he cited in Rubin, ed., *"Primitivism" in 20th Century Art*, p. 340, n. 204, and text p. 328.

FIVE / OVERVIEW:
THE FLIGHT OF THE MIND

PAGE 220, LINE 7
vertically"

From Erik Werenskiold, "Impressionisterne," in *Nyt Tidskrift*, 1882; reprinted in his collection of essays, *Kunst, Kampf, Kultur* (Kristiania: Cammermeyers, 1917), pp. 63–67. My thanks to Reinhold Heller for bringing this remark to my attention.

PAGE 221, LINE 11 *p. 223)*	William Rubin, "Jackson Pollock and the Modern Tradition, Part II," *Artforum*, 5, no. 7 (March 1967), pp. 28–37.

PAGE 225, LINE 20
two different things

Erwin Panofsky, "Die Perspektive als 'symbolische Form,'" *Vorträge der Bibliothek Warburg, 1924–1925* (Leipzig-Berlin: B. G. Teubner, 1927), pp. 258–330.

PAGE 234, LINE 29
the pontiff!)

On the incident of Rodin's encounter with Victor Hugo (and for reproductions of relevant drawings), see Claudie Judrin, *Rodin et les écrivains de son temps* ([Paris]: Musée Rodin, 1976), pp. 78 and 80–83. On Rodin's encounter with Benedict XV, see Judith Cladel, *Rodin: sa vie glorieuse, sa vie inconnue* (Paris: Bernard Grasset, 1950), p. 313.

PAGE 240, LINE 6
in the street"

"On n'a jamais fait encore les monuments ou les maisons, d'en bas, en dessous, de près comme on les voit en passant dans les rues," from "Notebook 30, p. 196" in Reff, *The Notebooks of Edgar Degas*, 1, pp. 134–35.

PAGE 243, LINE 28
a causal connection

For a history of the technological development of photographic views of the world from above, see Beaumont Newhall, *The Airborne Camera: The World from the Air and Outer Space* (New York: Hastings House, 1969).

PAGE 243, LINE 35
of the elevator

Coburn made a characteristic claim for the partnership of new vision and new developments in modern life: "Photography born of this age of steel seems to have naturally adapted itself to the necessarily unusual requirements of an art that must live in skyscrapers, and it is because she has become so much at home in these gigantic structures that the Americans undoubtedly are the recognized leaders in the world movement of pictorial photography." In "The Relation of Time to Art," *Camera Work*, no. 36 (October 1911), pp. 72–73.

PAGE 249, LINE 3
with fig. 261)

Wood engraving from a drawing by Nadar reproduced in Newhall, *The Airborne Camera*, p. 21.

PAGE 252, LINE 24
of vision"

Sir James Jeans quoted by Arthur Koestler, in *The Roots of Coincidence* (New York: Vintage Books, 1972), p. 99, n. 31; originally in Sir James Jeans, *The New Background of Science* (New York: The Macmillan Company; Cambridge, Eng.: University Press, 1933), p. 5.

PAGE 254, LINE 9
in space"

El Lissitzky (Cologne: Galerie Gmurzynska, 1976), p. 66; another translation (slight variation) is in Sophie Lissitzky-Küppers, *El Lissitzky: Life, Letters, Texts* (London: Thames and Hudson, 1968), p. 347.

PAGE 256, LINE 21
into the depths!"

Malevich quotations in John E. Bowlt, *Russian Art of the Avant-Garde: Theory and Criticism 1902–1934*, rev. and enl. ed. (London: Thames and Hudson, 1988), pp. 118 and 145. On Malevich and science fiction, see John E. Bowlt, "5 × 5 = 25: The Science of Constructivism," *The Nelson-Atkins Museum of Art Bulletin*, 5, no. 7 (October 1982), pp. 5–18.

PAGE 259, LINE 6
seeing

A[lexandr] Rodchenko, "Puti sovremennoi fotografii" (The Paths of Modern Photography), in *Novyi Lef*, no. 9, 1928, pp. 31–39, quoted in Selim O. Khan-Magomedov, *Rodchenko: The Complete Work* (Cambridge, MA: MIT Press, 1987), pp. 219–25, n. 10. See also Wolfgang Kemp, "Das neue Sehen: Problem-geschichtliches zur fotografischen Perspektive," in *Foto-Essays: zur Geschichte und Theorie der Fotografie* (Munich: Schirmer/Mosel, 1978), pp. 51–101; and Rupert Martin, ed., *The View from Above: 125 Years of Aerial Photography* (London: The Photographer's Gallery, 1983).

PAGE 259, LINE 35
not known.)

Victor Chklovski, *Sur la théorie de la prose* (Lausanne: Editions l'Age d'Homme, 1973). See also Abigail Solomon-Godeau, "The Armed Vision Disarmed: Radical Formalism from Weapon to Style," *Afterimage*, 10, no. 6 (January 1983), pp. 9–14; and Stanley Mitchell, "From Shklovsky to Brecht: Some Preliminary Remarks Towards a History of the Politicisation of Russian Formalism," *Screen*, 15, no. 2 (Summer 1974), pp. 74–102.

PAGE 264, LINE 9
comprehension

See László Moholy-Nagy, *Painting, Photography, Film*, with a note by Hans M. Wingler and a postscript by Otto Stelzer, trans. by Janet Seligman (Cambridge, MA: The MIT Press, 1987), 1st ed. 1969, p. 28:

We have hitherto used the capacities of the camera in a secondary sense only. . . . This is apparent too in the so-called "faulty" photographs: the view from above, from below, the oblique view, which today often disconcert people who take them to be accidental shots. The secret of their effect is that the photographic camera reproduces the purely optical image and therefore shows the optically true distortions, deformations, foreshortenings, etc., whereas the eye together with our intellectual experience, supplements perceived optical phenomena by means of association and formally and spatially creates a *conceptual image*. Thus in the photographic camera we have the most reliable aid to a beginning of objective vision. Everyone will be compelled to see that which is optically true, is explicable in its own terms, is objective, before he can arrive at any possible subjective position. This will abolish that pictorial and imaginative association pattern which has remained unsuperseded for centuries and which has been stamped upon our vision by great individual painters.

PAGE 265, LINE 5 *without it*	Ernst Mach, *Beiträge zur Analyse der Empfindungen* (Jena: G. Fischer, 1886). Trans. by C. M. Williams, under the title *Contributions to the Analysis of the Sensations* (La Salle, IL: Open Court, 1984).
PAGE 266, LINE 19 *we call art*	Quotes from Viktor Shklovsky, "The Resurrection of the Word (1914)," in Stephen Bann and John E. Bowlt, eds., *Russian Formalism: A Collection of Articles and Texts in Translation* (New York: Barnes and Noble, 1973), pp. 41–47; and *Sur la théorie de la prose*, p. 16. See also Christopher Pike, ed., *The Futurists, the Formalists and the Marxist Critique* (London: Ink Links, 1979), p. 13.
PAGE 266, LINE 37 *influence*	Vladimir Il'ich Lenin, *Materialism and Empirio-Criticism: Critical Comments on a Reactionary Philosophy*, in *Collected Works*, 14 (London: Lawrence & Wishart; Moscow: Foreign Languages Publishing House, 1962).
PAGE 271, LINE 9 *Wright brothers*	See William Rubin, "Pablo and Georges and Leo and Bill," *Art in America*, 67, no. 2 (March–April 1979), p. 147, n. 51; and his essay in *Picasso and Braque: Pioneering Cubism* (New York: The Museum of Modern Art, 1989), pp. 15–62.
PAGE 273, LINE 31 *neglected*	Henri Matisse, "Notes d'un peintre," *La Grande Revue*, 52, no. 24 (December 25, 1908), pp. 731–45; trans. in Jack D. Flam, ed., *Matisse on Art* (London and New York: Phaidon, 1973; New York: E. P. Dutton, 1978) pp. 35–40.

LIST OF ILLUSTRATIONS

Complete information about each work is given only at the first occurrence.

ONE / INTRODUCTION

TWO / NEAR AND FAR

36. Wilhelm Busch. *Forgive the photographer! He can't do anything about it!* From *Fliegende Blätter*, 1871, no. 1336. Woodcut

37. Parmigianino. *Self-Portrait in a Convex Mirror*, ca. 1524. Oil on panel, d. 9⅝". Kunsthistorisches Museum, Vienna

38. A. Houssin. *Boulevard in Paris*, 1863. Stereoscopic photograph. Bibliothèque Nationale, Paris

39. Hippolyte Jouvin. *Place de la Concorde*, 1867. Stereoscopic photograph. Bibliothèque Nationale, Paris

40. Benedict. *Saint John in Lateran, Rome*, 1867. Stereoscopic photograph. Bibliothèque Nationale, Paris

41. Edgar Degas. *Place de la Concorde (Vicomte Lepic and His Daughters)*, 1875

42. Garry Winogrand. *Untitled*. From *Women Are Beautiful*, 1969. Photograph, 8⅔ × 13". © 1984 The Estate of Garry Winogrand

43. Edgar Degas. *Racecourse, Amateur Jockeys*, 1876–87. Oil on canvas, 26 × 31⅞". Musée d'Orsay, Paris

44. Ando Hiroshige. *Ushimachi, Takanawa*. From the series *One Hundred Famous Views of Edo*, 1857. Woodblock print, 13¼ × 8⅝". The Brooklyn Museum

45. Vincent van Gogh. *Japonaiserie: The Tree*, 1887. Oil on canvas, 21⅝ × 18⅛". Vincent van Gogh Foundation, National Museum Vincent van Gogh, Amsterdam

46. Ando Hiroshige. *Plum Estate, Kameido*. From the series *One Hundred Famous Views of Edo*, 1857. Woodblock print, 13¼ × 8⅝". The Brooklyn Museum

47. Ando Hiroshige. *Kinryuzan Temple, Asakusa*. From the series *One Hundred Famous Views of Edo*, 1856. Woodblock print, 13¼ × 8⅝". The Brooklyn Museum

48. Ando Hiroshige. *Moon Pine, Ueno*, 1857

49. Shiba Kokan. *Ryogoku Bridge, Edo*, 1787. Etching. Kobe City Museum, Japan

50. Shiba Kokan. *Courtesan on Veranda*, ca. 1771. Woodblock. Tokyo National Museum, courtesy International Society for Educational Information, Japan

51. Odano Naotake. *Shinobazu-no-ike*, before 1780. Color on silk, 38¾ × 52¼". Prefectural Museum of Akita, Japan

52. Satake Shozan. *Pine Tree with a Foreign Bird*, before 1785. Color on silk, hanging scroll, 68 × 22⅞". Shoji Heizo, Akita, Japan

53. Katsushika Hokusai. *View of Mount Fuji from Takahashi*, ca. 1805. From *Landscape Prints in Western Style*. Woodblock print, 7¼ × 9⅝". Tokyo National Museum, Tokyo

54. Katsushika Hokusai. *Fuji from the Seashore*. From the series *One Hundred Views of Mount Fuji*, 1834–47. Woodblock print, 7⅜ × 5". New York Public Library, Spencer Collection

55. Katsushika Hokusai. *Fuji Straddled*. From the series *One Hundred Views of Mount Fuji*, 1834–47. Woodblock print, 7¼ × 5". New York Public Library, Spencer Collection

56. Katsushika Hokusai. *Fuji Bountiful*. From the series *One Hundred Views of Mount Fuji*, 1834–47. Woodblock print, 7¼ × 5". New York Public Library, Spencer Collection

THREE / FRAGMENTATION
AND REPETITION

135. Auguste Rodin. *Right-Hand Study for Pierre and Jacques de Wissant*, from *The Burghers of Calais*, 1885–86. Bronze, h. 12¼″. Musée Rodin, Paris

136. Auguste Rodin. *Left-Hand Study for Eustache de Saint-Pierre*, from *The Burghers of Calais*, 1885–86. Plaster, h. 11⅝″. Musée Rodin, Paris

138. Auguste Rodin. Detail of face, from *The Burghers of Calais*, 1884–86. Musée Rodin, Paris

153. Giacomo Balla. *Swifts: Paths of Movement + Dynamic Sequences*, 1913. Oil on canvas, 38⅛×47¼″. Collection, The Museum of Modern Art, New York. Purchase

FOUR / PRIMITIVISM

301 LIST OF ILLUSTRATIONS

303 LIST OF ILLUSTRATIONS

INDEX

Figures in *italics* refer to pages on which black-and-white illustrations appear; *cpl.* indicates the page on which a color plate appears.

ACKNOWLEDGMENTS

I would likely not have written this book at all, and certainly not in its present form, if I had not received a MacArthur Foundation Fellowship in 1984. I am immensely grateful to the John D. and Catherine T. MacArthur Foundation for this extraordinary grant, which changed the way I conceived my responsibilities as a researcher, teacher, and writer. I am also grateful to another MacArthur Fellow, Stephen Jay Gould, for the intellectual model of critical intelligence and clear writing his essays on evolutionary biology provided me.

Several doctoral candidates at the Institute of Fine Arts of New York University helped with research. Patricia Berman, Assistant Professor at Wellesley College, Joan Pachner, and Susan Forster all contributed in the early going. Daniel Schulman and Fereshteh Daftari (Ph.D., Columbia University) did the crucial final work to bring the volume to a publishable state. Professor A. Richard Turner of New York University, Frances Smyth and Gaillard Ravenel of the National Gallery of Art, and Anne Umland of The Museum of Modern Art all did me the favor of reading the manuscript, and offering comments and suggestions. At Harry N. Abrams, Inc., Phyllis Freeman did excellent, patient editing, Neil Ryder Hoos carried through the onerous task of obtaining pictures, both with exemplary good will, and Elissa Ichiyasu, who was wonderfully patient with many requests for small readjustments, gave the book its elegant design, and I very much appreciate her sensitivity to the visual material.

Chapters 2 and 3 had their beginnings in 1979–80, in articles dealing with the question of photography's influence on Impressionism. Those articles, and much of my thinking about Degas in particular, were greatly informed by discussions with my brother, S. Varnedoe; and I am deeply indebted to him for countless contributions and helpful critiques since. The articles also drew on my discussions with Peter Galassi, now Curator of Photography at The Museum of Modern Art, and I wish to thank him for sharing many of the ideas which informed the exhibition he curated in 1981, *Before Photography.*

Especially with regard to chapter 4, I wish to thank William Rubin, Director Emeritus of the Department of Painting and Sculpture at The Museum of Modern Art, both for ideas which I cite, and for inviting me to participate as Co-Director of the 1984 exhibition *"Primitivism" in 20th Century Art.*

Chapters 2, 3, and 5 first took their present shape in the form of the Beatty Memorial Lectures at McGill University in April 1988. I very much appreciate the opportunity afforded me by the selection committee of the Beatty Lectures, and thank in particular the Chair of the Beatty Committee, Professor Gordon Machlachlan, Dean of Graduate Studies, and Professor Myrna Gopnik for their role in that invitation.

Finally, I acknowledge a debt of thanks deeper than can be measured or repaid, to two people who suffered longest and most consistently with my efforts to bring this book into being. Adam Gopnik has read and reread endless drafts of every one of these pages, and has been an indispensable fount of criticism, encouragement, and intellectual sustenance. Many of the ideas expressed here grew out of our discussions, and owe directly to his contributions. He also played a key role in prompting me to bring more of the style of my lectures into these essays. Elyn Zimmerman, my wife, has extended superhuman patience as a reader and counselor, and has made improvements in every one of the many, many drafts she has thoughtfully screened for me. More important, she has shared with me her personal insights, as an artist, into the art works and the questions of creativity at issue here. Her way of seeing, and thinking, has educated me in a special and irreplaceable way. Hers may also be the greatest pleasure in seeing the work completed, for it means she will never again have to listen to me wrestling to respond to the question "What is the book about?"

New York City, August 1989

PHOTOGRAPH CREDITS